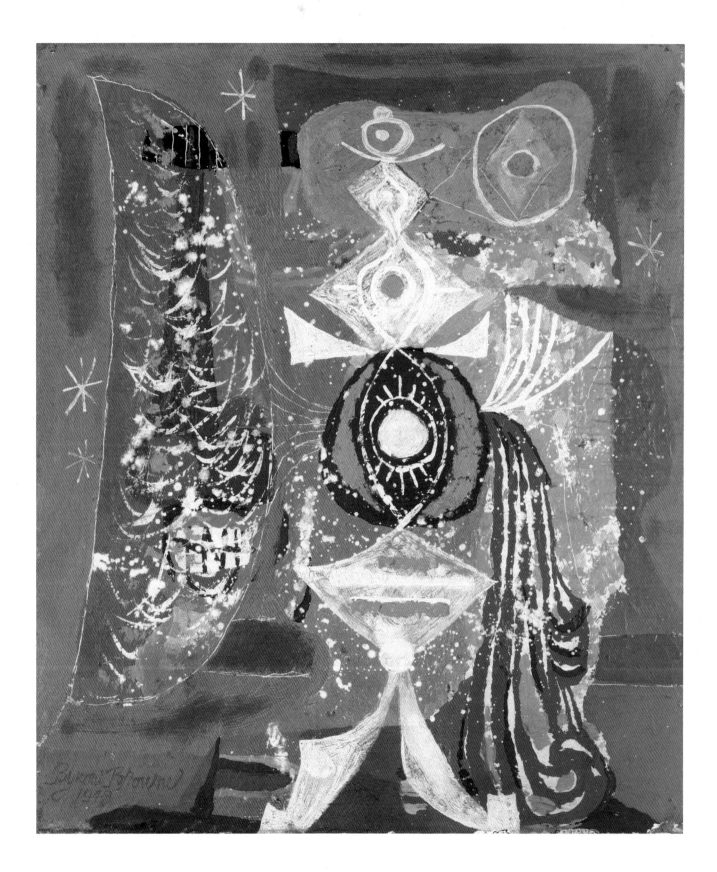

PRESENTED TO THE NATIONAL MUSEUM OF AMERICAN ART

THE PATRICIA AND PHILLIP FROST COLLECTION

AMERICAN ABSTRACTION 1930–1945

VIRGINIA M. MECKLENBURG

PUBLISHED FOR THE

NATIONAL MUSEUM OF AMERICAN ART

BY THE

SMITHSONIAN INSTITUTION PRESS

Published for the exhibition
The Patricia and Phillip Frost Collection: American Abstraction 1930-1945
National Museum of American Art
Smithsonian Institution, Washington, D.C.
8 September 1989–11 February 1990

Front cover: *Gridiron*, 1943-44, by Carl Holty (see p. 113)
Frontispiece: *Chinese Dancer*, 1949, by Byron Browne (see p. 46)
Pointed Brown and Floating Circles, 1933, by Werner Drewes (see p. 59)

Edited by Richard Carter
Designed by Polly Sexton
Typeset in Trump Medieval by BG Composition, Inc.
and printed by Ameriprint.

∞ The paper used in this publication meets the minimum requirements
of the American National Standard for Permanence of Paper for Printed
Library Materials Z39.48—1984.

Library of Congress Cataloging-in-Publication Data

Mecklenburg, Virginia M. (Virginia McCord). 1946–
 The Patricia and Phillip Frost Collection: American Abstraction
1930-1945 / Virginia M. Mecklenburg.
 p. cm.
 Catalogue of an exhibition held at the National Museum of American
Art, Sept. 8, 1989-Feb. 11, 1990.
 ISBN 0-87474-717-1 (alk. paper)
 1. Art, Abstract—United States—Exhibitions. 2. Art
Modern—20th century—United States—Exhibitions. 3. Frost,
Patricia—Art collections—Exhibitions. 4. Frost, Phillip—Art
collections—Exhibitions. 5. Art—Private collections—United
States—Exhibitions. 6. American Abstract Artists—Exhibitions.
I. Frost, Patricia. II. Frost, Phillip. III. National Museum of
American Art (U.S.) IV. Title
N6512.5.A2M4 1989
709.73'074'753—dc20 89-43055
 CIP

CONTENTS

FOREWORD

DURING THE PAST TEN YEARS SERIOUS ATTENTION HAS FOCUSED ON THE American Abstract Artists. Formed in 1937, to promote abstraction in the United States, the group's accomplishments were eclipsed after World War II by the emergence of Abstract Expressionism. During the early 1970s, scholars began to reassess the work of the American Abstract Artists and to reexamine the forces that shaped the artistic decisions of its members. Since then, collectors, the art press, and the marketplace have rediscovered this fascinating period. As a result, many early members of the American Abstract Artists are finally receiving long-overdue recognition.

When Patricia and Phillip Frost began collecting work by members of the American Abstract Artists, they brought a unique perspective and dedication to their search. Many paintings came through dealers, especially Martin Diamond and Joan Washburn, who had long championed abstraction of the 1930s. Dr. and Mrs. Frost discovered others on their own, by visiting artists, seeking out family members, and, in the case of Beckford Young's remarkable *Construction*, by delving into forgotten corners of dusty basement storerooms. From the beginning their commitment was to the members of the American Abstract Artists, although occasionally they acquired work by unaffiliated artists—Raymond Jonson, Emil Bisttram, and Ed Garman of the Transcendental Painting Group in New Mexico; Milton Avery and Hans Hofmann—who explored similar paths or exerted significant influence on the directions abstract artists pursued during the 1930s and early 1940s. Dr. and Mrs. Frost also sought works that offered some special insight into the experimental nature of abstraction during the 1930s, and in some cases bought paintings that represented an artist's "alternative side"—expressionistic, figurative-based compositions that did not dovetail with the geometric approach usually associated with the American Abstract Artists.

In addition to their acute sense of historical moment, the Frosts also became friends with many of the artists whose work they collected, inviting them to their home in Miami Beach for salon-style dinner parties and helping to make their work more widely known.

Their decision in 1986 to present the collection to the National Museum of American Art marked a milestone for the museum. The NMAA collection has long been rich in figurative painting of the 1930s. But developing a significant collection of abstract art from these years seemed increasingly elusive. Through the generosity of Patricia and Phillip Frost, it is now possible for the National Museum of American Art to present the multiple crosscurrents in American art of the 1930s and early 1940s.

It has been a special privilege to work with Dr. and Mrs. Frost and a pleasure to have met the artists and others who have generously contributed their time and knowledge. I am very grateful to Stephen Browne, Giorgio Cavallon, Charlotte Cushman, Eleanor De Laittre, Martin and Harriette Diamond, Herzl Emanuel, Ed Garman, Dwinell Grant, Balcomb Greene, Hananiah Harari, Fannie Hillsmith, Gerome Kamrowski, Ibram Lassaw, Emily Mason, George McNeil, John Opper, Joel Schanker, Verna Sennhauser, Esphyr Slobodkina, Gail Stavitsky, Ann Vytlacil, and Frederick Whiteman for the friendship and hospitality each showed during our conversations. The contributions of research assistants Mary Virginia Drach and Sonita Singwi were exceptional, as were

those of NMAA intern Margaret Morse and volunteer Leo LeMaire. I would especially like to thank intern Catherine Groos, who drafted biographical entries on Gerome Kamrowski, Alice Trumbull Mason, and Charles Shaw. The assistance of my colleagues at the National Museum of American Art, especially former director Charles C. Eldredge, and the Archives of American Art has been, as always, remarkable.

I would particularly like to thank the Smithsonian Institution's Special Exhibition Fund for supporting the exhibition, catalogue, and interpretive programming, and the Scholarly Studies Program for supporting research on American abstraction during this fascinating period.

Our most sincere appreciation to Patricia and Phillip Frost for their generous support of the exhibition publication and related programs.

VIRGINIA M. MECKLENBURG

PREFACE

WHEN PATRICIA AND PHILLIP FROST, IN THE EARLY 1980s, BEGAN ACQUIRING art created by the members of the American Abstract Artists group, they showed a sophistication and intellectual proclivity that is unusual in beginning collectors. Abstract art is still difficult for many people to love and rarely forms the sole focus of collections even though it has now enjoyed decades of critical praise. The structured, densely formal abstractions of the 1930s and 1940s are an especially unusual first romance because they avoid the easy allure of fluid brushwork and luscious color. This is a laboratory art—a disassembling of the gears and wires of image-making, and an engineering blueprint for the construction of a new kind of visual expression.

The Frosts recognized, however, that seeing these rigorously analytical paintings, drawings, constructions, sculptures, and collages together creates a rare excitement rather like an intense argument among close friends. This is what critic Clement Greenberg alluded to in 1942 when he reviewed the sixth exhibition of the American Abstract Artists, speaking of the "exhilaration peculiar to well-housed shows of abstract art." This is not an art of finished commodities made for a luxury market, but a groping toward the language of the future at a moment when that future was clouded by economic chaos and war. "Here was art in movement, new possibilities . . . that burst the confines of the set easel-picture and sculptured piece," continued Greenberg. "Upon this future a lot depends."

Apart from Greenberg, not many saw the relevance of experiments in abstraction in a time of soup lines or war mobilization. The 1936 Artists' Congress had rallied painters and sculptors to the cause of a social art explicitly engaged in economic, labor, and political reform. No less a critic than Meyer Schapiro spoke pessimistically of the "apparent isolation of the modern artist . . . detached from practical and collective interests . . . helpless to act on the world." Lewis Mumford was typical of many speakers in sounding an alarm and call to action, saying "We are in the midst of what is plainly a world catastrophe, and we have to realize what our position is, and do our best to put our hands to the oar and do whatever else is necessary to face this emergency."

Artists devoted to abstraction had to be rugged individualists to withstand such pressures for explicit social relevance, but even individualists found stimulation in collective activity in the leftist climate of the mid 1930s. The year after the Artists' Congress, they banded together to form the American Abstract Artists, seeking reinforcement in their common belief that art maintains its own special engagement with the world even in the face of catastrophe.

Despite the rift that developed in the 1930s between the various artistic camps, the art of the abstractionists like that of the social realists was less an expression of private visions than a search for a new order. The rigorous nature of their visual experiments—their primary concern for interlocking compositional structures and the frequent banishment of autographic marks and bright colors—reflects a preoccupation with new organizational principles and a rejection of the "cult of personality and the senses," as a Marxist of the period might have phrased it.

In the postwar climate of the late 1940s, the sense of world catastrophe gave way to triumph and celebration; a looser, freer, more brilliant and virtuosic abstraction based on the artist's inner life emerged to fit the new national self-confidence. The American Abstract Artists were overshadowed and finally displaced by a generation of younger painters whose heroism centered in personal psychic struggle and transcendence. Two generations of collectors and critics have embraced the Abstract Expressionists as the high priests of modernism, relegating earlier abstractionists to the role of forerunners if they are noticed at all.

Fortunately, Patricia and Phillip Frost were not blinded by prevailing preferences and so were able to assemble an exceptional collection of the earlier and very different experimentations in nonobjective art. They clearly perceived the "laboratory" nature of their work, taking care to represent in their collection not only major canvases but also the studies, collages, constructions, sketches, and sculptures through which these artists so often solved their formal problems. The Frosts are especially sensitive to the new combinations of materials used to test the limits of traditional formats, so that in their collection we can clearly recapture the "art in movement, new possibilities" of which Clement Greenberg wrote.

Dr. and Mrs. Frost were ideally suited to rediscover this lost generation of experimentalists, for Phillip Frost, a dermatologist, has had a career as an innovator in academic medicine and in the pharmaceutical industry. Patricia Frost, an educator, is the principal of West Laboratory School, the educational research facility for the University of Miami and the Dade County Public Schools. Their professional lives have been dedicated to the frontiers of research and to the proposition that intellectual independence leads to social progress. Just as essential for their collecting, the Frosts feel the "exhilaration" in the presence of art that Greenberg spoke of—an intuitive recognition of the spark given off by ideas in visual form.

The Frosts created their collection for the express purpose of giving it to a public institution. By generously donating these 113 remarkable objects to the nation, they have ensured that this seminal movement will never again be obscured in the history of American art. The members of the American Abstract Artists will be remembered for the testimony they brought to bear in the most difficult of times—a statement of faith that the language of art, even in its purest, irreducible form, speaks of the most essential concerns of society and culture.

ELIZABETH BROUN
Acting Director
National Museum of American Art

DISSENTING VOICES

THE PATRICIA AND PHILLIP FROST COLLECTION: AMERICAN ABSTRACTION 1930-1945

The Great Depression was in full swing. Contemplating going into the arts as a lifetime profession was the ultimate in an irrational hope and a guarantee of economic and social suicide. Then, of all things, to choose an area of interest . . . that was so coldly received as was abstract painting was yet another step into the twilight zone.
ED GARMAN[1]

THE ART WORLD DURING THE 1930s WAS RIFE WITH TURMOIL. TRADE UNIONism, leftist politics, and social agitation vied with utopian social improvement programs for influence in the art and popular press. For emerging artists, especially those seeking liberation from academic stylistic and thematic strictures, the decade offered exciting, though unsettling, possibilities. The American Abstract Artists group was born in this turbulent time.

One of the few organizations established for artistic rather than political purposes during the 1930s, the American Abstract Artists was formed in January 1937 to promote abstraction within a generally hostile New York art world.[2] Its members, many of whom were still grappling with conflicting ideas in their own art, represented a variety of artistic approaches. In varying degrees, however, all looked to European modernism—Cubism, Constructivism, Neo-plasticism—for stylistic and intellectual roots. This was one of their strengths. American abstract artists drew ideas from many quarters, combining, refining, and reshaping stylistic and theoretical issues developed abroad over the course of twenty years, giving them new life in a distinctly different atmosphere.

Formation of the American Abstract Artists stemmed from initial conversations at Ibram Lassaw's studio in the spring of 1936. Lassaw, along with Rosalind Bengelsdorf, Byron Browne, Burgoyne Diller, Balcomb Greene, Albert Swinden, and George McNeil met to consider a group exhibition.[3] In the months that followed, others joined the discussions, and while acknowledging the need for some sort of organization, they recognized the difficulty of drafting a group manifesto that would achieve consensus on either stylistic or programmatic grounds.[4]

Sporadic informal meetings culminated in November 1936, when George McNeil, Balcomb and Gertrude Greene, Vaclav Vytlacil, and others arrived, friends in tow, at Harry Holtzman's newly rented loft. The group met this time at the invitation of Holtzman, who was seeking broad-based support for an abstract artists' cooperative and workshop school. Holtzman's proposal was soon quashed in favor of a more pragmatic program, and within eight weeks the fledgling group had adopted a name and a statement of purpose.[5]

The "General Prospectus" established the American Abstract Artists as a group devoted to advancing abstract art in the United States through the exhibition of work by its members. "We believe," the founders declared in the organizational statement, "a new art form has been established which is definite enough in character to demand this united effort. This art is to be distinguished from those efforts characterized by expressionism, realistic representation, surrealism, etc."[6] Many of the early members of the American

Abstract Artists were identified with pure abstraction—either the structural geometries of Piet Mondrian and the Russian Constructivists, or the organic forms of Joan Miró and Paul Klee. Yet, as George McNeil later pointed out, over half the founding members were or had been students of Hans Hofmann, a Cubist turned Expressionist who had long taught the importance of some aspect of nature as the starting point for art.[7]

Despite heated discussions over the nature of abstraction at the group's weekly meetings, the common purpose of exhibiting in the face of overwhelming opposition from critics and museums was an exciting prospect. In April 1937, the group opened its first annual exhibition.

What prompted this bold step at a time of little interest and critical opposition? The scarce opportunities to exhibit in commercial galleries certainly contributed.[8] But the most direct catalysts were the two New York museums most likely to show progressive art by young Americans: the Museum of Modern Art and the Whitney Museum of American Art. In 1935, the Whitney's large exhibition *Abstract Painting in America* ignored the fertile new experiments of young New Yorkers in favor of work by Max Weber, Abraham Walkowitz, Marsden Hartley, John Marin, Arthur Dove, and others associated with Alfred Stieglitz's pioneering efforts. Although Stuart Davis was included, Davis's catalogue statement declared that the significant phase of abstraction in the United States had ended around 1927. In 1936, the Museum of Modern Art opened *Cubism and Abstract Art*, which showcased European art next to the work of a few American expatriates (Lyonel Feininger, Man Ray, and Alexander Calder).[9] While no one questioned the exhibition's importance in exposing European modernism to New York, its historical framework, coupled with the exclusion of recent New York artists, added to the sense of neglect felt by American abstractionists.[10] It was clear that little sympathy for the younger Americans' cause would be forthcoming from New York art institutions.

Ignored by the museums to whom they looked for support, American abstract artists found few advocates. The art press provided little support, and more often than not, turned its back on the abstractionists. The debate over abstraction versus figuration was not a new argument. Many of the issues that were raised by the Armory Show in 1913 were being rehashed with little change. Yet the very nature of art was at question. Is a painting first a pictorial arrangement whose meaning derives from formal considerations, or is its formal framework merely a vehicle for communicating narrative imagery?

Among artists, critics, and in the press these ideas sparked vehement debate in the United States. The social and economic fallout of the Depression led social commentators as well as artists to reexamine art in the context of American life. Although the issues were complex, many debated the question of art's relevance to the broad American public on nationalistic grounds. It was argued that recognizable subject matter was the only vehicle whereby artists could communicate with the public. By presenting American scenes, manifesting "native" qualities, and rejecting European art forms, American artists could help repair the Depression's damage to the national psyche.[11] The ethical tenor of this argument suggested that abstract artists were abnegating a deep

social responsibility. Not surprisingly, many budding abstractionists felt morally condemned for choosing an esoteric path.[12]

Yet, the vitriolic diatribes of antagonists like Thomas Craven, who railed against "lady art students and students of philosophy mired in [the] aesthetics" of European art movements, were easier to counter than were the arguments of more moderate critics.[13] For example, Lloyd Goodrich of the Whitney said that excluding subject matter ran

> counter to a universal and powerful human instinct. . . . Abstractionism, by excluding the associative values of images, has denied itself the most profound plastic values. It has created striking and intriguing decoration, but not art which approaches the depth and power of the great masters of the Western Tradition.[14]

More subtle, and more pernicious, was the position that mankind is physiologically or psychologically unable to disconnect pure form and color from references to the natural world. The idea that human beings respond physically or psychologically, rather than intellectually, to arrangements of color and form in the visual arts was used by both sides. Comparing abstract painting with music, a writer for *American Magazine of Art* argued that human beings are innately capable of receiving pleasure from the abstract art of music because they expect no connection between music and sounds heard in the external world. However, the writer argued, the opposite was true for the visual arts. The visual arts, he said, "are so closely linked with our experience of physical objects that they are saturated with representational suggestiveness." Thus, a line drawn on a piece of blue paper elicits an unwitting reaction in humans; references to horizon lines, sky, ocean were psychologically inescapable.[15]

Abstract artists found it difficult to refute the inevitability of human psychological response. After all, it was an argument they themselves frequently used in order to promote abstraction as a means of direct communication between the artist and the viewer.

But how could abstract artists—particularly those with leftist social leanings—respond to these charges? They, too, were suffering the Depression's effects and somehow had to survive despite rampant unemployment. An organization of diverse individuals, which in Rosalind Bengelsdorf's words represented "every avant-garde school of the time," the American Abstract Artists was not in a position to present cohesive theoretical arguments in support of the cause.

Bengelsdorf said there were two primary groups that made up the American Abstract Artists: "Those stemming from Hofmann meant they liked Mondrian, Picasso, Braque, Matisse (for color). Opposed were those reflecting the impact of the Bauhaus (Kandinsky was Bauhaus too) and Gris, who was really more allied to Feininger than Picasso. Byron [Browne] and I and our ilk valued the experiments of Malevich, Pevsner, and Gabo, and we valued Gonzalez more and Miró."[16]

Many original members of the American Abstract Artists had been to Paris or Germany.

Many had at least visited, and in some cases become friendly, with leading European painters and sculptors. Albert E. Gallatin, Charles Shaw, George L. K. Morris, Balcomb and Gertrude Greene, Vaclav Vytlacil, Carl Holty, Ilya Bolotowsky, John Ferren, Jean Xceron, and others had spent greater or lesser amounts of time in Paris during the early 1930s. Josef Albers and Laszlo Moholy-Nagy both had taught at the Bauhaus, and Werner Drewes had been a student there.

Even those who remained in New York were moderately well versed in European modernism. The publications of various European groups—de Stijl, *Abstraction-Création*, the Constructivists, along with the periodical *Cahiers d'Art*—were certainly familiar. Friends not affiliated with the group, for instance Arshile Gorky and John Graham, helped acquaint their less well-traveled colleagues with the mysteries of Cubism and other vanguard styles. But, by the late 1920s it was also possible to see examples first-hand. Katherine Dreier's remarkable Société Anonyme collection was shown at the Brooklyn Museum during the winter of 1926–27. In December 1927, Albert E. Gallatin opened the Gallery of Living Art (later called the Museum of Living Art) at New York University and the opportunity to study European vanguard art at length, and at leisure, was finally available.[17] Commercial galleries also showed recent vanguard European art. No fewer than forty-five gallery exhibitions featured Picasso, Kandinsky, Klee, Léger, and Feininger between 1930 and 1940.

Almost half the original members of the American Abstract Artists, including Vaclav Vytlacil, George McNeil, Giorgio Cavallon, Rosalind Bengelsdorf, Carl Holty, and Wilfrid Zogbaum, had converted to modernism through the insights of Hans Hofmann, himself an eclectic advocate of modern movements. Others were drawn to the purified utopian ideas of Piet Mondrian, the Russian Constructivists, and the *Abstraction-Création, Art Nonfiguratif* group in Paris. Understandably, the group could not agree on a single theoretical statement.

Yet, in the 1938 Yearbook, published in conjunction with the annual exhibition, various members defined, explained, and justified abstraction in terms they considered meaningful to the times. Isolationism was not the answer—the creation of a universal language in art that reached beyond narrow chauvinism, drawing from European art and ideas as well as native concerns, might better address man's future well-being.

Few members of the American Abstract Artists were real theorists of the new art. Indeed, by the 1930s it was often difficult to disentangle the ideas of various European movements. For example, the utopian vision of the Bauhaus artists and the Russian Constructivists did not conflict, at least in the minds of Americans, with the formal concerns espoused by Cubists or by Hans Hofmann. Americans instead blended sources, drawing formal devices from one group, theoretical concerns from others.

Hans Hofmann, perhaps the single most influential proponent of the new art in New York City, had spent the early years of his career in Paris and was intimately acquainted with the analytical and synthetic phases of Cubism and their offshoots as well as with Matisse's early experiments with color and space. He was thoroughly familiar with Wassily Kandinsky's work, according to Carl Holty, who reported that Kandinsky had

left his early work in Munich and had been unable to return at the beginning of World War I.[18] Hofmann was visiting his family in Munich when war broke out. Unable to return to Paris, he opened a school for modern art.

Hofmann's concerns as a teacher went far beyond instruction in modernist principles. As in more academic institutions, Hofmann's students first learned to draw, working from life and from still-life arrangements, before beginning to paint or use color.[19] At his school in Munich and later in New York, he illustrated lectures with diagrams of composition and movement in Old Master and modern works. Some of his favorite examples were Michelangelo's God and Adam panel from the ceiling of the Sistine Chapel, Rembrandt's drawings, works by Piero della Francesca, Giotto, Cézanne, and the Cubists.

The core of Hofmann's teaching was his treatment of the painting as an independent object, itself not a new concept. As early as 1890 Maurice Denis had written that a picture, "before being a battle horse, a nude woman, or some anecdote—is essentially a plane surface covered with colors assembled in a certain order."[20] Albert Gleizes and Jean Metzinger had taken this idea one step farther: a true painting, they wrote, "carries within itself its *raison d'être*. . . . Essentially independent, necessarily complete . . . it does not harmonize with this or that ensemble, it harmonizes with the totality of things, with the universe; it is an organism."[21]

The creation and balancing of space—both forward and back—via manipulation of color and form on the two-dimensional canvas lay at the heart of Hofmann's theories. As important as form in painting were the voids—the space "between and around portions of visible matter" throughout the picture plane. Hofmann advocated separating planes and colors from the outlines of objects and distributing them over the entire surface of the canvas. Through his analyses of the picture plane, the relationship of forms and colors to each other, and especially his emphasis on rhythm, which he called "the highest quality" in a work of art, Hofmann opened many eyes, already well trained by academy standards, to new possibilities in paint.

Hofmann's emphasis on formalism was based on a deep-seated belief in the psychological impact of art. He stressed empathy, a concept developed by Wilhelm Worringer, which Hofmann defined as "the intuitive faculty to sense qualities of formal and spatial relations or tensions, and to discover the plastic and psychological qualities of form and color."[22] An intuitive painter himself, Hofmann wrote that "color stimulates certain moods in us. It awakens joy or fear in accordance with configuration."[23]

Bengelsdorf called Hofmann the "catalyst who helped me see 'holes' in pictures, who attempted to maneuver me so I could produce paintings that 'held the surface' while they indicated innumerable depths."[24] As a result of his teaching, Hofmann's students came to believe that a work of art began in the rhythms, forms, and colors of nature. He did not argue against nonobjectivity—many of his own works have no identifiable objects—but taught fundamental principles. Through his schools in New York and Provincetown, he reached a large number of forward-looking artists, and a public lecture series he gave during the winter of 1937–38 attracted widespread attention in New York.

Hofmann's influence went far beyond the students who attended his New York and Provincetown schools. During the 1920s, Vaclav Vytlacil, Worth Ryder, Ernest Thurn, Carl Holty, and other young Americans attended Hofmann's classes in Munich or in the various towns in Germany, Italy, and France where his summer sessions were held. Many of these younger artists became Hofmann's apostles. Through Ryder, who began teaching at the University of California at Berkeley, Vytlacil, who became an instructor at the Art Students League in New York, and Thurn, who opened a school in Boston, Hofmann's teachings found an American audience several years before Hofmann himself took up residence in the United States.[25]

Although Hofmann never joined the American Abstract Artists, he gave his blessing when the group was formed, and his protégés represented a significant faction within the organization.

If Hofmann taught the psychological impact of pictorial arrangements, the ideas generated at the Bauhaus and by the Russian Constructivists provided meaningful models for arguing the social relevance of abstraction. In the aftermath of World War I, it was clear to Constructivists Naum Gabo, Antoine Pevsner, Vladimir Tatlin, and others that the structures on which modern civilization was built had failed. For them history provided flawed models, so they designed a new art, a constructive art. Built around the ideas and materials of the age of science, for a time this new art was considered the true style of the Russian proletariat. Their utopian vision inspired Constructivists to believe that their new art could induce order in an otherwise chaotic society. For left-wing American artists struggling against charges of social meaninglessness, Constructivism had strong appeal.

Among the American Abstract Artists, Rosalind Bengelsdorf, John Ferren, and Josef Albers were especially conscious of living in a new age—an age of science and the machine. Bengelsdorf described the modern artist as "a researcher in his medium, parallel to the scientist experimenting in a laboratory," seeking to discover "those infinite phenomena that actually make life experiences, thereby giving to humanity a better means of dealing with his only defense against natural enemies. And this defense is knowledge."[26] Although couched in more personal terms, Josef Albers reflected similar sentiments: "Through works of art we are permanently reminded to be balanced, within ourselves and within others; to have respect for proportion, that is, to keep relationships. It teaches us to be disciplined, and selective between quantity and quality."[27] Like the Constructivists, these artists believed abstraction addressed a larger human concern—the possibility for order within the universe.

Many Americans became familiar with Constructivist ideas through the members and publications of *Abstraction-Création, Art Nonfiguratif*, a Paris-based international association established to promote "the cultivation of pure plastic art, to the exclusion of all explanatory, anecdotal, literary and naturalistic elements."[28] Leading members included Piet Mondrian, the Russians Naum Gabo, Antoine Pevsner, Kasimir Malevich, and El Lissitzky, as well as Wassily Kandinsky and other teachers from the Bauhaus. Among those who later belonged to the American Abstract Artists, Carl Holty, Jean Hélion, John

Ferren, and Jean Xceron were members of the French group. Hélion's fluent command of English made him an especially important member. It was Hélion who introduced Albert Gallatin, George L. K. Morris, Charles Shaw, and other Americans to various members of the international group. Balcomb and Gertrude Greene, both active in leftist organizations in New York, were attracted by the art and social ideas when they encountered *Abstraction-Création* shortly after its formation in 1931. But the Americans did not adopt Constructivism wholesale.

Several members of *Abstraction-Création*, notably Mondrian and Kandinsky, also proposed a spiritual foundation for art. Most members of the American Abstract Artists had read Kandinsky's *On the Spiritual in Art* and were conversant with the spiritual underpinnings of Neo-plasticism. Based on theosophy, the ideas of Kandinsky and Mondrian had a direct impact on the Transcendental Painting Group in New Mexico—notably Raymond Jonson and Emil Bisttram. In New York, the spiritual explanations for art were most staunchly advocated by Hilla Rebay, Solomon R. Guggenheim's art advisor, whom most members of the American Abstract Artists regarded as an adversary.

A difficult and opinionated woman, Rebay advocated pure nonobjectivity as the key to "a world of unmaterialistic elevation."[29] She spoke of cosmic order, universal understanding, and intuitive genius, and had little patience for those who disagreed with her narrow stylistic preferences. Even those members of the American Abstract Artists who enjoyed her support—Dwinell Grant, Gerome Kamrowski, and John Sennhauser—generally remained disenchanted with her cosmic ideas. (Kamrowski exhibited his Surrealist canvases anonymously for several years to prevent Rebay's discovering that he had strayed from her stylistic fold.) When the Guggenheim collection opened for public viewing in 1937, Rebay's articulate explanations of nonobjectivity were opposed by those members of the American Abstract Artists who advocated the social relevance of abstraction.

Given the support for populist art in the press, Rebay's elitist position could only harm the cause. So in 1937, Hananiah Harari composed a letter to the editor of *Art Front*, the publication of the Artists' Union, signed by Byron Browne, Herzl Emanuel, George McNeil, Rosalind Bengelsdorf, Jan Matulka, and Leo Lances. The letter refuted Rebay's view of nonobjective art and reaffirmed the connection between abstraction and the real world:

> It is our very definite belief that abstract art forms are not separated from life, but on the contrary are great realities, manifestations of a search into the world about one's self, having basis in living actuality, made by artists who walk the earth, who see colors (which are realities), squares (which are realities, not some spiritual mystery), tactile surfaces, resistant materials, movement. . . . Abstract art does not end in a private chapel. Its positive identification with life has brought a profound change in our environment and in our lives. . . .[30]

These artists proposed that abstraction provided a direct mechanism for the artist to communicate with his audience, free of the limitations imposed by subject matter. In

Balcomb Greene's words, "The abstract artist can approach man through the most immediate of aesthetic experiences, touching below consciousness and the veneer of attitudes. . . .[31]

Apart from aesthetic questions, for pragmatic reasons it was important to connect abstract art with contemporary life. As director of the mural project for the New York City WPA, Burgoyne Diller hired Byron Browne, George McNeil, Hananiah Harari, and others to design murals for public walls around New York City. Argument that abstract art was elitist, particularly from such a well-placed figure as Rebay, jeopardized the precarious relationship between abstract artists and the WPA.[32]

An early devotee of the ideas and art forms promoted by *Abstraction-Création*, Diller was a former Hofmann student who had begun incorporating the Constructivist principles of El Lissitzky and Kasimir Malevich into his own work as early as 1930. By late 1933, he had discovered Mondrian, and from that time on Neo-plasticism became a primary concern.[33]

As director of the WPA mural program, Diller was in a unique position to act on the idea that abstract art could serve larger social ends. The murals completed under his supervision—for radio station WNYC in New York's municipal building, the Chronic Disease Hospital, the Central Nurses Home on Welfare Island, the 1939 World's Fair, and other prominent locations—represented a significant milestone for abstract art.

One of the largest mural sites was the Williamsburg Housing Project, a modern complex of twenty apartment buildings designed as workers' housing under the progressive eye of architect William Lescaze. The project provided a unique opportunity to test the Constructivist-based idea of abstraction as a proletarian style. With Lescaze's support, Diller arranged for Stuart Davis, Balcomb Greene, Harry Bowden, Ilya Bolotowsky, and Albert Swinden, among others, to paint geometric abstractions on walls in communal rooms throughout the complex that were in keeping with the clean design of the architecture.[34]

In arguing for the placement of abstract murals on public walls, Diller blended the Constructivist-styled language of social usefulness with Hans Hofmann's psychological understandings. He explained the motivation behind the Williamsburg Housing Project:

> The decision to place abstract murals in these rooms was made because these areas were intended to provide a place of relaxation and entertainment for the tenants. The more arbitrary color, possible when not determined by the description of objects, enables the artist to place an emphasis on its psychological potential to stimulate relaxation.[35]

If the emotional and psychological life of man could be improved through abstract art, science and technology offered ways to break through what the Museum of Modern Art's Alfred Barr called the "treacherous wilderness of industrial and commercial civilization."[36] For American Abstract Artist members, the views of social commentator Lewis

Mumford held real appeal. Mumford believed that the machine fostered "cooperative thought and action," that it instilled a desire for order, and that the task of the artist was to interpret this new order.[37]

The most significant attempt to integrate technology with art had begun during the early 1920s at the Bauhaus, the famous experimental school for industrial design in Germany, where both Josef Albers and Laszlo Moholy-Nagy had taught. When the Bauhaus closed in 1933, Albers accepted a teaching position at Black Mountain College in North Carolina, and in 1937, Moholy-Nagy settled in Chicago, establishing a new industrial design school.[38] Utopian in philosophy, the Bauhaus curriculum had a strong pragmatic basis that served as a model for an experimental school established under WPA auspices in New York. Its name, the Design Laboratory, underscored its experimental nature, and the innovative curriculum required courses in sociology and psychology as well as art, industrial design, and the science of industrial materials.[39]

Both the Design Laboratory and Moholy-Nagy's Institute of Design in Chicago emphasized the connection between art and American industry. Advertising and marketing had become sophisticated fields, and many felt it was time product design caught up. By educating a new breed of artist-designers who would develop useful objects that could be easily mass produced, the Design Laboratory and the Institute of Design aimed to raise the American public's standard of living, broaden its aesthetic appreciation, and create a demand for well-designed, useful objects. (During World War II, the Institute of Design developed creative ways for manufacturers to cope with shortages: wooden bed springs to replace metal springs, an infrared oven made of an oil drum, and other objects were proposed, although only prototypes were ever built.)[40]

The philosophy of the Design Laboratory and the Institute of Design infiltrated the American Abstract Artists through Irene Rice Pereira, Robert Jay Wolff, and Laszlo Moholy-Nagy. The programs of these schools provided tangible evidence that Bauhaus and Constructivist ideas played a significant part in reorienting contemporary notions of the role of art within American society. They reflected a social optimism that marked the improving economic situation during the last years of the 1930s.

Given the remarkable variety in art and ideas within the membership of the American Abstract Artists, it was probably inevitable that serious internal dissension would occur, despite the success of its exhibition program. From the outset the group divided on stylistic issues, but became increasingly associated with geometric abstraction, due partly to the leadership of Balcomb Greene and Carl Holty. Yet many members found this emphasis increasingly confining.

Hananiah Harari was one who could not accept the idea that "a formally pure art in and of itself denoted an evolutionary advance over an art of forms rooted in the natural world."[41] George McNeil described his work during the 1930s as a dialogue (not a conflict) between geometric abstraction and a more expressionistic style that used identifiable subject matter. Byron Browne and Ilya Bolotowsky both made delicate, classical drawings throughout the late 1930s and early 1940s. Clearly, a doctrinaire commitment

to some form of modernism was not a sole motivating factor in their work. Jean Hélion, George McNeil, Herzl Emanuel, and even Balcomb Greene returned to figuration following their active involvement in the American Abstract Artists. They recognized the importance of Cubism, Constructivism, Neo-plasticism, but used the work of their European antecedents as devices, as vocabulary or syntax (as Herzl Emanuel phrased it) for the development of their mature styles.

The American Abstract Artists also divided on political grounds. The intrusion of leftist politics threatened to split the group apart before the end of its first year. Open warfare erupted between a faction of Communist party members who demanded the group take political positions and others determined to leave such concerns to the Artists' Union and the American Artists' Congress. Both were formed to address the political turmoil of the mid and late 1930s. Stalinist purges, the Russo-Finnish War, the Italian invasion of Ethiopia, the Spanish Civil War, and the Nazi-Soviet Nonaggression Pact had upset political alignments among New York artists. Many found their earlier positions no longer tenable in light of recent events. Within the American Abstract Artists, Stalinists were pitted against Trotskyites, and socially minded leftists found themselves in a close struggle for power. On one occasion, Balcomb Greene barely maintained the chair during a meeting in which members of the Communist party attempted his ouster.[42]

Despite political and stylistic disagreements and the lukewarm, at times hostile reaction of New York critics, the American Abstract Artists had a remarkable degree of success during its fledgling years. While controversial, the first several annual exhibitions attracted a great deal of attention—some fifteen hundred people saw the first annual show in 1937 at Squibb Gallery, while the 1938 annual attracted some seven thousand New Yorkers in addition to those who attended in Seattle, San Francisco, Kansas City, and Milwaukee. Two additional exhibitions were held in 1938—at the Contemporary Art Center of the 92nd Street YMHA and at the newly opened Municipal Art Center. In addition to the 1940 annual, which included vanguard architects, the group staged a protest against the Museum of Modern Art and passed out a pamphlet, "How Modern is the Museum of Modern Art?" designed by Ad Reinhardt.

World War II dispersed many of the American Abstract Artists' original members. Some went into military service, others into defense-related work. The dissolution of the WPA took an obvious toll. By the early 1940s, many members, including the Greenes, felt that the group had fulfilled its mission and resigned.

Ironically, the 1942 exhibition, which Esphyr Slobodkina described as boasting "several radiant, new Mondrians, a large canvas by Hélion—one of the last abstractions he painted . . . , a boring but very learned exposition of the subject of making abstract films by Hans Richter, and one or two examples of each member's work which in most cases, including myself, were beginning to show signs of true maturity and considerable originality. . . ." had very small attendance.[43] By the end of the war, the opportunities to exhibit expanded dramatically, but more importantly, the art climate, and the artists themselves had changed. No longer committed to promoting abstraction, they dispersed to jobs around the country where many eventually developed styles that no longer coincided with the group's earlier view.

Yet the legacy of the American Abstract Artists is significant on its own terms. Despite post mortems that suggested its primary value lay in preparing the groundwork for the Abstract Expressionists, the group supported independent effort and process rather than resolution. An important body of significant art was the result. In words they themselves might have used, the American Abstract Artists played a part in the evolution of modern art, and cemented the conviction that experimentation has merit on its own terms. Well-grounded academically, they valued past art, while recognizing that they must seek new forms to speak to the conditions of contemporary life.

1. Ed Garman, letter to the author, 15 February 1988, curatorial files, National Museum of American Art, Smithsonian Institution, Washington, D.C.

2. Apart from groups like the John Reed Club that were specifically political organizations, a number of other artist organizations had political or labor union missions. The Unemployed Artists' group, the Artists' Union, and the American Artists' Congress were the most active of these. In addition, The Ten was established in 1935 to champion artistic experimentation and internationalism. The Ten showed together at the Montross Gallery, Passedoit Gallery, Mercury Gallery, and the Galérie Bonaparte in Paris. For the 1938 exhibition at Mercury Gallery, The Ten published a manifesto that denounced the "symbol of the silo" associated with regionalists John Steuart Curry, Thomas Hart Benton, and Grant Wood as well as the "reputed equivalence of American painting with literal painting." For a detailed study of The Ten, see Lucy McCormick Embick, "The Expressionist Current in New York's Avant-Garde: The Paintings of the Ten" (M.A. thesis, University of Oregon, 1982).

3. Reminiscences vary as to who attended the early meetings that gave rise to the American Abstract Artists. Susan C. Larsen reports that the first meeting included Rosalind Bengelsdorf, Byron Browne, Albert Swinden, and Ibram Lassaw, and that the meeting at Lassaw's studio was held early in 1936. See her article, "The American Abstract Artists: A Documentary History, 1936–41," *Archives of American Art Journal* 14, no. 1 (1974): 2.

4. It was also clear that several of the stronger personalities involved sought to dictate the directions the group might take. The oft-told story of Arshile Gorky and Willem de Kooning walking out of an early meeting because other artists refused Gorky's self-proclaimed status as critic of their work is the best-known example of this.

5. John Elderfield has described the American Abstract Artists as a "tactical response to the difficulties of exhibiting rather than a polemical stance for one kind of art alone." See his "American Geometric Abstraction in the Late Thirties," *Artforum* 11 (December 1972): 35–42.

6. "Organization," *American Abstract Artists: Three Yearbooks (1938, 1939, 1946)* (reprint, New York: Arno Press, 1969), p. 6.

7. See George McNeil, "American Abstractionists Venerable at Twenty," *Art News* 55, no. 3 (May 1956): 64.

8. Although the Julian Levy Gallery, the Downtown Gallery, and the East River (Willard) Gallery sometimes showed the work of individual abstract artists, none was devoted to American abstraction. However, several alternative spaces, among them the Eighth Street Playhouse Theater gallery and the Artists' Gallery, provided opportunities for abstract painters and sculptors. The Artists' Gallery, a nonprofit space founded in 1936, was supported by contributions; it charged exhibitors no fees and took no commissions.

9. Although Calder lived in New York, his early development and success in France allied him with the School of Paris. Also included were several émigrés—Alexander Archipenko, who had come to the United States in 1923, and Rudolf Belling, a German-born sculptor living in New York.

10. Alfred Barr justified his selections on the basis that the Whitney had featured American abstract artists the year before, an argument that Balcomb Greene and others found particularly infuriating.

11. In 1934 and 1935, the *American Magazine of Art* featured a series of articles about the validity of abstraction in which one William Schack maintained that "... there must be a medium of visual exchange between the artist and his audience, and the infinite number of objects which comprise the world constitute such a medium, and the only one we have...." William Schack, "On Abstract Painting," *The American Magazine of Art* 27, no. 9 (September 1934): 470.

12. George McNeil, interview with the author, 29 November 1988; a videotape of this interview is available through the National Museum of American Art.

13. An ardent champion of regionalists Thomas Hart Benton and Grant Wood, Craven ridiculed progressive art, contending that the United States would never accept abstraction:
> ... art for its own sake or beauty's sake or for the sake of abstraction whatever, will not thrive in America. . . . The kind of painting exploited by our international dealers is a hothouse product nurtured in little pots of imported soil, and . . . will never exert an iota of influence on American life or thought. . . . If we are ever to have an indigenous expression, it will be an art proceeding from strong native impulses, simple ideas, and popular tastes. . . ."

Quoted in Barbara Rose, *Readings in American Art Since 1900* (New York: Frederick A. Praeger, 1968), p. 103.

14. Lloyd Goodrich, quoted in "Whitney Symposium," *Art Digest* 7, no. 15 (1 May 1933): 6. This article summarizes remarks presented at a symposium entitled "The Problem of Subject Matter and Abstract Aesthetics in Painting," held at the Whitney Museum. Speakers, in addition to Goodrich, were Morris Davidson, a proponent of abstraction; Leo Katz, who spoke on the influence of social conditions on art; and Walter Pach, who said, "The true work of today does not stand between these two extremes, it stands above them. Its human values unite with its aesthetic values to engender a life that is absent from work which tries to exist without such a union."

15. Walter Abell, "The Limits of Abstraction," *The American Magazine of Art* 28, no. 12 (December 1935): 737.

16. Rosalind Bengelsdorf, letter to Henry Hunt, 1 February 1974, in Rosalind Bengelsdorf Browne Papers, Archives of American Art, Smithsonian Institution, Washington, D.C., roll 2016: 426, hereafter cited as Bengelsdorf Browne Papers.

17. Located on Washington Square, an area surrounded by artists' studios, the Gallatin collection by 1933 presented "a fairly comprehensive selection of the vital painting of our immediate epoch." Almost half the works were Cubist, although André Masson, Joan Miró, and several other Surrealists were represented, as were Jean Arp, Piet Mondrian, and Henri Matisse. When the Museum of Modern Art opened in 1929, works by Bauhaus artists and Constructivists were available as well.

18. Carl Holty, interview with Nina Wayne, Archives of American Art, roll 670: 613–697.

19. For a thorough discussion of Hofmann's approach to teaching, see Cynthia Goodman, "Hans Hofmann As Teacher," *Arts Magazine* 53, no. 8 (April 1979): 120–25.

20. Quoted in Herschel B. Chipp, *Theories of Modern Art* (Berkeley: University of California Press, 1968), p. 94.

21. Albert Gleizes and Jean Metzinger, "Cubism," quoted in Robert L. Herbert, ed., *Modern Artists on Art: Ten Unabridged Essays* (Englewood Cliffs, N.J.: Prentice Hall, 1964), p. 5.

22. Quoted in Goodman, n. 33.

23. Quoted in Sandra Gail Levin, "Wassily Kandinsky and the American Avant-Garde, 1912–1950" (Ph.D. diss., Rutgers University, 1976), p. 194.

24. Letter to Henry Hunt, Bengelsdorf Browne Papers.

25. During the winter of 1927–28, Vytlacil gave a series of lectures at the Art Students League that introduced Hofmann's ideas and opened many eyes to the principles as well as the appearance of European modernism. Following by a year the exhibition of Katherine Dreier's remarkable Société Anonyme collection at the Brooklyn Museum, Vytlacil's lectures were an important first step toward introducing the principles of European vanguard art in terms Hofmann had developed.

26. "Basic Approach to the New Realism in Art," draft of lecture given at a meeting of the Artists' Union in 1936, Bengelsdorf Browne Papers, roll 2014: 767.

27. From a speech given by Albers at Black Mountain College in 1940, quoted in Nicholas Fox Weber, "Josef Albers," in John R. Lane and Susan C. Larsen, *Abstract Painting and Sculpture in America, 1927–1944* (Pittsburgh: Museum of Art, Carnegie Institute in association with Harry N. Abrams, 1983), p. 47.

28. Quoted in John Elderfield, "The Paris-New York Axis: Geometric Abstract Painting in the Thirties," in *Geometric Abstraction: 1926–1942* (Dallas, Texas: Dallas Museum of Fine Arts, 1972; translation by the author).

29. Hilla Rebay, "Definition of Non-Objective Painting," in *Solomon R. Guggenheim Collection of Non-Objective*

Paintings (Charleston, S.C.: Carolina Art Association, Gibbes Memorial Art Gallery, 1936), p. 8.

30. "To the Editors," *Art Front* 3, no. 7 (October 1937): 21.

31. Balcomb Greene, "Expression As Production," *American Abstract Artists: Three Yearbooks*, p. 31.

32. Although the vast majority of work done under the Federal Art Project reflected mainstream American Scene painting, abstract artists did find some support. Yet Byron Browne believed he had been cut from the pilot program, the Public Works of Art Project, because his work was too abstract. In an impassioned plea to Juliana Force, the program's New York administrator, in which he said he would work for half the normal stipend because he needed the money so badly, Browne reflected the situation of many. The importance of the Federal Art Project cannot be overestimated. The financial assistance allowed artists the time for day-to-day development, something that would not have been possible had they held, if they could find, other types of work. Perhaps more significant, as Bengelsdorf later wrote, "by giving artists a chance to work without starving, the PWAP, CWA, and WPA created a spiritual renaissance that lifted American painting away from the murky, poorly rendered social scene painting typical of the Depression period." "Abstract Art and the W.P.A.," Bengelsdorf Browne Papers, roll 2014.

33. Mondrian's 1932 *Composition*, on view at the Gallery of Living Art, which Burgoyne Diller no doubt saw, had prompted Harry Holtzman to make a pilgrimage to Paris to meet the master. An immediate convert to Neo-plasticism, Holtzman was an important spokesman for Mondrian's work back in New York. During his four months in Paris, Holtzman also met Le Corbusier, Cesar Nieuwenhuis-Domela, Naum Gabo, and Antoine Pevsner whose more utopian or spiritual ideas about art infected young Americans as well. Even before his abortive attempt to establish a workshop for abstract art was voted down by the soon-to-be American Abstract Artists, as Diller's assistant on the WPA mural program, Holtzman worked to advance the cause of geometric abstraction in New York.

34. When model apartments were opened for preview by prospective tenants, they were decorated, in Hananiah Harari's words, with "Fake Modern" furniture and dime store prints. Harari, who had designed but not executed a mural for the complex, was outraged. He spoke of the "glaring discrepancy between the prints and the creative art [tenants] will find in the public rooms of their new dwellings, which will make for confusion about a subject which is already overly confused in the minds of many. Isn't it time that American workers stopped the commercial interests from contemptuously throwing the dried bones of degenerate capitalist 'culture' in their faces?" See Harari, "Who Killed the Home Planning Project?" *Art Front* 3, no. 8 (December 1937): 14–15.

35. Burgoyne Diller, "Abstract Murals," in Francis V. O'Connor, ed., *Art for the Millions* (Greenwich, Connecticut: New York Graphic Society, Ltd., 1973), p. 69. Twelve artists executed work for the Williamsburg Housing Project: Stuart Davis, Jan Matulka, Francis Criss, Paul Kelpe, Byron Browne, George McNeil, Willem de Kooning, Balcomb Greene, Ilya Bolotowsky, Harry Bowden, Eugene Morley, and Albert Swinden. For a discussion of Diller and his program, see Greta Berman, "Abstractions for Public Spaces, 1935-1943," *Arts Magazine* 56, no. 10 (June 1982): 81–86.

36. Alfred H. Barr, Jr., "Foreword," *Machine Art* (New York: Museum of Modern Art, 1934).

37. Lewis Mumford, *Technics and Civilization* (New York: Harcourt, Brace and World, 1963; original edition published 1934), pp. 324, 334.

38. Moholy-Nagy came to Chicago to set up and direct the New Bauhaus, which soon folded for lack of funds. In its place he founded the Institute of Design, an independent school that was subsequently incorporated into the Illinois Institute of Technology.

39. The Design Laboratory was founded in September 1935 under WPA auspices. When the WPA underwent extensive cutbacks and abandoned the program in June 1937, the Federation of Architects, Engineers, Chemists and Technicians assumed sponsorship and integrated the Design Laboratory into the Federation Technical School. Members of the advisory board included Donald Deskey, Russell Wright, William Zorach, Raymond Loewy, Lewis Mumford, and Meyer Schapiro.

40. See Robert M. Yoder, "Are You Contemporary?" *Saturday Evening Post*, 3 July 1943, p. 16, for a description and illustrations of several amusing contraptions devised by Institute of Design students.

41. Hananiah Harari, "WPA-AAA," handwritten reminiscence of his experience on the WPA provided by Harari, in the curatorial files of the National Museum of American Art.

42. Alice T. Mason, letter to Warwood Mason, 9 March 1938, Alice Trumbull Mason Papers, Archives of American Art, roll 629: 366–373.

43. Esphyr Slobodkina, *Notes for a Biographer*, vol. 2 (privately printed, 1980), p. 629.

CATALOGUE

Dimensions are in inches, with height preceding width and depth. Dimensions for works on paper indicate sheet size, and those for sculpture include bases when integral to the piece. Accession numbers are provided for further identification.

JOSEF ALBERS

(1888 Germany–1976 USA)

AN ELEMENTARY SCHOOL TEACHER FOR TWELVE YEARS, AND AN INSTRUCTOR AT the Bauhaus from 1923 until 1933, Josef Albers was one of the most influential artist-educators to immigrate to the United States during the 1930s. Following early academic training at the Royal Art School in Berlin (1913–15), the *Kunstgewerbeschule* in Essen (part-time from 1916 to 1919), and the Art Academy in Munich (1919–20), Albers turned in 1920 to the innovative atmosphere of the Weimar Bauhaus. There he began his experimental work as an abstract artist. After three years as a student, he was hired to teach the famed *Vorkurs*, the introductory class that immersed students in the principles of design and the behavior of materials.

Albers was convinced that students needed to develop an understanding of "the static and dynamic properties of materials . . . through direct experience." His students made constructions with wire netting, matchboxes, phonograph needles, razor blades, and other unusual materials. They also visited workshops where craftsmen worked daily with the structural and behavioral characteristics of industrial and natural materials.[1]

In his own work, Albers investigated color theory and composition. He began to explore mathematical proportions as a way to achieve balance and unity in his art. Yet, Albers did not aim to be a purely analytical painter. Although he had not taken classes with either Klee or Kandinsky as a Bauhaus student, and did not profess metaphysical concerns, Albers believed that "Art is spirit, and only the quality of spirit gives the arts an important place in . . . life."[2]

Albers had come to his own brand of abstraction over the course of many years. By 1908, he had discovered Matisse and Cézanne, and in Berlin he encountered work by Munch, van Gogh, the German Expressionists, Delaunay, and the Italian Futurists. Initially an expressionist, Albers began experimenting with abstract principles and unusual materials about 1923. His glass assemblages of these formative years explored the possibilities of stained, sandblasted, and constructed arrangements. They are remarkable for their deft incorporation of such "accidental" effects as ripples and bubbles—inherent in the medium itself—into sophisticated designs that explored balance, translucence, and opacity.

Albers had weathered Bauhaus moves from Weimar to Dessau, and then to Berlin, remaining steadfast even after Walter Gropius and Laszlo Moholy-Nagy left in 1928. In 1933, when the Nazis forced the closing of the Berlin Bauhaus, Albers left for America where he introduced Bauhaus concepts of art and design to the newly formed experimental community of Black Mountain College in North Carolina.

After fifteen years he left Black Mountain and, in 1950, became chairman of the Department of Design at Yale. *On Tideland*, painted between 1947 and 1955, marks this transition and was painted concurrently with the earliest examples of his well-known series, *Homage to the Square*.

Albers, always a careful craftsman, was concerned that future generations understand his working methods. He often documented, on the reverse of the fiberboard panels he preferred for his paintings, the pigments, brands, varnishes, and grounds he had used in making the painting. Fascinating notations document his spatial proportions and the mathematic schemes he incorporated in each work. *On Tideland*, for example, was painted according to "Scheme M," in which twenty units of vertical form balance thirty units of horizontal form. Although concerned with a severely restricted format in his own work, Albers admitted other

On Tideland
1947–55
oil on fiberboard
27¼ x 36
1986.92.1

approaches: "Any form [of art] is acceptable if it is true," he stated. "And if it is true, it's ethical and aesthetic."[3]

An original member of the American Abstract Artists, Albers showed annually throughout the group's formative years.

1. Josef Albers, "Concerning Fundamental Design," in Herbert Bayer, Walter Gropius, and Ise Gropius, eds., *Bauhaus: 1919–1928* (Boston: Charles T. Branford Co., 1959), pp. 114–21.

2. Josef Albers, "A Note on the Arts in Education," *American Magazine of Art* (April 1936): 233.

3. Katharine Kuh, "Josef Albers," in *The Artist's Voice: Talks with Seventeen Artists* (New York: Harper and Row, 1962), p. 12.

MILTON AVERY

(1885–1965)

MILTON AVERY LIVED IN AND AROUND HARTFORD, CONNECTICUT, UNTIL 1925, when he moved to New York City. A factory worker as a young man, one day he saw an advertisement for a class in lettering at the Connecticut League of Art Students and enrolled. He thought he might make money at this pursuit, but when the class was canceled—just a month after he entered—he took a life drawing class instead.[1] In 1918, while working for an insurance company at night, he studied at the School of the Art Society of Hartford. The following year, he won top honors in the portrait and life drawing classes. In 1920 Avery began spending summers in Gloucester, Massachusetts. There, in 1924, he met a young painter named Sally Michel. He followed her to New York, and in 1926 they were married. At the beginning of their marriage, Sally Avery determined to place her own artistic concerns second to those of her husband, and she worked as a freelance illustrator to free Avery from the need to support his family.

Avery's early training had prepared him for a career as an academic painter. But he frequented the New York galleries that exhibited modernist European art, including the Valentine Gallery, which held a retrospective of Matisse's work in 1927. By 1930, references to Matisse and Picasso can be discerned in Avery's paintings, and he began to introduce the simplified forms and flattened space that would, along with clear, unmodulated color, become the hallmarks of his later work. The 1930s were financially precarious times for the Averys. Avery exhibited his work frequently, but it did not sell well. However, a 1935 invitation to join the prestigious Valentine Gallery, which exhibited Matisse, Picasso, Miró, Derain, Braque, Kandinsky, Stuart Davis, and others, had a vitalizing effect on his painting and his outlook.

Although Avery never joined any of the artists' organizations that proliferated in New York during the 1930s, the couple's apartment became a meeting ground for young painters. Adolph Gottlieb, Mark Rothko, and Barnett Newman were frequent visitors, and often joined the Averys during summers spent in Gloucester or southern Vermont. Many of Avery's paintings originated during these summers away from the city. A quiet man who seldom participated in conversations about him, Avery constantly sketched—landscapes, people, interiors— whatever was at hand. *Man Fishing*, for example, which probably dates from Avery's summer on the Gaspé Peninsula in 1938, indicates the degree of formal simplification that his sketches occasionally took. Around 1938, the Averys began organizing sketch classes where they and their friends shared the costs of a model. John Opper was among those who congregated at the Averys and remembered the lively talk and stimulating company.

In 1943, Avery joined the New York gallery of Paul Rosenberg, an important dealer who had been forced to flee Paris when the Nazis took the city. This affiliation, coupled with a retrospective exhibition at the Phillips Memorial Gallery in 1944, brought Avery national acclaim. Yet sales remained few, and New York museums, for the most part, showed little enthusiasm for his work. Avery persisted nonetheless, refining form and clarifying color. In 1946, the family spent three months in Mexico, where not only the landscape but the peasants and city streets offered new subject matter. Three years later Avery suffered a heart attack from which he never fully recovered. Prevented by his health from working outdoors, Avery began making monotypes, a medium that requires rapid execution. These monotypes affected his painting style, and after about 1950, Avery increasingly eliminated extraneous detail from his work and began focusing on the harmony of the overall canvas rather than the interrelation of its parts.[2] Critical acclaim for Avery's work waned for several years during the early 1950s, eclipsed,

perhaps, by Abstract Expressionism. Yet, by late in the decade, his independent vision, distilled, vibrant color, and acutely refined forms had secured his recognition as one of the most subtly powerful artists in midcentury America.

1. The best, and most accurate, account of Avery's early years and subsequent career can be found in Barbara Haskell, *Milton Avery* (New York: Whitney Museum of American Art in association with Harper and Row, 1982).

2. Haskell, p. 117.

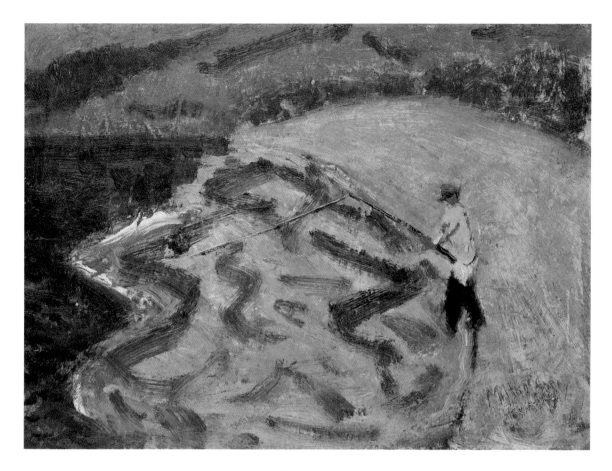

Man Fishing
ca. 1938
oil on fiberboard
10 x 13½
1986.92.2

ROSALIND BENGELSDORF (BROWNE)

(1916–1979)

ONE OF THE YOUNGEST MEMBERS OF THE AMERICAN ABSTRACT ARTISTS, Rosalind Bengelsdorf championed abstraction in her writings and lectures as well as in her paintings. As a teenager, she studied at the Art Students League (1930–34) with John Steuart Curry, Raphael Soyer, Anne Goldthwaite, and George Bridgman, and then for a year at the Annot School. In 1935, she entered Hans Hofmann's atelier as one of the many scholarship students he took on. The following year, she joined the abstract artists working on WPA murals under Burgoyne Diller's enlightened leadership.

In Hans Hofmann, Bengelsdorf found a true mentor. His dedication to the painting as an independent object matched her growing belief that the picture plane was a "living reality" of forms, energies, and colors. Like Hofmann, Bengelsdorf believed that "the shapes that compose the picture belong to nothing else but the picture."[1]

She had begun to analyze objects in terms of geometric form under George Bridgman at the league and subsequently at Annot. In a high school chemistry class, Bengelsdorf became fascinated with the idea that space is filled with "myriad, infinitesimal subdivisions." She saw "the universe as a charged miracle, a vibrating orchestration of the continuous interplay of all forms of matter."[2] Under Hofmann, who emphasized the interrelationship of objects and the environments they occupy, these impulses merged. For Bengelsdorf, the artist's task became the description of "not only what he sees but also what he knows of the natural internal function" of objects and the "laws of energy that govern all matter: the opposition, tension, interrelation, combination and destruction of planes in space."[3] This meant that the abstract painter was studying the laws of nature, tearing it apart and then reorganizing the parts into a new creation.[4]

Despite this emphasis on formalism, Bengelsdorf also believed that abstract art played a larger function within society. She separated artistic concerns from economic ones and championed art's potential for increasing knowledge and understanding. Satire, motion pictures, posters, and other pictorial solutions addressed some kinds of human concerns; but the larger ones—of the mind, of the possibility for order within life's experience—these were the domain of abstraction.[5]

In her own paintings, such as *Abstraction* and *Seated Woman*, Bengelsdorf was concerned with these questions. *Abstraction*, which relates to a WPA mural (now destroyed) Bengelsdorf painted for the Central Nurses Home on Welfare Island, balances simple geometric forms through position and color. *Seated Woman*, which was featured in the 1939 American Abstract Artists annual exhibition, owes a clear debt to Picasso's *Girl Before a Mirror* (1932, Museum of Modern Art) and gives clear evidence of her belief that "energy and form are inseparable."

After her marriage to Byron Browne in 1940, and the birth of their son, Bengelsdorf turned from full-time painting to teaching, writing, and criticism. An articulate and perceptive writer, she often reviewed the exhibitions of work by her friends from the early days of the American Abstract Artists, and continued, through her writings, to champion the cause of abstract art.

A founding member of the American Abstract Artists, Bengelsdorf had been involved in the group's earliest discussions. Reminiscing about the early meeting that Arshile Gorky had

Abstraction
1938
oil on canvas
36 x 24
1986.92.10

walked out of, she said that she and Browne were sympathetic with Gorky's position. "We shared empathy with his concept of a basic abstract language of art. . . . Gorky could see beyond the limits of his own abstract idiom expressive of the climate of our time."[6]

1. Rosalind Bengelsdorf, "The New Realism," in *American Abstract Artists: Three Yearbooks (1938, 1939, 1946)* (reprint, New York: Arno Press, 1969), p. 22. Bengelsdorf articulated these ideas in specific and clear terms in a lecture she gave at the Artists' Union in 1936. Her handwritten notes can be found in the Rosalind Bengelsdorf Browne Papers, Archives of American Art, Smithsonian Institution, Washington, D.C., roll 2014. She spoke of energy and movement, and of movement and form respectively. She used diagrams of atomic structure to explain the interaction of spatial planes—what we now call negative space—with the forms within a painting. Along with Hofmann's lectures of 1937–38 at the Art Students League, Bengelsdorf's presentation of the "science" of abstract art was a vital justification for the potential of art in light of new scientific insights.

2. Letter from Rosalind Bengelsdorf to Henry Hunt, 7 February 1971, Bengelsdorf Browne Papers, roll 2016: 417.

3. Bengelsdorf, "The New Realism," p. 21.

4. Ibid.

5. In her 1936 lecture at the Artists' Union, Bengelsdorf addressed the question of art's social utility. She equated the "plastic painter" to a scientist who is constantly researching to discover more about life. She also thanked the members of the Artists' Union for their indulgence in allowing herself and others to proselytize about abstract art.

6. Letter to Henry Hunt, 7 February 1971. Bengelsdorf added that she and Byron Browne "shared empathy with [Gorky's] concept of a basic abstract language of art underlying changing styles for millennia—a language attempting to equate the creative acts apparent in nature everywhere."

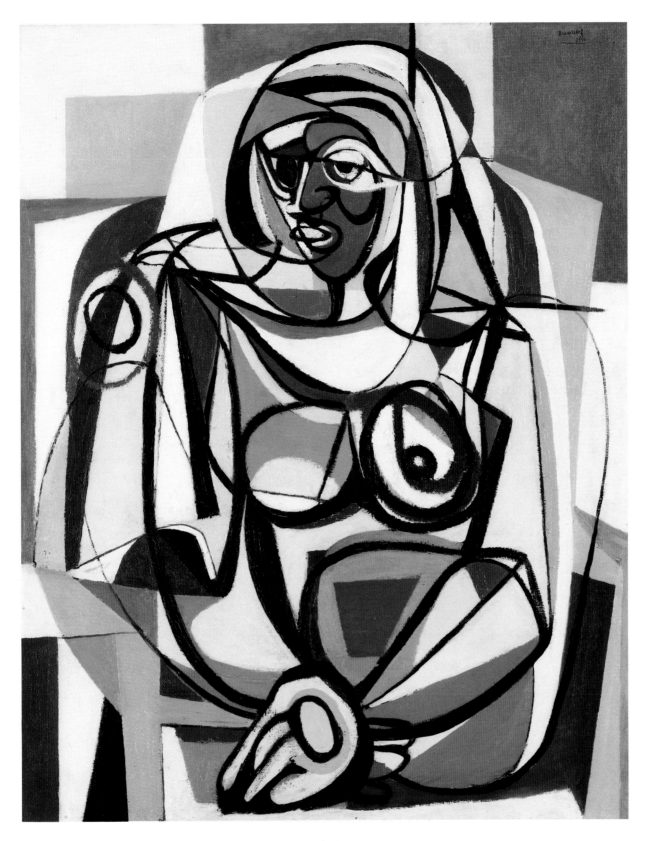

Seated Woman
1938
oil on canvas
38 x 30
1986.92.11

EMIL BISTTRAM

(1895 Hungary–1976 USA)

ALONG WITH RAYMOND JONSON, EMIL BISTTRAM IS ONE OF THE BEST-KNOWN members of the Transcendental Painting Group of New Mexico. A native of Hungary, Bisttram came to the United States when he was eleven. In New York, he set up a commercial art business and took night classes with Leon Kroll, Jay Hambidge, and Howard Giles at the National Academy of Design, the Cooper Union, Parsons School of Design, and the Art Students League. After completing his studies, Bisttram joined the faculty at the New York School of Fine and Applied Arts where he taught the principles of dynamic symmetry developed by Hambidge. He subsequently taught for five years at the Master Institute of the Roerich Museum in New York, and in 1931, supported by a Guggenheim Fellowship, went to Mexico to study fresco painting with Diego Rivera.[1]

Bisttram first visited New Mexico in 1930, but was "frustrated by the grandeur of the scenery and the limitless space."[2] Yet in 1932 he returned and settled in Taos, where he founded the Taos School of Art. Bisttram's paintings of the early 1930s reflect his all-consuming commitment to the New Mexico environment. Highly stylized canvases depict Hopi snake dancers, portraits of Indian and Mexican-American women, and the distinctive architectural style of Southwest churches. By the mid 1930s, he was actively engaged in mural projects for public buildings in New Mexico, Washington, D.C., and other cities under the sponsorship of Franklin D. Roosevelt's various New Deal programs. From a rather conventional, representational style of the 1920s, during the mid 1930s Bisttram moved toward nonobjectivity. Yet he continued to paint more traditional work. For example, his mural for the U.S. Department of Justice, commissioned in 1936, is an allegorical composition contrasting the life of modern women with that of "Old World" women.

In 1938, Bisttram founded, with Raymond Jonson, the Transcendental Painting Group, an organization devoted to nonobjective painting that aspired to enhance the spiritual level of society. For Bisttram, who was a Theosophist, the Transcendental Painting Group formalized ideas he had held for many years. Like his New York contemporaries who were centered around Hilla Rebay and the Guggenheim, Bisttram sought a new art for a new world order, and he wrote of universalism and "the essential Oneness of all things" as replacing the mechanistic, dualistic concepts of the past.[3] He spoke out against abstract art as a means of producing simple aesthetic emotion through the psychological impact of pure form and color. Instead, he argued that artists should stimulate deeper ideas and intuitions and thereby make a "significant contribution to the development of our culture and the advance of civilization."[4]

In his paintings of the late 1930s and beyond, Bisttram explored these concepts and gave titles, such as *Upward* (ca. 1940), and *The Oversoul*, that indicated the spiritual understandings he intended.

Throughout his life, Bisttram actively contributed to the artistic development of New Mexico. He continued to draw inspiration from legends and visual motifs native to the Southwest but couched them in the nonobjective, transcendental terms he had evolved during the late 1930s.

1. Rivera shared Bisttram's interest in dynamic symmetry. For additional information about Bisttram's life and career, see Tricia Hurst, "Emil J. Bisttram (1895–1976)," *Southwest Art* 7, no. 10 (March 1978): 83–87.

2. Emil Bisttram Papers, Archives of American Art, roll 2893: 202.

3. Emil Bisttram, "The New Vision in Art," *Tomorrow* 1, no. 1 (September 1941): 35.

4. Ibid., p. 37.

Upward
ca. 1940
oil on canvas
50 x 50
1986.92.3

ILYA BOLOTOWSKY

(1907 Russia–1981 USA)

ILYA BOLOTOWSKY WAS NOT ONLY A FOUNDING MEMBER OF THE AMERICAN Abstract Artists, but also one of the forces behind its programs and exhibitions. A Russian immigrant to New York in 1923, Bolotowsky studied at the National Academy of Design between 1924 and 1930. He then worked for several years as a textile designer and taught art in settlement houses. By 1932, he had saved enough money so that, combined with a small scholarship, he was able to spend ten months in Europe, primarily Italy, Germany, Denmark, and England, with a few weeks in Paris. When he left for Europe, Bolotowsky was already familiar with Picasso, Matisse, other avant-garde Parisian painters, and Russian Constructivists. He appreciated Cubism because it shattered naturalism.[1] Yet, his work in Europe was more akin to the Expressionism of Chaim Soutine, which he knew through his friend William H. Johnson, another Soutine aficionado.[2]

Bolotowsky again did textile designing on his return to New York. In 1934, he worked for the Public Works of Art Project, a pilot program of federal support that paved the way for the WPA-FAP in 1935. When Gertrude Greene mentioned that Burgoyne Diller was heading up a WPA mural project that would use abstract artists, Bolotowsky submitted sketches. Diller arranged Bolotowsky's transfer from the WPA teaching project, and Bolotowsky set to work on a mural design for the Williamsburg Housing Project, whose architect, William Lescaze, was sympathetic to abstraction.

In his abstract compositions of the mid 1930s, Bolotowsky gave free rein to a variety of stylistic approaches. He encountered the work of both Miró and Mondrian in 1933, and by 1936 introduced a Mondrianesque grid pattern as the framework for playful biomorphic forms and rectangular planes of unmodulated color. His flirtation with Miró is apparent in the lyric dancing of simple geometric shapes, organic forms, and thin, directional lines over the surface of a mural study he completed for the Hall of Medical Science in the Health Building at the 1939 New York World's Fair.

During World War II, Bolotowsky served in the Army Air Corps. After his discharge, he replaced Josef Albers for two years at Black Mountain College in North Carolina. From 1948 to 1957 he taught at the University of Wyoming and at Brooklyn College; from 1957 to 1965 he was Professor of Art at State Teacher's College in New Paltz, New York, and from 1965 until 1971 he taught at the University of Wisconsin in Whitewater. At various times he also held short-term or adjunct positions at Hunter College in New York, the University of New Mexico, and Queens College.

During the 1940s, Bolotowsky began looking more closely at the purist geometries of his friends Burgoyne Diller and Albert Swinden, and especially at Mondrian's Neo-plastic paintings. His own work underwent a purification of both form and color.[3] He did not immediately reduce his palette to the primary colors, as well as black and white, as did the Dutch painter, nor did he focus exclusively on rectangular geometric configurations. In paintings such as *Architectural Variation* of 1949, Bolotowsky exorcised all suggestions of illusionistic space. He described his work during the forties in terms of surface tensions:

> In the early forties I still used diagonals. A diagonal, of course, creates ambivalent depth—diagonal depth might go either back or forth. It's not like perspective which goes only one way. . . . I had to give up diagonals because the space going back and forth was becoming too violent. The diagonal space was getting in the way of the tension on the flat surface. You cannot get an absolute flatness in painting because of the interplay of the colors, the way they feel to us. But

Architectural Variation
1949
oil on canvas
20 x 30
1986.92.4

you can achieve relative flatness, within which the colors and the proportions might push back and forth creating an extra tension. This tense flatness must not destroy the overall flat tension, which, to my mind, in two-dimensional painting is the most important thing.[4]

In Wyoming, Bolotowsky began making experimental films, usually based on either Greek myths or myths Bolotowsky fabricated. His films used actors and were not abstract. Bolotowsky believed that film was an art of empathy and that abstraction represented a conceptual approach more appropriately conveyed through painting and sculpture.[5]

Before the war, Bolotowsky had exhibited in a variety of group exhibitions, including the Museum of Modern Art's *New Horizons in American Art* in 1936 and in both the second and third annual shows of The Ten (1936 and 1937). In 1946, after his return, his paintings began to receive wide attention. He had solo exhibitions at J.B. Neumann's New Art Circle and at The Pinacotheca gallery, and in 1954, he joined Grace Borgenicht's gallery, where he showed biennially into the 1970s.

1. Deborah M. Rosenthal, "Ilya Bolotowsky," in John R. Lane and Susan C. Larsen, *Abstract Painting and Sculpture in America, 1927–1944* (Pittsburgh, Pa.: Museum of Art, Carnegie Institute, in association with Harry N. Abrams), pp. 51–54.

2. Louise Averil Svendsen and Mimi Poser, "Interview with Ilya Bolotowsky," in *Ilya Bolotowsky* (New York: Solomon R. Guggenheim Museum, 1974), p. 15.

3. See Ilya Bolotowsky, "On Neoplasticism and My Own Work: A Memoir," *Leonardo* 2, no. 3 (July 1969): 221–30; and Nancy J. Troy, *Mondrian and Neo-Plasticism in America* (New Haven, Conn.: Yale University Art Gallery, 1979).

4. Svendsen and Poser, "Interview," p. 24.

5. Bolotowsky explained empathy according to Wilhelm Worringer's definition, as "the essence of any vitality, activity, anything to do with life. Brancusi's bird or fish are extreme examples of empathy. . . . On the other hand, a very beautiful bridge, I would say that's pure abstraction. It's not alive. It's just a perfection in structure beyond human bounds. And so that would be pure abstraction." Svendsen and Posner, "Interview," p. 18.

HARRY BOWDEN

(1907–1965)

A NATIVE OF CALIFORNIA, HARRY BOWDEN BEGAN HIS ART STUDIES AT THE Los Angeles Art Institute and later worked in commercial advertising. Between 1928 and 1931, Bowden divided his time between the National Academy of Design, the Art Students League in New York, and the Chouinard School of Art in Los Angeles. He soon became dissatisfied with academic training: "It made art too much of a craft. You win a prize and pretty soon you have a home in the country and it becomes a routine business."[1] In 1931, after a summer class with Hans Hofmann at the University of California at Berkeley, Bowden determined to pursue painting seriously. He made his way to New York working as a petty officer on a merchant ship. By 1934, he was again studying with Hofmann. The following year he became one of Hofmann's assistants and was friendly with George McNeil, Albert Swinden, Wilfrid Zogbaum, Ad Reinhardt, and Willem de Kooning. In 1937 and 1938, he painted two murals for the Williamsburg Housing Project.

Bowden's New York work prior to 1940 reflects his fascination with a broad range of abstract themes, some of which, like *Untitled: Nude*, have a figurative basis, while others, as *Number 47 (Untitled Abstraction)*, avoid reference to recognizable elements. Throughout his work from these years, however, runs evidence of Hofmann's teachings and an abiding interest in Cubism.[2] The unsigned catalogue statement for the 1940 exhibition of Bowden, McNeil, and Swinden at the New School for Social Research stresses the significance of abstract concepts, whether or not recognizable objects appeared in their work: "In each [work] an idea has been adapted to the elements of painting. . . . " Pure nonobjectivity, like pure representation, was sterile ground: "An artist who only portrays a geometric arrangement of colored forms he has in mind, contributes nothing more than the artist who tries to copy nature. They show us the possibilities of a painting, but do not fulfill the promise. . . . A painting embraces many ideas, symbols, forms, tones, and colors, but all are resolved into a new thing. The metamorphosis makes the painting real—gives it a life of its own."[3]

In New York, Bowden achieved recognition through exhibitions of his paintings at the nonprofit Artists' Gallery (1938–46), the Egan Gallery, the Reinhardt Gallery, and the New School for Social Research. His fashion and commercial photography was also well received.[4]

In 1942, after the United States entered World War II, Bowden returned to California to become a shipfitter. Although he continued to show in New York, and periodically visited there, Sausalito became his permanent home. Following the war, photography again became an important part of his life. From the mid 1950s until his premature death of a heart attack in 1965, he concentrated, in both photography and painting, on the figure. An admirer of Edward Weston, of whom he made an unfinished film called "Wildcat Hill Revisited," perhaps Bowden remains best known for photographs of sensual female nudes in landscape settings and portraits of jazz musicians, writers, and other painters.

1. "Artist Tells Why He is Anti-Academic," *Sausalito Independent Journal*, 13 January 1951, sec. M7; Harry Bowden Papers, Archives of American Art, Smithsonian Institution, Washington, D.C., roll 1882.

2. Although never a Cubist, Bowden's ideas about abstract art are colored by his appreciation for Cubism. His notebooks are sprinkled with quotations by Juan Gris, Georges Braque, Picasso, and others. Firsthand contact with Fernand Léger, whom he (along with McNeil, de Kooning, and others) assisted on an unrealized mural project for the French Line terminal in New York in 1936, further cemented his commitment to abstraction based on objects, although he continued to do nonobjective work occasionally over the next several years.

3. "Paintings: Bowden, McNeil, Swinden," Exhibition brochure (New York, New School for Social Research, 1940); in Bowden Papers, Archives of American Art, roll 1892: 111.

4. The Artists' Gallery, where a number of members of the American Abstract Artists exhibited, was formed in 1936 to exhibit the work of "mature contemporary artists, so that their work could be seen by the public . . . and picked up by commercial sales galleries." Supported by voluntary contributions, the gallery charged no fee to the artist and did not receive a portion of sales proceeds for the exhibitions. Among the original sponsors of the gallery were Clive Bell, C.J. Bulliett, Fiske Kimbel, Walter Pach, Frank Jewett Mather, Jr., Audrey McMahon, Paul Sachs, Meyer Schapiro, and James Johnson Sweeney.

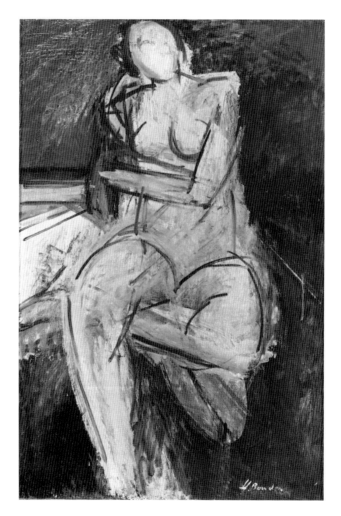

Untitled: Nude

ca. 1937

oil on canvas

36 x 24

1986.92.6

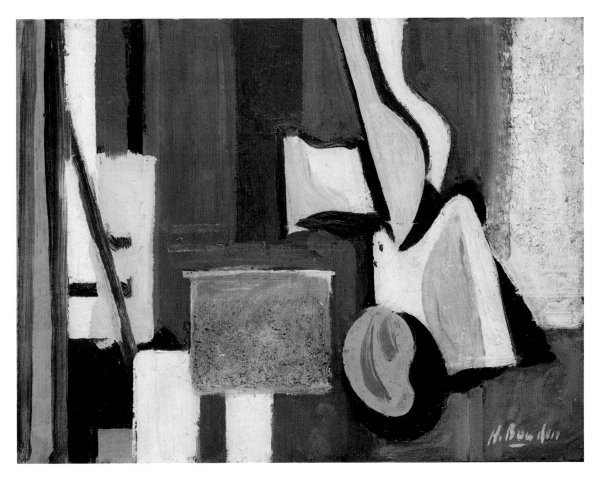

Number 47 (Untitled Abstraction)
ca. 1936–37
oil on fiberboard
9¹/₁₆ x 11³/₄
1986.92.5

BYRON BROWNE

(1907–1961)

BYRON BROWNE WAS A CENTRAL FIGURE IN MANY OF THE ARTISTIC AND political groups that flourished during the 1930s. He was an early member of the Artists' Union, a founding member of the American Abstract Artists, and participated in the Artists' Congress until 1940 when political infighting prompted Browne and others to form the break-away Federation of Modern Painters and Sculptors. Browne's artistic training followed traditional lines. From 1925 to 1928, he studied at the National Academy of Design, where in his last year he won the prestigious Third Hallgarten Prize for a still-life composition. Yet before finishing his studies, Browne discovered the newly established Gallery of Living Art. There and through his friends John Graham and Arshile Gorky, he became fascinated with Picasso, Braque, Miró, and other modern masters.

The mid 1930s were difficult financially for Browne.[1] His work was exhibited in a number of shows, but sales were few. Relief came when Burgoyne Diller began championing abstraction within the WPA's mural division. Browne completed abstract works for Studio D at radio station WNYC, the U.S. Passport Office in Rockefeller Center, the Chronic Disease Hospital, the Williamsburg Housing Project, and the 1939 World's Fair.[2]

Although Browne destroyed his early academic work shortly after leaving the National Academy, he remained steadfast in his commitment to the value of tradition, and especially to the work of Ingres.[3] Browne believed, with his friend Gorky, that "every artist has to have tradition. Without tradition art is no good. Having a tradition enables you to tackle new problems with authority, with solid footing."[4]

Browne's stylistic excursions took many paths during the 1930s. His WNYC mural reflects the hard-edged Neo-plastic ideas of Diller, although a rougher Expressionism better suited his fascination for the primitive, mythical, and organic. A signer, with Harari and others, of the 1937 *Art Front* letter, which insisted that abstract art forms "are not separated from life," Browne admitted nature to his art—whether as an abstracted still life, a fully nonobjective canvas built from colors seen in nature, or in portraits and figure drawings executed with immaculate, Ingres-like finesse.[5] He advocated nature as the foundation for all art and had little use for the spiritual and mystical arguments promoted by Hilla Rebay at the Guggenheim Collection: "When I hear the words non-objective, intra-subjective, avant-garde and such trivialities, I run. There is only visible nature, visible to the eye or, visible by mechanical means, the telescope, microscope, etc."[6]

Increasingly in the 1940s, Browne adopted an energetic, gestural style. Painterly brushstrokes and roughly textured surfaces amplify the primordial undercurrents posed by his symbolic and mythical themes. In 1945, Browne showed with Adolph Gottlieb, William Baziotes, David Hare, Hans Hofmann, Carl Holty, Romare Bearden, and Robert Motherwell at the newly opened Samuel Kootz Gallery. When Kootz suspended business for a year in 1948, Browne began showing at Grand Central Galleries. In 1950, he joined the faculty of the Art Students League, and in 1959 he began teaching advanced painting at New York University.

The three works in the Frost collection, *Abstract Collage* (1933), *Head* (1938), and *Chinese Dancer* (1949), represent distinct phases in Browne's artistic career. The collage, created at a time when he was fascinated with Cubism, is a lyrical, delicately balanced work in which calligraphic line, imposed or incised, moves freely across the surface of the paper. The boldly colored, unrefined shapes of *Head* and the tactile surface of *Chinese Dancer* are premonitions of the Abstract Expressionism that would be the hallmark of Browne's later work.

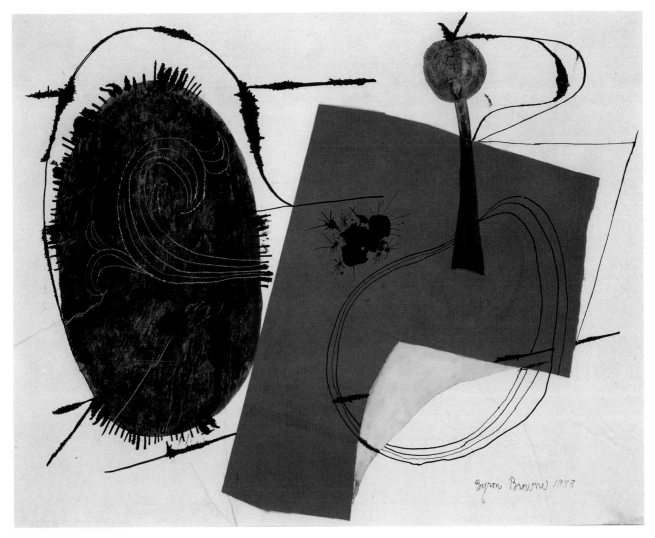

Abstract Collage
1933
pen and ink, ink wash, gouache,
and paper on paper mounted on paperboard
15 7/16 x 19 5/16
1986.92.7

1. When she met him in October 1934, Rosalind Bengelsdorf Browne recalled that her future husband's daily diet consisted of a quart of milk, a box of cornmeal, a head of lettuce, and some raisins. See Rosalind Bengelsdorf Browne Papers, Archives of American Art, Smithsonian Institution, Washington, D.C.

2. Browne was also involved with Léger's mural project for the French Line terminal building that was canceled after officials discovered Léger's communist sympathies. Ibid.

3. The abstract quality of Ingres's work held special appeal not only for Browne, but for John Graham and Arshile Gorky. Rosalind Bengelsdorf Browne remembered Gorky waving an Ingres reproduction around at the opening of the first American Abstract Artists annual exhibition and proclaiming that the French master was more "abstract" than all the work in the exhibition. Ibid.

4. Gorky is quoted in Melvin P. Lader, "Graham, Gorky, de Kooning and the 'Ingres Revival' in America," *Arts Magazine* 52, no. 7 (March 1978): 99.

5. The classical drawings, a group of which was exhibited at Washburn Gallery in 1977, show heads (often of cross-eyed women) and classically garbed and garlanded seated figures. They have important stylistic parallels to John Graham's paintings and drawings of the period.

6. Quoted in Gail Levin, "Byron Browne in the Context of Abstract Expressionism," *Arts Magazine* 59, no. 10 (Summer 1985): 129. Browne's notebook is in the collection of his son, Stephen B. Browne. The idea of portraying matter visible through telescope or microscope parallels the fusion of scientific and artistic vision discussed by Rosalind Bengelsdorf.

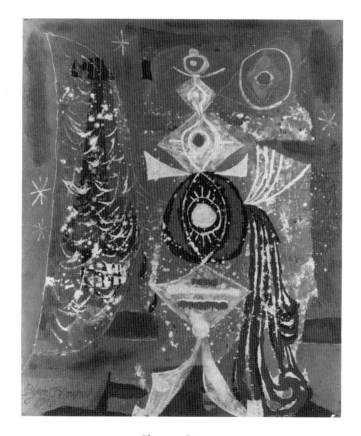

Chinese Dancer
1949
oil on fiberboard
14 x 12
1986.92.8

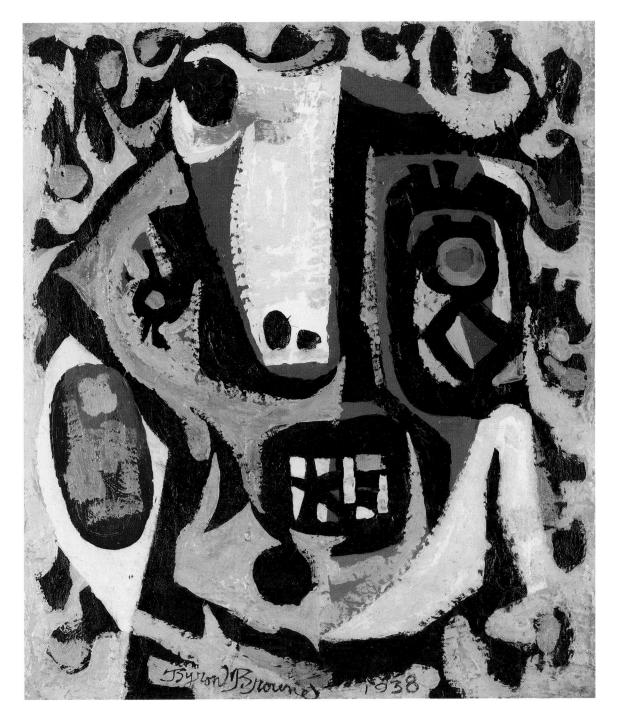

Head
1938
oil on fiberboard
14 x 12
1986.92.9

GIORGIO CAVALLON

(born Italy 1904)

WHEN HE WAS SIXTEEN, CAVALLON IMMIGRATED TO THE UNITED STATES from Sorio, a small town in the province of Vicenza, Italy. He worked for several years in a factory in Massachusetts while studying art privately, and in 1926, he went to New York.[1] During night sessions at the National Academy of Design, Cavallon took the antique class and worked from casts. After five years at the academy, he left his daytime work as a carpenter and began full-time study for six months. There he met Ilya Bolotowsky, Lee Krasner, Byron Browne, and others. He spent two summers in Provincetown studying with Charles Hawthorne, who taught him to put aside drawing and instead work directly with color. Although Cavallon's painting at this point was still relatively conventional, he already thought of himself as "modern" and began to speak out against the academy's curriculum.

Despite this, Cavallon had become an accomplished painter under the academy's tutelage. In 1929, he received a Louis Comfort Tiffany fellowship that provided living quarters and studio space at the Tiffany estate at Oyster Bay, New York, for a summer. When the Depression struck, Cavallon returned to Italy where he remained for three years. Back in New York in 1933, he studied drawing with Hans Hofmann in exchange for carpentry work. During the summers he returned with Hofmann's class to Provincetown. Among the Hofmann group, he became especially friendly with George McNeil, Harry Bowden, and Albert Swinden. Although he did not yet profess to fully understand abstract art, Cavallon began looking at Picasso, Braque, and Jean Hélion. Unlike many of his contemporaries, Cavallon found little inspiration in Picasso; instead he admired the structural solidity of Cézanne and Hélion. Although in 1935 Cavallon exhibited landscapes done in Italy, he soon moved toward abstraction, initially working from still-life compositions that showed evidence of Cézanne's influence. Once determined to put subject matter aside altogether, he moved quickly toward the freely brushed geometric phrasing apparent in *Country Scene* of 1938. In his paintings of the late 1930s, Cavallon often employed a loose grid structure, which led critics to suggest an interest in Mondrian; yet Cavallon was more concerned with light and evocations of landscape than with the strict formal structure of the Dutch master.

As a Hofmann student, Cavallon was friendly with the organizers of the American Abstract Artists, and he exhibited in the group's annual exhibitions from 1937 until 1957. In 1946, Cavallon joined Charles Egan's gallery and had his first one-man show in eleven years. Although sales were few, Cavallon found himself in a supportive environment and enjoyed arguing art with Willem de Kooning, Jack Tworkov, Franz Kline, Philip Guston, and the other artists who showed there. He became a charter member of "the Club"—the group of Abstract Expressionists who habituated the Cedar Bar—and participated in the group's "Ninth Street Show" in 1949. After Egan closed his space, Cavallon exhibited at Stable Gallery, and then at Kootz Gallery in New York. He taught briefly at the University of North Carolina and served as visiting critic in painting at Yale University in 1964.

1. For further information about Cavallon, see *Giorgio Cavallon, Paintings 1937–1977* (Purchase, N.Y.: Neuberger Museum, State University of New York at Purchase, 1977).

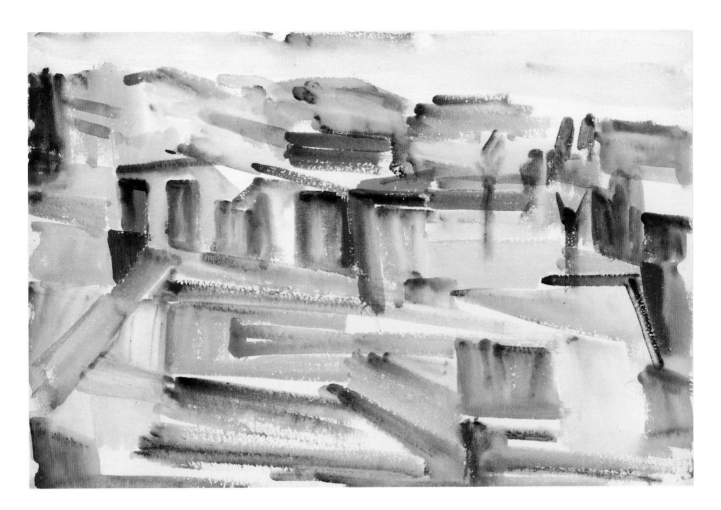

Country Scene
1938
pencil and watercolor on paper
15 ¾ x 23
1986.92.12

ARTHUR N. CHRISTIE
(1891–1980)

ARTHUR N. CHRISTIE WAS BORN IN JERSEY CITY, NEW JERSEY, AND STUDIED AT Pratt Institute, the American Artists' School, with Stefan Hirsch, and later with Hans Hofmann in New York and Provincetown, Massachusetts.[1] Christie began doing abstract painting about 1931. From 1937 to 1941, he exhibited with the American Abstract Artists. During the late 1920s and 1930s Christie worked as a designer of bank notes and currency. Among his accomplishments were designs for the national currency of Panama, the Dominican Republic, Guatemala, and Turkey. He later worked for the New York office of civil defense.

Christie's paintings and drawings indicate his thorough acquaintance with Hans Hofmann's theories of space and balance within the picture plane. Both *Regatta* and *Kilimanjaro* draw from the natural world for their motifs, but the highly abstracted, rhythmic line with which they are executed indicates Christie's thorough conversion to modernist aesthetics and reflects ideas expressed in one of his few extant statements: "In presenting a work in the abstract we are manipulating hard/edge form. The evolving idea is couched in the landscape of form. And is transmitted by a plastic motility. Inherent in a calligraphy of form and/or line/the subliminal is indicated."[2]

In his later work, Christie explored Abstract Expressionism. In several highly detailed sketches for sculpture, he explored the juxtaposition of open and solid form using wire and wood. Christie did a large number of sketches from life and was fascinated with the human form in motion. He thought of himself as an artistic researcher and for a series of drawings designed a situation to test the validity of artistic transcription. He invited a dancer to improvise before two artists who made abstract sketches of the dancer's movements. A second dancer was then asked to use the drawings as a basis for duplicating the improvisation. The artists could then assess the effectiveness with which they had captured the postures, movements, and rhythmic changes of their subject.

A resident of New York in midcareer, Christie subsequently moved to Philadelphia where his paintings were occasionally featured in group exhibitions.

1. Apart from a few gallery announcements and an undated review of an exhibition in the Arthur N. Christie Papers, Archives of American Art, Smithsonian Institution, Washington, D.C., little published material exists from which to reconstruct Christie's life and career. Even Christie's papers offer little substantive evidence. Among them are his handwritten quotes by other artists, critics, and literary figures, and a large number of drawings, most of which are undated.

2. From handwritten notes entitled "These are the researches of A. N. Christie," which appear to be a draft for a catalogue statement; see Christie Papers, Archives of American Art.

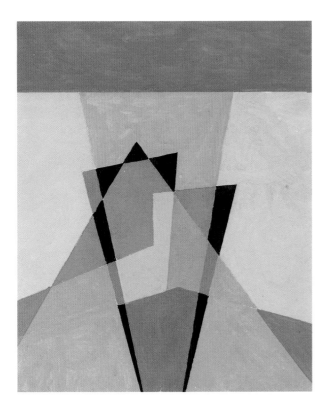

Kilimanjaro
ca. 1938
gouache on paper mounted on paper
12 $^3/_{16}$ x 9 $^3/_4$
1986.92.13

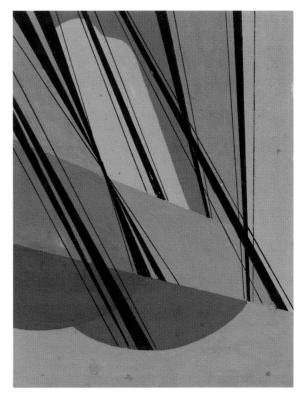

Regatta
ca. 1938
gouache on paper mounted on paper
12 $^3/_8$ x 9 $^7/_{16}$
1986.92.14

CHARLOTTE CUSHMAN (EVANS)

(born 1906)

AFTER GRADUATION FROM SMITH COLLEGE, CHARLOTTE CUSHMAN STUDIED art with Charles Hawthorne in Provincetown, Massachusetts, during the summers of 1929 and 1930.[1] She then spent a year at the school of the Museum of Fine Arts in Boston and became friends with Eleanor De Laittre. In 1932, Cushman and De Laittre moved to New York where they studied with George Luks. Cushman remained in New York for only a year. Responding to family pressure, she returned to Boston and resumed her studies, this time with Ernest Thurn, a Chicago native who had worked at the Académie Julian in Paris and the Royal Academy of Art in Munich, and had been an assistant in Hans Hofmann's Munich school. Cushman herself first met Hofmann when he visited Thurn's summer school in Gloucester, Massachusetts, following his first summer at the University of California at Berkeley.

Cushman first encountered Cubism and abstract art while studying with Thurn, although she did not develop her own variant of Cubism until after her return to New York in 1937. She especially admired Georges Braque, whose paintings she knew primarily from books. Back in New York, Cushman supported herself by teaching part time. In the mornings she attended Hofmann's classes. The afternoons were given over to a sculpture course at the Art Students League. Although her schedule left little time for her own independent painting, she began exhibiting with the Contemporary Arts Gallery in New York. In 1940, she joined the American Abstract Artists, although she did not play an active role in the organization and seldom attended its meetings. Instead, she, De Laittre, and Fannie Hillsmith, whom she had known in college, met frequently to discuss their work, current exhibitions, and the impact that European artists fleeing Hitler might have in America.

The decade that Cushman spent in New York was a fertile period. She put aside the landscapes and figural work rendered with rich, painterly surfaces that had been the focus of her student years and began to merge an interest in Analytical Cubism with new understandings of space and pictorial tension gleaned from Hofmann. *Shells, Buoys and Bottle* of 1944 exemplifies her mature artistic concerns. Still-life forms are dematerialized and three-dimensional space is dramatically distorted. The significance given the backdrop cloth and fish net represent a step towards the all-over compositional approach that played an important role in Hofmann's discussions of pictorial balance. Despite their finished appearances, Cushman's paintings began as highly realistic drawings from which she abstracted forms. Still-life arrangements are the predominant subjects, although Cushman did, on occasion, go beyond abstraction into completely nonobjective art.

In 1947, Cushman married and moved to Detroit. Finding little sympathy there for her modernist work, she stopped painting for ten years. When she again picked up her brushes, her technical and thematic interests had shifted. She did not return to the thin oils and egg tempera in which much of her earlier work was executed, but instead she chose watercolor as especially well suited to capturing the light and atmosphere of the Mediterranean area, where she frequently travels, in landscapes which are now her most frequent subjects.

1. Charlotte Cushman Evans, interview with Virginia M. Mecklenburg, 26 January 1989. I am grateful to Ms. Cushman for speaking with me about her art and life.

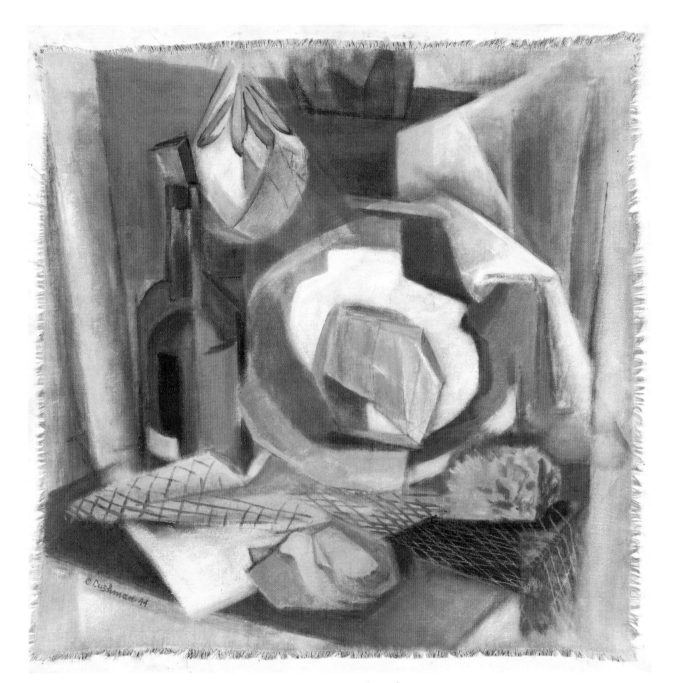

Shells, Buoys and Bottle
1944
egg tempera on linen
mounted on fiberboard
24 x 24
1986.92.15

ELEANOR DE LAITTRE

(born 1911)

ELEANOR DE LAITTRE BECAME INTERESTED IN ART AFTER A COURSE IN ART theory at Smith College. She left Smith to pursue her newfound interest and spent two years in life and drawing classes at the school of the Museum of Fine Arts in Boston. In 1932, she left Boston for New York, first to study with George Luks, and after Luks's death, with John Sloan.

As a young artist in New York, De Laittre became friends with Fanny Hillsmith, who shared her growing fascination with modern art. Through illustrations and the paintings then to be seen in New York, De Laittre taught herself the principles of abstract art by working in the manner of European masters. An early painting explored form in the style of Modigliani, but, De Laittre explained, she discovered the laws of perspective after looking at Miró, while Klee's paintings inspired experimentation with textural richness.[1] Soon De Laittre put aside the portraits and landscapes that had occupied her student years, and although not yet an abstract artist, her paintings took on a simplicity and a calligraphic clarity reminiscent of Raoul Dufy.

After her marriage in 1934, De Laittre moved to Chicago. Over the next several years, she exhibited regularly in annual exhibitions at the Art Institute of Chicago. Back in New York by 1940, she became active in the American Abstract Artists, with whom she exhibited annually from 1940 until 1946, and in the Federation of Modern Painters and Sculptors. Her work matured during her six years in Chicago, and by the 1940s, Cubism offered the most compelling problems of space and form. The spatial configuration De Laittre employed in the small *Untitled* painting of 1949 is an adaptation from Picasso's large *Three Musicians* in the Gallatin Collection. By juxtaposing background areas of white, blue, and bare brown canvas, however, De Laittre enhanced the flattened space inhabited by the abstract linear shapes.

Increasingly during the 1940s, De Laittre turned to sculpture. At Ibram Lassaw's studio she learned the technical processes of welding in steel. Her highly refined, welded sculpture of the 1940s evidences a growing awareness of Surrealism, and the intricate interweaving of steel and open space showed affinities with the work of David Hare. Although she has never stopped painting, De Laittre now prefers the challenges presented by articulating three-dimensional form and space. Yet, the lyrical balance of mass and openness in her current sculpture retains echoes of her earlier affection for Analytical Cubism.

1. Eleanor De Laittre, interview with Virginia M. Mecklenburg, 4 January 1989. I am grateful to Ms. De Laittre for speaking with me about her art and life.

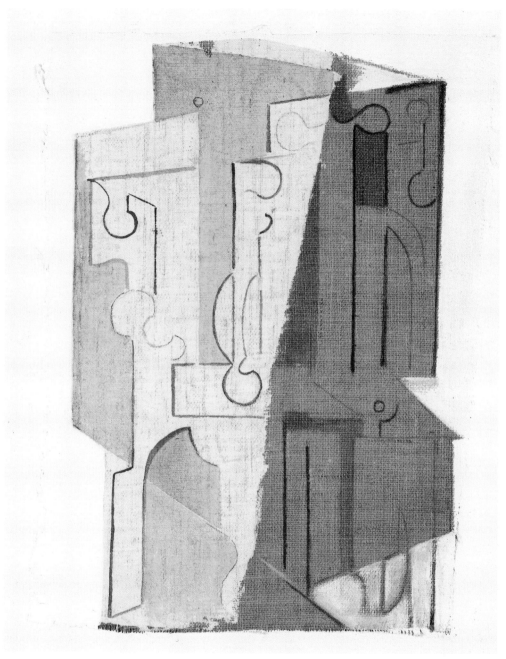

Untitled
1949
oil on linen mounted
on fiberboard
12 3/8 x 10 5/8
1986.92.16

WERNER DREWES

(1899 Germany–1985 USA)

THE SON OF A LUTHERAN MINISTER WHO WAS INTERESTED IN ARCHAEOLOGY and the natural sciences, Werner Drewes believed that art provided an avenue to understanding the mysteries of life:

> What is the mystery underlying the Architecture of our Universe? What are the laws which create the pattern of the frost which forms on our windows? What causes the stars to stay in their orbit? What is it which creates joy and sorrow within us? . . . All these are problems belonging to the world we live in and which should concern the artist, as well as those problems of sunlight or the growth of a tree. But art is also a world with its own laws, whether they underlie a painting of realistic or abstract forms. . . .
>
> To create new universes within these laws and to fill them with the experiences of our life is our task. . . . When they convincingly reflect the wisdom or struggle of the soul, a work of art is born.[1]

These words, written in 1936, provide a framework for understanding Drewes's work throughout his life. From his student days, he was fascinated with the formal possibilities of line and color. Yet, he was unwilling to forego the profound expressive potential of thematic motifs. Drewes moved easily between pure abstraction and expressionistic figuration, occasionally using highly energized abstract forms to express powerful emotions, as in his 1934 woodcut series, *It Can't Happen Here*.

Following military service in World War I, Drewes studied architecture and design in Berlin and Stuttgart. But he was soon attracted to the experimental freedom and the notion of the unity of the arts associated with the Bauhaus curriculum. In 1921, he enrolled in classes with Johannes Itten, Paul Klee, and Oskar Schlemmer. Unsettled yet as an artist, in 1923 Drewes began several years of world travel, initially to Italy and Spain, where he studied Veronese, Tintoretto, Velazquez, and El Greco. His *wanderjahren* then took him to Latin America (he had exhibitions in Buenos Aires and Montevideo), the United States, the Orient, and finally, via the trans-Siberia railroad, through Manchuria, Moscow, and Warsaw, back to Germany.

In 1927, Drewes returned to the Bauhaus, which had moved from Weimar to Dessau. But he found that its emphasis, as well as its location, had changed. The rather loose, experimental phase of the school's early years had yielded to a firmer commitment to design, to the potential for uniting art and technology, and to the artist's "new" social role in molding society.[2]

In spite of his preference for the earlier days, Drewes resumed his studies with Klee and Schlemmer. He attended Wassily Kandinsky's weekly painting classes and became close friends with Lyonel Feininger, Moholy-Nagy, and Josef Albers. He left the following year, however, at a time when the Bauhaus was in turmoil. He worked independently and taught, and in 1930, Drewes settled in New York. Kandinsky provided an introduction to Katherine Dreier, an abstract artist and founder of the Société Anonyme, who immediately began to include Drewes's work in the group's exhibitions.[3] He subsequently taught at the Brooklyn Museum (under the sponsorship of the WPA's Federal Art Project) and at Columbia University. In 1940 he was appointed director of the WPA's graphic art division in New York. In 1946, after additional teaching posts at Brooklyn College and at Moholy-Nagy's Institute of Design in Chicago, Drewes accepted a position at Washington University in St. Louis. He remained there until his retirement in 1965.

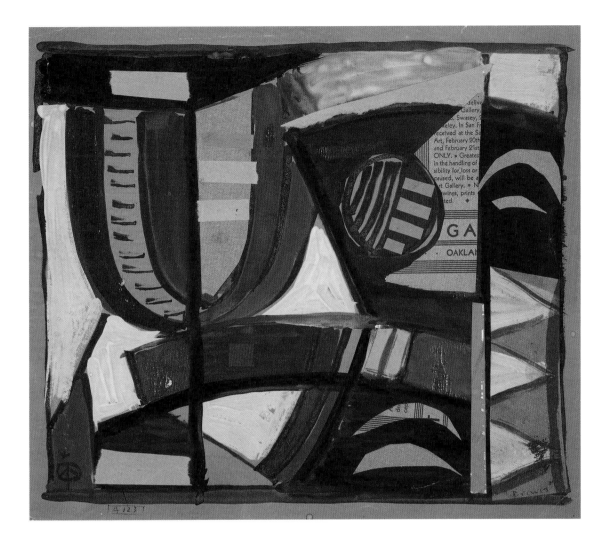

Untitled
1941
paper and gouache on paper
9¹/₄ x 10⁵/₈
1986.92.18

The obvious kinship between Drewes's *Pointed Brown and Floating Circles* and Kandinsky's paintings of the mid 1920s is more than a testament of respect from student to master. After a friendship begun at the Bauhaus, Kandinsky became Drewes's artistic mentor. The two corresponded frequently in the years after Drewes settled in New York, and the young Drewes assisted with Kandinsky's New York exhibitions. Kandinsky's letters are filled with news of the Bauhaus, the worsening political situation in Germany, and, when Drewes sent photographs, of reactions to his recent work. Drewes's frequent practice of painting thinly, which in this painting allows the woodgrained panel to suggest the organic movement of ocean in the sea-green foreground, is an aspect of Drewes's technique that Kandinsky especially admired.[4]

A founding member of the American Abstract Artists (by one account Drewes showed Arshile Gorky the door when the Armenian immigrant stalked out of an early meeting), Drewes exhibited more frequently in commercial galleries and museum exhibitions than did many of his friends within the group.[5] Drewes often received positive reviews, and his work occasionally won prizes during these difficult years.[6] He remained actively involved during the organization's early days and provided support and encouragement to his fellow abstract artists.

1. Werner Drewes, "Statement," in exhibition brochure, *4 Painters: Albers, Dreier, Drewes, Kelpe*, Société Anonyme traveling exhibition, 1936; in Werner Drewes Papers, Archives of American Art, Smithsonian Institution, Washington, D.C., roll 1498.

2. Peter Hahn, "About Werner Drewes," in Ingrid Rose, *Werner Drewes: A Catalogue Raisonné of His Prints* (Munich and New York: Verlag Kunstgalerie Esslingen, 1984), p. 21.

3. Drewes subsequently became vice president of the Société Anonyme.

4. Wassily Kandinsky, letter to Werner Drewes, 14 March 1932, in Drewes Papers, Archives of American Art, roll 1497: 466-67, translated by Leo R. LeMaire and Mary V. Drach.

5. Ilya Bolotowsky, "Reminiscences about the American Abstract Artists," 20 June 1966, in Ilya Bolotowsky Papers, Archives of American Art, roll 2787: 288–294.

6. A reviewer of Drewes's 1939 exhibition at the Artists' Gallery mentioned the "breadth of scope," the "clear eloquent color," and "imaginative designs," and recommended the show to "anyone who searches for meaning in abstractions...." See "New Exhibitions of the Week," *Art News* 37, no. 28 (8 April 1939): 14.

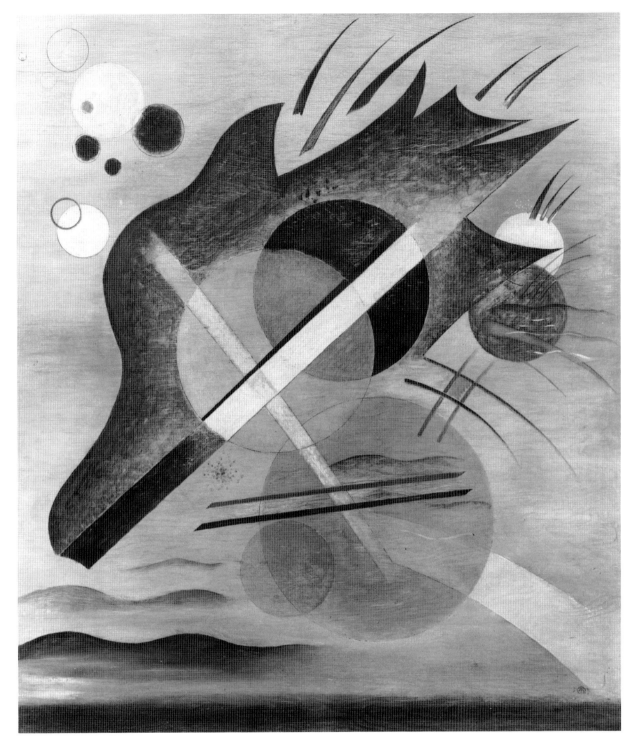

Pointed Brown and Floating Circles
1933
oil, pencil, and pen
and ink on plywood
29^{15}/$_{16}$ x 26
1986.92.17

HERZL EMANUEL

(born 1914)

AS A TEENAGER, HERZL EMANUEL STUDIED ART AT THE ROCHESTER MEMORIAL Art Gallery in Rochester, New York. Emanuel quit high school in 1931, and, with the assistance of several patrons who recognized his talent, went to Paris, hoping to study with Emile-Antoine Bourdelle. Although the French master died shortly after Emanuel's arrival, he studied with Charles Despiau and Fernand Léger and attended lectures given by André Lhote. He was soon joined by Hananiah Harari, then a student at Syracuse University, with whom he shared a studio and later accompanied to Palestine. In Paris, the two young men were intrigued by contemporary art. They felt its validity and power without fully understanding why Picasso, Matisse, and others could so successfully do such violence to the figure.[1] Believing the answer to their questions lay deep in the history of art, Emanuel and Harari spent a year drawing from the collections at the Louvre. Beginning with Hittite and Egyptian art, they worked their way chronologically to the nineteenth century, seeking to understand the structure and logic of the art of the past. In the Louvre, Emanuel says, "we learned the grammar of art. We learned its syntax, its alphabet, until contemporary art represented no mystery. We learned its rationale, where it came from, the basic language. We saw its connection with the art of the past."[2] Although in Paris when *Abstraction-Création* was being formed, Emanuel and Harari saw such publications but paid little attention to the theories or the movements germinating around them.

As fascism threatened Europe, Emanuel and Harari left for Palestine where they worked on a kibbutz for over a year. Although the kibbutz regimen left little time for art, the experience enriched them philosophically. After a brief stay in Jerusalem, Emanuel returned to the United States and in 1936 joined the sculpture division of the New York Federal Art Project.[3] During the mid 1930s, Emanuel was sympathetic with leftist political causes. By participating in the WPA, he said, "we felt we were working directly for society."

When war came, Emanuel went to work for a shipyard, and afterwards made his living doing display work. Later he worked as an illustrator. During the mid 1950s he taught illustration, sculpture, and a foundation course at the School of Visual Arts in New York. After six years, he gave up his teaching position to return to Europe. In Rome, he set up a studio that he still maintains.

Throughout his career, Emanuel's art has been centered in a deeply felt humanism. Art for him offers a way to come to terms with the human condition. Though he still finds inspiration in Romanesque and Italian Renaissance art, it was Picasso's *Guernica* that had the most dramatic impact in his life. Calling it the most significant work of art of the twentieth century, Emanuel has sought to achieve in his own work a fusion of abstracted form with tragic content that parallels Picasso's powerful statement. Since the 1930s, his sculpture has evolved from an Analytical Cubist format to an Expressionism in which the human form is distorted to convey the human condition. Yet by intertwining limbs and connecting gazes in multifigural compositions, he offers up human relationships as notes of hope that temper the effects of a tragic existence.

Emanuel participated in exhibitions of the American Abstract Artists for only a few years during the late 1930s. His fascination with Cubist formal structure, apparent in *Head of the Prophet* (1935) and *Lower Manhattan from Apartment in Brooklyn* (1937), later yielded to an

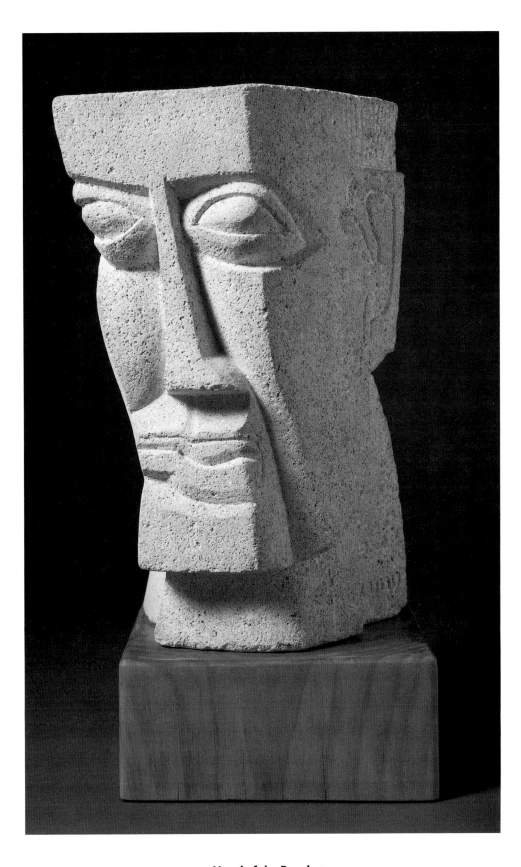

Head of the Prophet
1935
stone
15⅝ x 9½ x 10½
1986.92.19

expressionistic outlook. The growing domination of purist geometric abstraction within the group's program conflicted with Emanuel's evolving aims for his own sculpture, and he let his membership lapse.

1. Herzl Emanuel interview with Virginia M. Mecklenburg, 10 December 1988. I am grateful to Mr. Emanuel for speaking with me about his art and life.

2. Ibid.

3. Most of Emanuel's WPA sculpture was destroyed when the project came to an end. He was able to retrieve several pieces before the rest of his work, along with a large body of sculpture created by other sculptors on the project, was dumped into the East River.

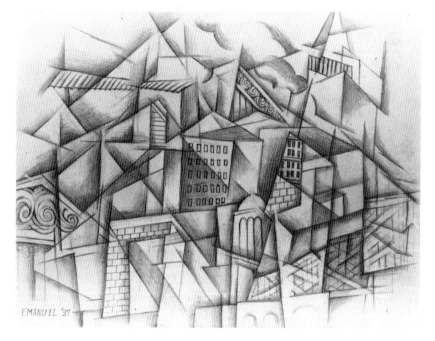

New York City Skyline
1937
pencil on paper
7 1/2 x 9 5/8
1986.92.21

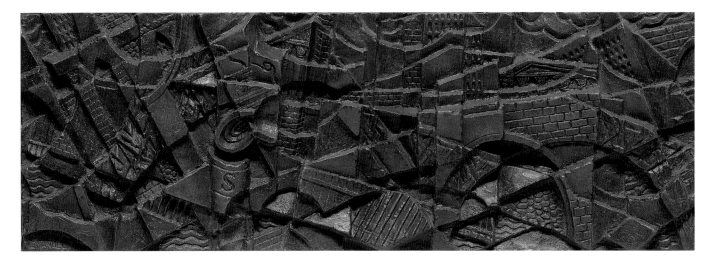

Lower Manhattan from Apartment in Brooklyn
1937
bronze
$8^{1}/_{4}$ x $23^{13}/_{16}$ x $1^{1}/_{2}$
1986.92.20

JOHN FERREN

(1905–1970)

JOHN FERREN WAS ONE OF THE FEW MEMBERS OF THE AMERICAN ABSTRACT Artists to come to artistic maturity in Paris. A native of California, in 1924 Ferren went to work for a company that produced plaster sculpture. He briefly attended art school in San Francisco. Later he served as an apprentice to a stonecutter. By 1929, Ferren had saved enough money to go to Europe, stopping first in New York where he saw the Gallatin Collection. He went to France and to Italy. In Saint-Tropez, he met Hans Hofmann, Vaclav Vytlacil, and other Hofmann students. When Ferren stopped to visit them in Munich, he saw a Matisse exhibition, an experience that was instrumental in shifting his work from sculpture to painting.[1] In Europe, Ferren did not pursue formal art studies, although he sat in on classes at the Sorbonne and attended informal drawing sessions at the Académie Ranson and the Académie de la Grande Chaumière. Instead, Ferren said, he "literally learned art around the café tables in Paris, knowing other artists and talking."

After this initial year in Europe, Ferren returned to California. By 1931, he was again in Paris, where he lived for most of the next seven years.[2] Surrounded by the Parisian avant-garde, Ferren wrestled with his own idiom. His diaries from these years indicate far-ranging explorations—from a Hofmann-like concern for surface to the spiritual searches of Kandinsky and Mondrian.[3]

Although Gallatin and Morris were the first Americans to buy his paintings, Ferren associated with members of the *Abstraction-Création* group rather than with the American expatriate community. He married the daughter of a Spanish artist, Manuel Ortiz de Zarate. Through this union he met the circle of Parisian-Spanish painters that included Picasso, Miró, and Torres-Garcia. With Jean Hélion, Ferren wrote manifestoes against Surrealism, although he remained friendly with Max Ernst and André Breton, and illustrated books by Surrealist poets. In Paris, he met Pierre Matisse who in 1936 hosted a show of Ferren's work at his New York gallery.

Following his divorce in 1938, Ferren returned to the United States. He attended American Abstract Artist meetings but felt little of the frustration that had prompted the organization's formation. After Ad Reinhardt used Ferren's name without permission on a pamphlet passed out on the Museum of Modern Art picket line, Ferren broke from the group.

During World War II, Ferren served with the Office of War Information in the North African and European theaters. By this time, Ferren had reintroduced the figure into his paintings without giving up abstraction, and following the war he turned to Abstract Expressionism.

In moving from geometric abstraction to the academically based figure and still-life paintings he did after the war, and finally to the freely painted expressionist work of his later years, Ferren searched for a way to express moral truth. Throughout his life, he viewed painting as a means of seeking the reality behind appearance. His early appreciation of Kandinsky and a fascination with Zen that dated from his youth helped define the way he thought about painting throughout his life. He called art the "great common denominator between knowledge and insight," and said it should explore the intuitive—the spiritual, mental, social, or psychological—forces of life.[4]

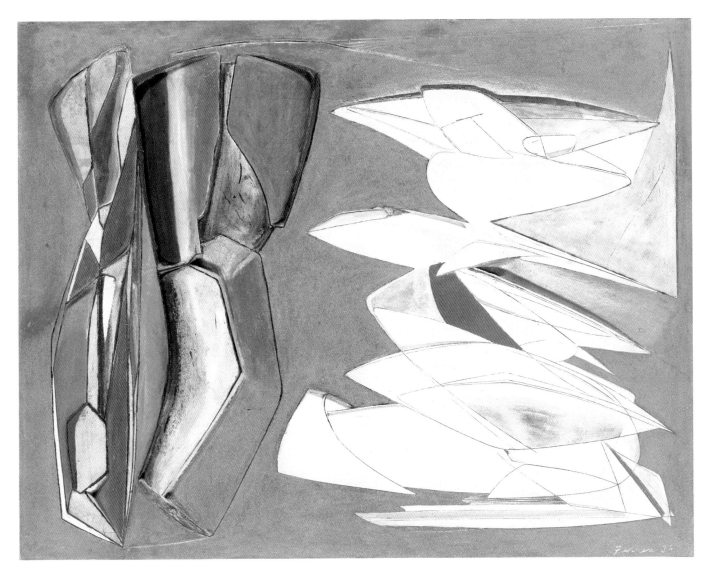

Untitled
1937
carved, engraved, and painted plaster
18 x 22
1986.92.23

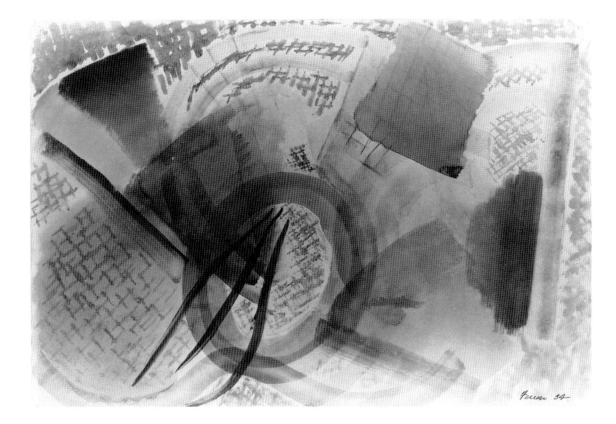

Untitled
1934
watercolor on paper
mounted on paperboard
12^{7}/$_{8}$ x 19
1986.92.22

Ferren's *Untitled* relief of 1937 reflects an approach he developed while working at Stanley William Hayter's Atelier 17. Hayter introduced Ferren to a nineteenth-century printing technique in which an etched and inked plate is imprinted on wet plaster. The plaster was then carved and painted, using the etched lines as a guide. Pierre Matisse showed several of these plasters in the 1936 exhibition of Ferren's work and gave Ferren a contract to do more. After a year, Ferren gave up the medium entirely, despite the positive reception this work received in the New York press.[5] The lively surfaces, clear color, and unusual technique reflect Ferren's noncanonical search for new means of expression.

Ferren was an early member of The Club, an organization of Abstract Expressionists, and in 1955 served as its president. He taught at the Brooklyn Museum School, the Cooper Union, and Queens College.

1. Craig Ruffin Bailey, "John Ferren," in John R. Lane and Susan C. Larsen, *Abstract Painting and Sculpture in America, 1927–1944* (Pittsburgh, Pa.: Museum of Art, Carnegie Institute in association with Harry N. Abrams, 1983), p. 77.

2. Interview with Paul Cummings, 7 June 1968, Archives of American Art, Smithsonian Institution, Washington, D.C., used with the permission of Mrs. Rae Ferren. For more information about Ferren's years in Paris, and his sojourn in 1932 and 1933 in Mallorca, see James Fitzsimmons, "A John Ferren Profile," *Art Digest* 27, no. 10 (15 February 1953): 11, 25–26.

3. In late 1931 Ferren wrote: "Painting coming near the surface," a direct reflection of Hofmann; less than two weeks later he described articles by Kandinsky and Henri Doerner in an issue of *Cahiers D'Art* as "expressing perfectly my hitherto original opinion," and continued, "Voila—I am reconvinced that my vague gropings are correct." Diary entries from 9 December and 21 December 1931, Ferren Papers, Archives of American Art, roll 371.

4. Typescript entitled "Address to Advanced Painting Class, Brooklyn Museum Art School," 8 April 1949, Ferren Papers, Archives of American Art, roll N69–98: 143.

5. Ferren described this work in an interview with Dorothy Seckler, 12 June 1965, Archives of American Art. It is used with the permission of Mrs. Rae Ferren.

ALBERT EUGENE GALLATIN

(1881–1952)

PAINTER, WRITER, PATRON, FOUNDER OF THE GALLERY OF LIVING ART AT New York University, Albert Gallatin's contributions to abstract art in New York took many forms. Trained as a lawyer, Gallatin never practiced. Instead he concentrated his energies on collecting and writing about art. Initially interested in Aubrey Beardsley, James McNeill Whistler, the American Impressionists, and other turn-of-the-century artists, Gallatin turned to modern art in the 1920s.[1] By 1927, his collection had grown sufficiently to be shown publicly. He established the Gallery of Living Art, dedicated to the ongoing display of European moderns.[2] Located on Washington Square—near the studios of many young painters— New York University became home for his collection. There, Gallatin hoped to create an informal atmosphere for intellectual exchange, as well as a place where artists could congregate and study the newest developments in European art.

By 1933, when its second catalogue was published, the Gallatin Collection featured paintings by Cézanne, Picasso, Braque, Léger, Gris, Mondrian, Ozenfant, Torres-Garcia, and others. With Jean Hélion, who served as advisor and friend, Gallatin increasingly focused his collection on a unified view of modernism. By 1937, its core artists were Picasso, Gris, Léger, and Braque. Masterworks purchased included Picasso's large *Three Musicians* and Léger's *The City*. Gallatin began adding work by American moderns as well.[3]

Gallatin's collecting brought him into contact with leading artists and groups of the day. He knew many of the members of *Abstraction-Création*, and its short-lived predecessor *Art Concret*. He visited the studios of Picasso, Braque, Mondrian, Miró, and others, during his annual trips to Paris. As important as his acquaintance with these artists was for his own painting, of greater significance was the link it provided between them and the growing circle of vanguard artists in New York.

Although many young Americans followed the Parisian art scene through *Cahiers d'Art*, *Abstraction-Création*, and other magazines, the opportunity to study original work firsthand was unparalleled. Through purchases for the collections and backing for exhibitions, Gallatin lent significant support to his younger colleagues. He bought paintings by Rupert D. Turnbull, Gertrude Greene, Jean Xceron, Charles Biederman, John Ferren, George L. K. Morris, and Charles Shaw. He sponsored shows of work by Alice Trumbull Mason, Esphyr Slobodkina, and others. In 1936, under the auspices of the Gallery of Living Art, the Paul Reinhardt Galleries presented "Five Contemporary American Concretionists," a widely reviewed exhibition of work by Biederman, Alexander Calder, Ferren, Morris, and Shaw.

Gallatin viewed modern art in international terms. He considered the gallery to be akin to a scientific laboratory where experimentation and exploration were documented.[4] Hélion agreed, and in an essay for the 1933 catalogue of the collection, further argued that the newest developments should be understood as part of an evolutionary process. The concerns of "politics and the struggle for life," so popular among Social Realists, had no place in modern art.[5]

In December 1942, New York University determined to retrieve the space occupied by the Gallatin collection. Looking about for another site, Gallatin rebuffed overtures from Alfred Barr at the Museum of Modern Art because he found Barr's lack of sympathy for younger American abstract artists disturbing. He gave the collection to the Philadelphia Museum of Art.

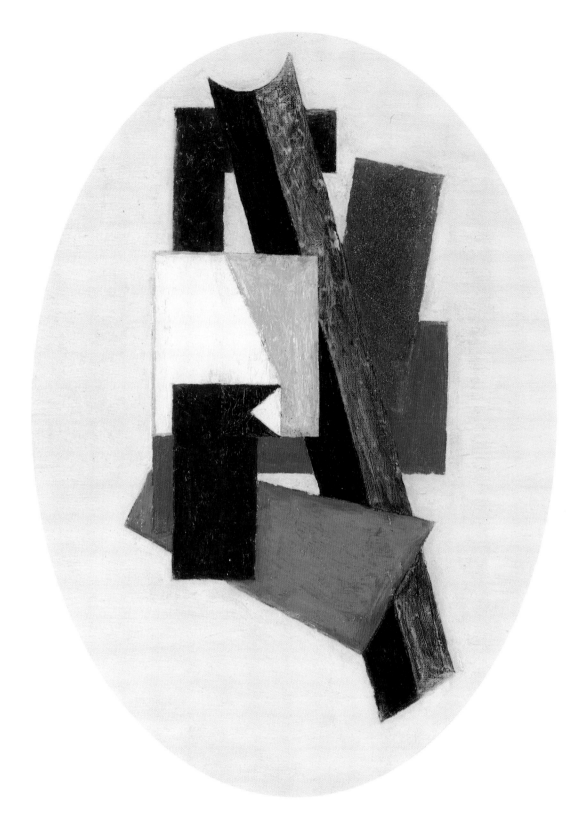

Untitled
1936
oil on canvas
12 x 9
1986.92.24

Although Gallatin's perceptive eye benefited from the advice of Hélion, Morris, and others, his acute understanding of the formal basis of Cubism and other modernist forms is clear from his own paintings. During the mid 1920s, when Gallatin was fifty-five, he began painting in a modified Cubist style. Both the *Untitled* canvas of 1936 and *Composition* (1937) reflect Gallatin's admiration for Juan Gris, whose "honest and profound paintings, so free from all pretention, take on more and more weight year by year."[6]

Although Gallatin provided substantial moral and financial support for the American Abstract Artists, and was among the early, although not original members, he was both older and considerably wealthier than most of its members. Along with Charles Shaw, George L. K. Morris, and Suzy Frelinghuysen, Gallatin was dubbed a "Park Avenue Cubist." He remained a man whose elegant life style set him apart from the younger, poorer members of the group.

1. Gallatin's first major publication appeared in 1903: *Aubrey Beardsley's Drawings*. The following year he wrote *Whistler's Art Dicta*; additional volumes on Whistler appeared in 1907 and 1912.

2. Among the almost seventy works featured in the opening exhibition of the Gallery of Living Art were paintings by Braque, Cézanne, Chagall, de Chirico, Gris, Léger, and Picasso.

3. Figurative art took a second place in the collection, and Gallatin removed from the collection work by Pavel Tchelitchew, Morris Kantor, Max Ernst, and Henry Billings. Surrealists were also discarded, although Miró and Masson, due to "technical virtuosity," remained within the gallery's purview. He reduced his holdings to one work each by Marin, Demuth, and Sheeler, but added Calder, Ferren, Morris, Shaw, and others whose work had direct links to recent European art.

4. Gallatin was delighted that the Museum of Living Art occupied the space used by Samuel F. B. Morse when he developed the electric telegraph.

5. Jean Hélion, letter to Albert E. Gallatin, 21 November 1934, Albert Gallatin Papers, Archives of American Art, Smithsonian Institution, Washington, D.C., roll 507: 404.

6. Albert Gallatin, "Abstract Painting and the Museum of Living Art," *Plastique* 3 (Spring 1938): 9.

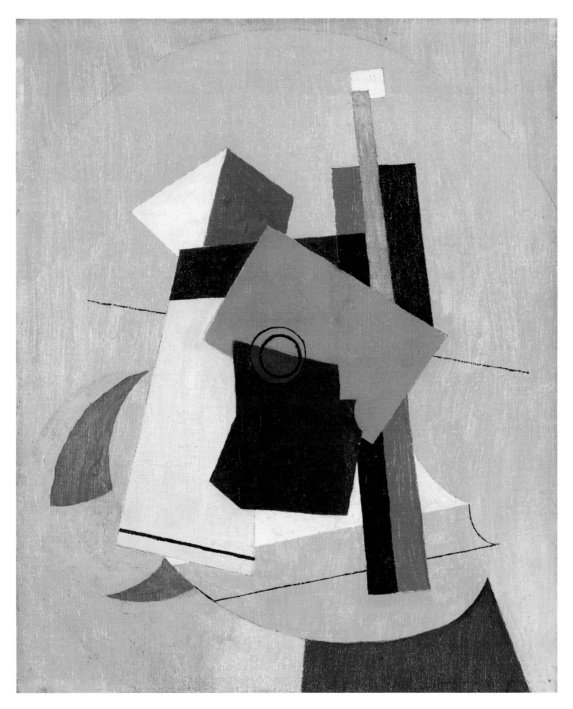

Composition
1937
oil on canvas
12 $^5/_{16}$ x 10 $^3/_{16}$
1986.92.25

ED GARMAN

(born 1914)

ED GARMAN WAS BORN IN BRIDGEPORT, CONNECTICUT, BUT GREW UP IN THE Lehigh Valley of Pennsylvania. In 1933, he entered the University of New Mexico. While working for the university theater, he discovered the work of Adolph Appia and Edward Gordon Craig, turn-of-the-century pioneers of modern stage sets whose stark, simple designs opened Garman's eyes to the dramatic possibilities of structural form. Later, working for a WPA project, Garman sorted pottery shards at an archaeological dig and became fascinated with the patterns and arrangements of Indian designs. These two discoveries shaped his growing enthusiasm for abstraction, as did a 1935 retrospective of van Gogh's paintings at the Art Institute of Chicago. Shortly thereafter, Garman completed his first group of semi-abstract paintings. Yet Garman was not convinced that his own future lay in abstraction. Consequently, he went to Mexico for six months in 1937 to study murals by Diego Rivera and Clemente Orozco. He found himself unimpressed, however, by the nationalistic context of the Mexican muralists. He turned instead to art history, seeking in the art of the past the clues that would enable him to better understand his own reactions to his environment.

Garman was fully conscious that becoming an artist in the 1930s was a risky decision:

> The Great Depression was in full swing. Contemplating going into the arts as a lifetime profession was the ultimate in an irrational hope and a guarantee of economic and social suicide. Then, of all things, to choose an area of interest in painting that was so coldly received as was abstract painting was yet another step into the twilight zone.[1]

Yet the challenges were exciting. Garman compared them to the feelings of a scientist "discovering an improbable life form that seemed to contradict all other forms of life and yet lived. Abstraction was like that—it lived."[2]

Garman joined the Transcendental Painting Group in 1941, several years after the group's formation. By this time he had become close friends with Raymond Jonson, who encouraged the younger artist to continue with his painting and his ideas. But World War II intervened, and in late 1943 Garman left New Mexico to serve with the U.S. Navy in California. Despite little time to paint, his ideas about abstraction continued to germinate, fueled in part by the progressive exhibitions he saw at the San Francisco Museum of Art. By the mid 1940s, Garman had developed a sophisticated theory he called "dynamic painting" in which varied empathetic responses could be stimulated through elements of movement and its counterpoint, rest.

The war had a tremendous impact on Garman's artistic ideas: "[It] has shown me more than ever the terrific need for an idealism that is truly transcendental. It has shown me more than ever the poverty of spiritual beauty in the world. . . ."[3]

In contrast to Raymond Jonson, who worked intuitively, Garman conceived his paintings in intellectual terms, using geometries, rather than sinuous, rhythmic forms as the structural basis for his work. In *Composition #261*, for example, brightly colored geometric shapes dance in a yellow field, creating rhythms through color rather than through directional form.

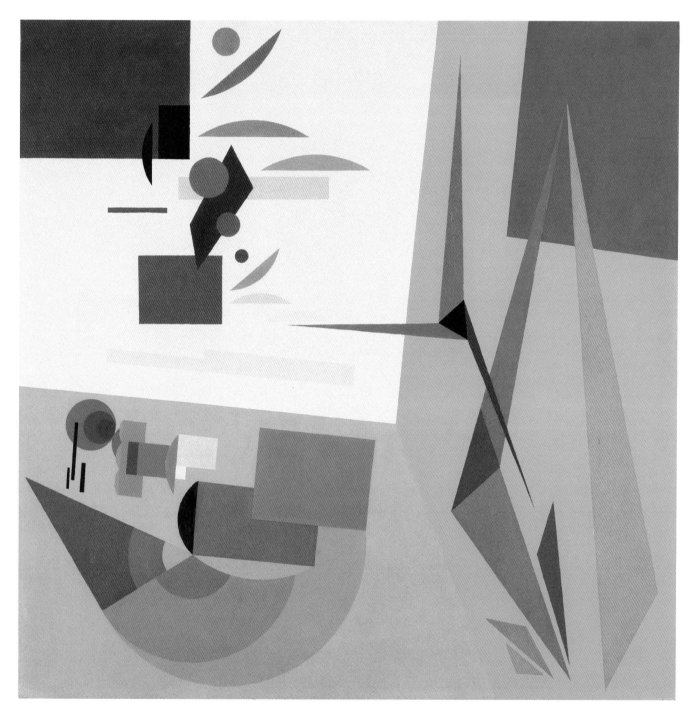

No. 260
1942
oil on fiberboard
30 x 30
1986.92.26

Garman described his artistic development as steady and consistent. His paintings evolved "from a highly simplified and almost primitive realism through the various shades of the abstract to the nonobjective."[4] In his later work he has continued to explore movement and rest through geometric form and has retained the vitality of color so important in his paintings of the 1940s.

1. Ed Garman, letter to Virginia Mecklenburg, 15 February 1988, in the curatorial files of the National Museum of American Art, Smithsonian Institution, Washington, D.C.

2. Ibid.

3. Ed Garman, letter to Raymond Jonson, 10 April 1946, Raymond Jonson Papers, Archives of American Art, Smithsonian Institution, Washington, D.C., roll RJ3: 1774.

4. Undated biographical statement prepared by Ed Garman for Raymond Jonson, Jonson Papers, Archives of American Art, roll RJ3: 1769.

MAURICE GOLUBOV

(1905 Russia–1987 USA)

MAURICE GOLUBOV FIRST STUDIED ART AS A TEENAGER DURING EVENING classes with John Sloan at a Hebrew Educational Society settlement house.[1] At age fifteen Golubov dropped out of school and apprenticed himself to a fashion studio where he copied figure illustrations. A chance encounter with Mark Tobey, who also worked as a fashion illustrator, introduced Golubov to the National Academy of Design. There, Golubov spent week nights for four years studying with Ivan Olinsky, Charles Curran, and George L. Nelson. In 1922, his mastery of the academic regime was recognized when he received the Suydam Silver Medal for excellence in life drawing.

In the spring of 1923 Golubov left both the commercial studio and the academy. Although he had not yet encountered vanguard European, or even American art, Golubov was already making abstract geometric designs. He first visited the Metropolitan Museum of Art in the winter of 1923–24, studying Venetian and Flemish painting and glazing techniques. He was also studying Greek, Neoplatonic, and American Transcendentalist philosophy at the public library while he painted at night.

With funds running short, Golubov returned to commercial art in 1924. At first full-time, his position eventually became seasonal, allowing him to paint for months at a time. By the late 1920s, he had discovered other New York museums. Kandinsky and Picasso joined Cézanne on his roster of revered masters. During the late 1920s, he determined to break from commercial work to concentrate full time on painting. He became friendly with a number of other artists—Max Weber, Raphael Soyer, Stuart Davis, Byron Browne, and Arshile Gorky. The summer of 1928 proved a turning point. Working in Woodstock, where he met Milton Avery and David Smith, Golubov began bringing compositional organization to his abstract experiments. Back in the city at the end of the summer, he brought a greater sense of confidence to his work and began attending meetings at the John Reed Club.[2]

In 1933, when his savings ran out, Golubov returned to full-time commercial work, though it left him little time to paint. The same year he married. During slow periods at work, he began doing miniatures in gouache and watercolor, which were often later worked out full-size. By the late 1930s, Golubov began spending his summers in Rockport, Massachusetts, and his winters in the city. He continued to move between abstraction and figuration. During the summers, his oils were frequently figurative, while his abstract canvases, with loose grid structures, dark colors, and expressionist surfaces, were done primarily during the winter months in New York.

In late 1939, Golubov found a seasonal job at Vogue Wright Studios. At Vogue Wright, he worked long hours for several months and then took off about six months for painting. He continued this arrangement until his retirement in 1967. In 1941, Golubov had a solo exhibition at the Artists' Gallery. Alice T. Mason and George L. K. Morris saw the show and invited Golubov to join the American Abstract Artists. Finally he began showing with the group in 1944.

By the late 1940s, most of Golubov's work was abstract. He continued to exhibit at the Artists' Gallery, as well as in group exhibitions at the Walker Art Center, the Jewish Museum, the Museum of Modern Art, and the Whitney Museum of American Art. In 1943 and 1952, he had solo shows at the Mint Museum in Charlotte, North Carolina. Even at this point, however, he had not completely relinquished figuration. In 1962 Golubov's work was featured in *Recent Painting USA: The Figure* at the Museum of Modern Art.

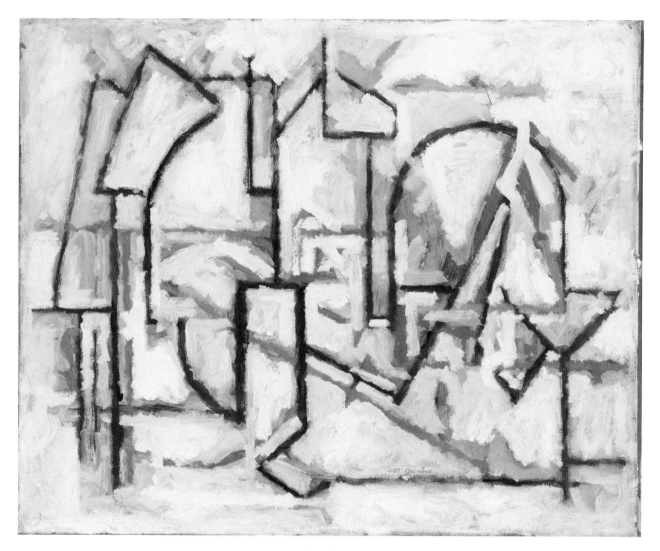

Landscape
1936
oil on fiberboard
22 3/8 x 27 7/8
1986.92.27

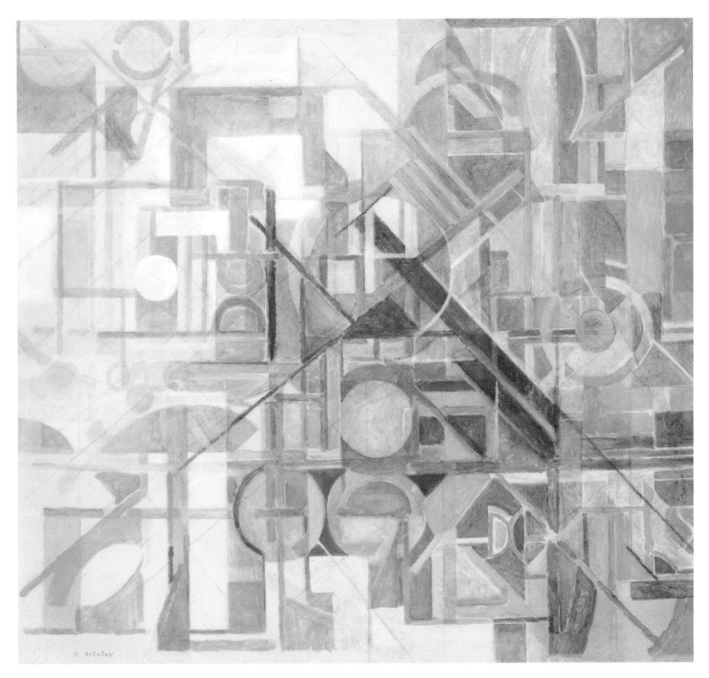

Untitled
1948
oil on canvas
41$\frac{1}{2}$ x 45$\frac{1}{4}$
1986.92.28

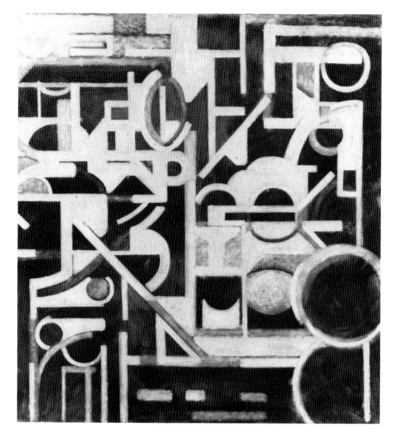

Untitled
1938
oil on canvas
23 x 21
1986.92.29

Untitled
1939
watercolor on paper
1³/₈ x 5¹/₂
1986.92.30

Although Golubov's abstractions began as experiments in design, he came to see them as a form of mental rather than visual realism. He grew up in a Hasidic household and as a child began studies toward a rabbinical education. Thus he was grounded in mysticism from an early age, and from his teenage years Golubov was captivated by the world of philosophy. He read Spinoza, Schopenhauer, Kant, Fichte, Berkeley, and Emerson, which along with Eastern philosophy and medieval Jewish theology, provided a basis for his philosophy of art. "I could sense and feel more closely the things I felt were real and yet unseen. I didn't feel comfortable trying to express these in words, however; instead, I started to find symbolic means to be able to represent them pictorially." In his abstractions, Golubov sought to express the complexities of the world, a "world where endless moments are arrested into one whole *instant moment.*"[3]

Golubov came late to the American Abstract Artists. The pressing discussions over the social relevance of abstraction, and the heated arguments over political issues were, by the mid 1940s, in the past. An admirer of Picasso, Kandinsky, and Cézanne, Golubov recognized, but did not take to heart, the stylistic accomplishments of his European prototypes. While his work did pass through stages, and he developed a theory of dimensional space, Golubov looked to himself, not to others for the inspiration, and the means, to express the mystical, the magical, and the profound beauties of life.

1. Golubov experienced a very difficult childhood. His father immigrated to the United States after his precarious shoemaking business failed. As World War I approached in Russia, his mother decided to leave with her six children. Golubov became separated from the rest of the family, and roamed for several months with a band of children who survived by raiding small farms. Golubov was eventually reunited with the family in Petrograd. The family finally made its way to New York. For this and other information about Golubov's life and career, see Daniel J. Cameron, ed., *Maurice Golubov, Paintings 1925–1980* (Charlotte, N.C.: Mint Museum Department of Art, 1980).

2. At the John Reed Club, Golubov met Moses Soyer, Ad Reinhardt, Saul and Eugenie Baizerman, William Zorach, and others. Although Golubov has frequently been described as an isolated figure, he was friendly with a number of other artists, including Lee Gatch, Reginald Marsh, Louis Lozowick, Jackson Pollock, Hans Hofmann, Theodore Stamos, Theodore Roszak, and others. And, if he didn't show with great frequency, his exposure was not significantly different from the other abstract artists during the 1930s and 1940s.

3. Undated, autobiographical typescript in artist's files, National Museum of American Art Library, Smithsonian Institution, Washington, D.C.

DWINELL GRANT

(born 1912)

WHEN HE WAS TWELVE, DWINELL GRANT BEGAN STUDYING LANDSCAPE PAINTing with his grandfather. Seeking further traditional training, in 1931 Grant enrolled at the Dayton Art Institute, which he soon discovered had modernist leanings. After a year, he left Dayton to go to New York where he entered the National Academy of Design in 1933. By the time he arrived in New York, he had seen the Bliss collection and had begun thinking along modern lines. Although at the time, he said, his painting had not yet progressed "beyond the pointillist stage." After five months, he left the National Academy and in 1935 became an instructor in art and director of dramatics at Wittenberg College in Ohio. By this time, Grant's paintings were nonobjective, and he had come to believe that nonobjectivism "is a part of the earth itself. . . . In creating it we do not say something about something else, but rather we produce a rhythm which is a part of nature's rhythm and just as deep and fundamental as a heartbeat, a thunderstorm, the sequence of day and night or the growth of a girl into womanhood. . . . Nature is not something to be commented on, it is something to be."[1]

At Wittenberg, Grant had little time to paint. His work with student dramatics provided an outlet for his innovative ideas. As the stage set for an experimental, symphonic drama, Grant designed and built a large, nonobjective construction, painted it gray, then lit it with colored lights controlled by dimmer switches. By varying the intensity of the lights, he found he could change the color, and therefore the mood, of the dramatic presentation.[2] Although Grant's avant-garde ideas soon brought him criticism at Wittenberg, his friends at the Dayton Art Institute encouraged his work, and suggested he write to Hilla Rebay at the Guggenheim Foundation for support.

Rebay quickly became enthusiastic about Grant's ideas and began sending him a fifteen dollar monthly stipend to help with the cost of materials. She arranged for Solomon Guggenheim to buy two of his drawings, and used several of his paintings in a group exhibition at the Museum of Non-Objective Painting in the summer of 1940.

The Constructivist stage set had transformed Grant's ambitions, and he yearned to make an experimental, nonobjective film. He wrote to Rebay, "I am no prophet. I am simply an artist who sees a neglected beauty that is bursting to be possessed. In the midst of the confusion of nationalistic isms here will be an art that is clean, naked and straightforward. It will be barbaric because it will have none of the sickening stupid veneer that civilization has laid on the arts for hundreds of years, but it will not be crude. And it will drive in to the emotions a new depth because of the primitiveness, the directness, and the fundamentalness of its expression."[3]

With Rebay's assistance, Grant moved to New York and began working at the Guggenheim. His own art flourished, and between 1938 and 1941, he made several experimental films, including *Contrathemis*, an eight-minute, animated production, for which he did some four thousand drawings. In 1942, Grant went to work for a commercial film company and during World War II made navy training films. Soon thereafter, he began doing scientific illustration and making teaching films for the medical profession. Although he continued to paint and draw independently, his career in medical films took precedence, and until the mid 1970s, he exhibited his creative work only on rare occasions.

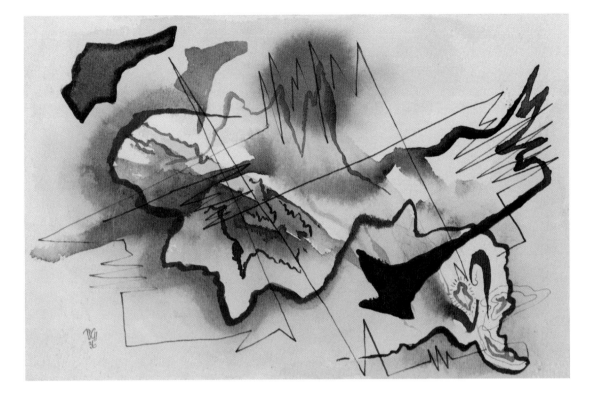

Untitled
1936
watercolor on paper
5³/₄ x 8⁷/₈
1986.92.31

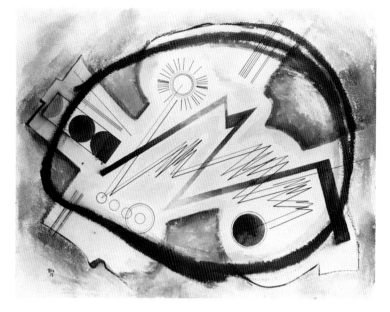

Zigzag
1937
watercolor and pencil on paper
15³/₈ x 19¹³/₁₆
1986.92.37

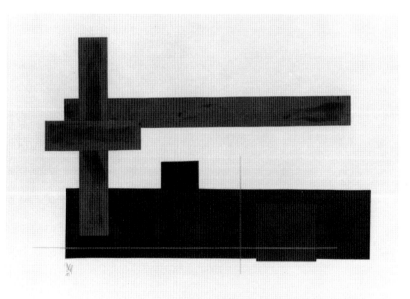

Collage for Film ''Contrathemis,'' Frame 590
1941
paper and crayon on paper
8¹/₂ x 11
1986.92.33

Drawing for Film "Contrathemis," Frame 2401
1941
crayon on paper
8½ x 11
1986.92.35

Collage for Film "Contrathemis," Frame 787
1941
paper and crayon on paper
8½ x 11
1986.92.34

In New York in the early 1940s, Grant was friendly with John Sennhauser, Jean Xceron, Irene Rice Pereira, and others associated with the Guggenheim Foundation. However, he did not become actively involved with either the American Abstract Artists or other organizations that provided an artistic or political forum for practicing artists. His own vision had developed independently, and although his paintings bear some resemblance to those of Kandinsky, his interest in balance and rhythm grew intuitively rather than as the result of a theoretical searching for new forms of expression.

1. Dwinell Grant, letter to Hilla Rebay, 24 July 1940, Dwinell Grant Papers, Archives of American Art, Smithsonian Institution, Washington, D.C.

2. For Grant's own description of the stage set and a newspaper clipping about the performance, see Grant's letter to Hilla Rebay, 5 May 1940, in Grant Papers, Archives of American Art. I am grateful to Marina Pacini and Judy Throm of the Archives staff for their assistance.

3. Dwinell Grant, letter to Hilla Rebay, 5 June 1940, Grant Papers, Archives of American Art.

Untitled
1938
pencil on paper
mounted on paperboard
7³/4 x 9⁷/8
1986.92.32

BALCOMB GREENE

(born 1904)

BALCOMB GREENE BEGAN HIS ART CAREER ONLY AFTER HE MARRIED GERTRUDE Glass in 1926. He had studied philosophy and psychology as a student at Syracuse University, and spent a year doing graduate work in psychology in Vienna. In 1927, the Greenes returned to New York, where Balcomb pursued advanced study in English literature. For the following three years, Greene taught English at Dartmouth College and wrote fiction. After the couple went to Paris for a year late in 1931, Greene began to experiment with painting. He worked independently at the Académie de la Grande Chaumière, but beyond this brief exposure to art school, he taught himself by frequenting the cafés of Paris and by looking at the new art to be seen in the French capital. He was fascinated with both Picasso and Matisse, but Juan Gris, Piet Mondrian, and the members of the *Abstraction-Création* group exercised special influence on Greene's development of a personal, artistic style.

In Paris, Greene quickly developed an acute analytical sense for modernism. After he and his wife settled in New York early in 1933, Greene published articles on art in *Art Front*, the magazine of the Artists' Union, as well as in several other publications. With his wife, he was active in several artists' organizations; in 1935 and 1936 he served as editor of *Art Front*, and he became the first chairman of the American Abstract Artists, a post to which he was twice reelected. In addition, Greene helped draft the group's charter, served on the editorial committee for the 1938 yearbook, and designed the cover for the first publication.

Until the WPA was formed in 1935, Greene made a precarious living writing for two sensationalist newspapers, *Broadway Brevities* and *Graft*.[1] After joining the WPA, he painted abstract murals for the Hall of Medicine at the 1939 New York World's Fair and for the Williamsburg Housing Project, and he designed a stained-glass window for a school in the Bronx. About 1940, Greene began working on a master's degree in art history at New York University. In 1942, he accepted a post at Carnegie Institute of Technology in Pittsburgh, where he taught art history until 1959. The Pittsburgh move did not mean cutting New York ties for the Greenes. The couple commuted between the two cities, and in 1947 purchased land at Montauk Point, Long Island, where they spent as much time as possible.

It was not until the 1950s that Greene began to exhibit with any frequency. He had shown his earliest paintings—admixtures of realism, fantasy, and incongruous stylistic elements—in Paris in 1932. His work was featured at J. B. Neumann's New Art Circle in 1947, and in 1950, Greene began exhibiting at the Bertha Schaefer Gallery in New York. By this time his painting had undergone a fairly dramatic stylistic shift. During the 1930s, Greene worked with angular, geometric planes, intersecting and overlaying color to create distinctive spatial configurations. Completely nonobjective, his forms often functioned as objects in space, their perspectives controlled through the juxtaposition of diagonal and rectilinear structure. Greene often worked out compositions by making small paper collages, such as the *Untitled* works identified as "34–8," "35–4," "35–7," and "39–03." Intended as preparatory studies, these collages represented a thinking-through process and lack the surface finish that characterized his oils.[2]

Around 1943, Greene again began using the human figure in his work. Although not conscious of Surrealist influences, Greene's odd merging of geometric space with organically abstracted human figures—evident, for example, in *Way Down Blue* of 1945—presents a distinctly Surrealist impression.[3] By the late 1940s, Greene began a clear transition to the figurative style for which he is now well known. Light entered his work as an abstract compositional device, as did a desire to reflect fundamental humanist concerns.

Way Down Blue
1945
oil on canvas
20 x 29 $^{15}/_{16}$
1986.92.44

Untitled (34–8)
1934
paper, gouache, watercolor,
and pencil on paper
6 5/8 x 8 5/16
1986.92.38

Untitled (35–4)
1935
paper, pencil, and gouache on paper
7 7/16 x 9 1/8
1986.92.39

Untitled (35–7)
1935
paper, pencil, and gouache on paper
8³⁄₈ x 6⁵⁄₈
1986.92.40

Untitled (35–14)
1935
paper on paper
7¹⁄₂ x 9
1986.92.41

Untitled
1936
paper and pencil on paper
mounted on paperboard
9 3/4 x 15 3/8
1986.92.42

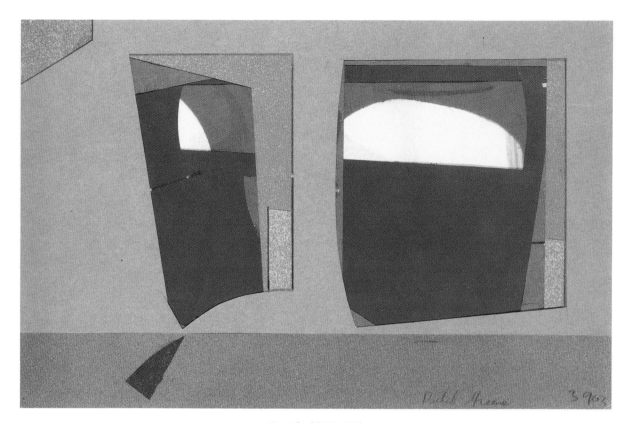

Untitled (39–03)
1939
paper and pencil on paper
7³/₈ x 11⁹/₁₆
1986.92.43

Beyond his involvement in artists' groups and his own paintings, Greene contributed significantly to the modernist cause through his eloquent and perceptive essays. He believed that the artist had a special gift for speaking directly to the individual:

> It is actually the artist, and only he, who is equipped for approaching the individual directly. The abstract artist can approach man through the most immediate of aesthetic experiences, touching below consciousness and the veneer of attitudes, contacting the whole ego rather than the ego on the defensive.[4]

He also argued specifically for a new language in art:

> Without denying that [the artist's] ultimate aim is to touch the crowd, he sees the futility of addressing it in the language commonly used by the crowd. He must employ his own language . . . in order to move, dominate and direct the crowd, which is his especial way of being understood. . . . The point in abstractionism, actually, is that the function of art and the means of achieving this function have been for the first time made inseparable.[5]

1. John I. H. Baur, "Balcomb Greene," in Balcomb Greene Papers, Archives of American Art, Smithsonian Institution, Washington, D.C., roll N658: 504.

2. Much of Greene's early work, along with his early manuscripts, was destroyed in a studio fire in 1941.

3. Baur, Green Papers, Archives of American Art.

4. Balcomb Greene, "Expression as Production," *American Abstract Artists: Three Yearbooks (1938, 1939, 1946)* (reprint, New York: Arno Press, 1969), p. 30.

5. Balcomb Greene, "Abstract Art at the Modern Museum," *Art Front* 2, no. 5 (April 1936): 8.

GERTRUDE GREENE

(1904–1956)

A POLITICAL LEFTIST AND SOCIAL ACTIVIST, GERTRUDE GREENE AVOIDED OVERT commentary in her art. Unlike Louis Schanker, Hananiah Harari, and others for whom art expressed societal concerns, natural forms, and structures, Greene looked to the purity of Mondrian and Russian Constructivists Antoine Pevsner, Naum Gabo, and Vladimir Tatlin for her artistic foundations.

Greene began studying sculpture at the Leonardo da Vinci School in New York in 1924. The curriculum at the Leonardo school paralleled the foundation classes at the National Academy of Design and other conservative art schools—students studied life drawing only after demonstrating proficiency in drawing from plaster casts. Greene's art interests carried over into the kindergarten she ran at the time; on rainy days, she took her young charges to the Brooklyn Museum where the students attempted to draw the sculpture and paintings.[1]

In 1926, Greene, née Glass, married Balcomb Greene. The young couple soon left for Vienna where Balcomb pursued graduate work in psychology. After a year abroad, they returned to New York via Paris, and in 1928, Balcomb accepted a teaching position at Dartmouth College in New Hampshire. During their three years in New Hampshire, the Greenes visited New York often. They frequented Gallatin's Gallery of Living Art and the newly opened Museum of Modern Art. This whetted Greene's appetite to see more vanguard art, and by late 1931, the couple had saved enough money to return to Paris.

Paris in the late 1920s and early 1930s offered remarkable opportunities for young artists seeking the avant-garde. Not only was the city the center for Cubism and Surrealism, but, with the formation of *Abstraction-Création, Art Nonfiguratif*, Constructivism was very much in evidence. The goal of this group, wrote sculptor Naum Gabo in the first issue of the eponymous publication, was the "cultivation of pure plastic art, to the exclusion of all explanatory, anecdotal, literary and naturalistic elements."

Greene, especially, became fascinated with the Constructivists' ideas about unifying art and politics—thoughts that grew out of their belief that when "purified," art would show the way for reordering society along higher planes. Even more than the theory, however, Greene was impressed with Pevsner's and Gabo's art, and began doing Constructivist drawings. After the Greenes returned to New York, Gertrude became active in leftist artists' organizations. She helped establish the Unemployed Artists' Group that was formed to lobby for federal support for unemployed painters, sculptors, and printmakers.

Throughout the 1930s, Greene's art progressed almost systematically toward geometrical purity. By 1935, the year the Museum of Modern Art presented excellent examples of work by Malevich, El Lissitzky, Rodchenko, Tatlin, and Pevsner in an exhibition entitled *Cubism and Abstract Art*, she herself had begun making constructions. Initially indicative of her appreciation for Jean Arp's work, Greene's constructions over the next two years moved between biomorphic and geometric abstraction. Increasingly, however, she began merging the two types of forms—one associated with Surrealism, the other with Constructivism—and after about 1940, a simple, geometric approach akin to Neo-plasticism and Constructivism predominated. As studies for these works, she began making paper collages that explored the merging of biomorphic and geometric form and experimented with layering as a spatial device.[2] Compared with the perfectly finished constructions, paper collages such as *36–09, 37–011, 37–015*, and *39–04* are more crudely cut and assembled, yet they offered a quickness and spontaneity not possible when working with wood.

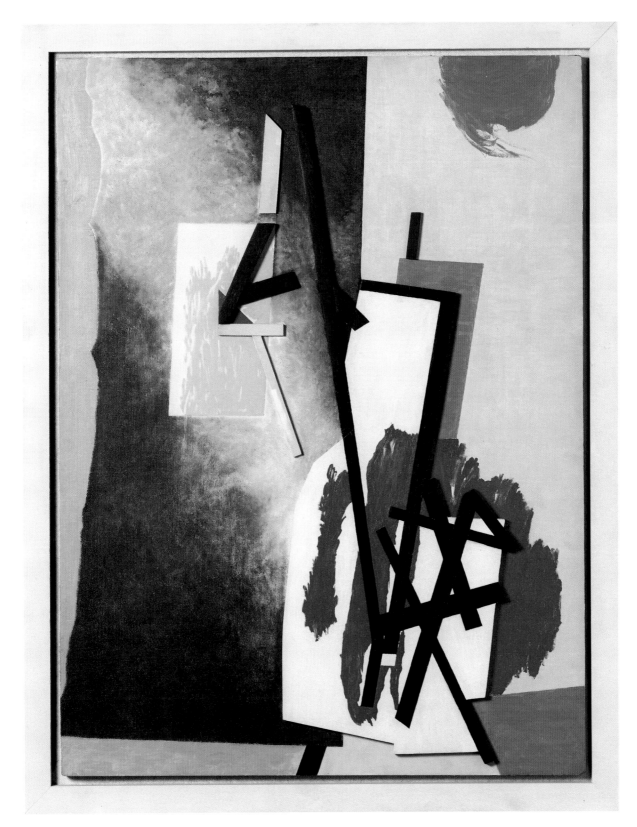

Construction 1946
1946
oil on wood and fiberboard glued to wood panel
40$\frac{1}{8}$ x 30$\frac{1}{8}$ x $\frac{5}{8}$
1986.92.50

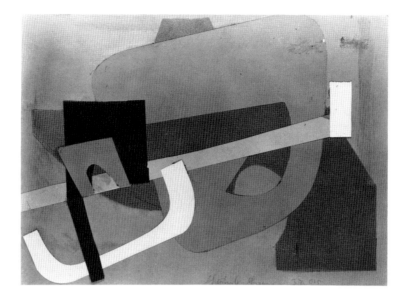

Untitled (37–015)
1937
paper on paper mounted on paperboard
9 x 12$^{11}/_{16}$
1986.92.48

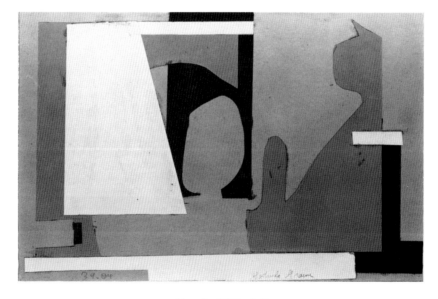

Untitled (39–04)
1939
paper and pencil on paper mounted on paperboard
7$^{3}/_{4}$ x 12
1986.92.49

Untitled (36–09)
1936
paper and pencil on paper
mounted on paper
12¹/₈ x 8
1986.92.46

Untitled (37–011)
1937
paper, pencil, and ink on paper
13⁵/₈ x 13¹/₂
1986.92.47

In her last constructions, such as *Construction 1946*, Greene began adding gestural areas of color. Although among her strongest and most original accomplishments, she put aside her relief constructions in favor of painting. Initially geometric, her paintings by the early 1950s became increasingly expressionistic. Her solo exhibitions, in 1951 and 1955, the first of her career, included only the late, gestural canvases.

In 1937, when the American Abstract Artists was formed, Greene was its first paid employee. She tended the desk at the Squibb Gallery exhibition in 1937, passing out questionnaires and answering the queries and jibes about the art that was featured in the first annual show. Her own work was also shown that year in the opening exhibition of the Museum of Non-Objective Painting.

Although she resigned her membership in the American Abstract Artists in 1942, only five years after the first exhibition, Greene did so in the belief that the group's mission had been largely accomplished. She had figured prominently in the group's programs and in promoting the purist point of view in arguments over the role of nature versus geometric purity in abstract art.

1. For additional biographical information, see Lynda Hyman, *Gertrude Greene: Constructions, Collages, Paintings* (New York: ACA Galleries, 1981).

2. Jacqueline Moss, "Gertrude Greene: Constructions of the 1930s and 1940s," *Arts Magazine* 55, no. 8 (April 1981): 123, reports that Greene destroyed many of her collages.

Untitled (36–07)
1936
paper on paper mounted on paper
8 x 12
1986.92.45

HANANIAH HARARI

(born 1912)

A NATIVE OF ROCHESTER, NEW YORK, HARARI BEGAN TO PAINT WHILE STILL A teenager. He studied first at the Rochester Memorial Art Gallery, and from 1930 to 1932 at the School of Fine Arts at Syracuse University. In Paris in 1932, he studied with Fernand Léger, André Lhote, and Marcel Grommaire. Through portrait commissions Harari was able to extend his stay on the city's Left Bank for several years. In Paris, Harari sought out Impressionist and Old Master paintings as well as modern works. He spent a year doing copy drawings from the collections of the Louvre. After a trip to Palestine, "where visual richness but little hard cash awaited him," he returned to the United States in 1935. Harari settled in New York City, and joined the circle of young abstractionists working on the WPA's mural project under Burgoyne Diller. For Harari, as for a host of others, the WPA experience provided unencumbered time to develop their art "in an environment of purpose and animation"[1]

After returning to New York, Harari became involved in the vanguard circle of the American Abstract Artists. Never a doctrinaire abstractionist, even in the early years of his career, Harari moved freely between abstraction and a lyrical expressionism that incorporated figurative elements. This is apparent in his *Sparklers on the Fourth* and *Jacob Wrestling with the Angel*. Harari was unwilling to relinquish the rich possibilities the natural world offered. Moreover, the strict avoidance of recognizable forms advanced by geometric abstractionist members of the American Abstract Artists (Ad Reinhardt for one), precluded expression of Harari's irrepressible wit. Their approach, he wrote,

> denied too much of art's potential and too many of its glories; in elevating neatness and order to a high altar, it failed to give adequate weight to the enriching concept of random upset (disorder, derangement, derailment)—a phenomenon abounding in all of life. I could not accept the idea that a formally pure art in and of itself denoted an evolutionary advance over an art of forms rooted in the natural world; to the contrary, I saw the former not leading forward, but, within its logic, veering toward a void.[2]

Within the American Abstract Artists, Harari was by no means alone in his unwillingness to renounce themes drawn from his experience of the world. In a letter to the editor of *Art Front*, drafted by Harari, and signed also by George McNeil, Byron Browne, Rosalind Bengelsdorf, Leo Lances, Herzl Emanuel, and Jan Matulka, the group declared: "It is our very definite belief that abstract art forms are not separated from life, but on the contrary are great realities, manifestations of a search into the world. . . ."[3] This desire to connect with the world at large is apparent not only in Harari's paintings but also in various letters to editors he wrote during this first decade of his career.[4] Social and political concerns, and a desire to educate those unfamiliar with modern art, color his philosophy about art's significance and potential. Several paintings from the late 1930s and early 1940s reflect his horror at the political oppression and social atrocities taking place in Germany.

Around 1939, Harari became fascinated with William Harnett, and began doing *trompe l'oeil* paintings. Several of these he also executed according to a Cubist vocabulary. A 1939 painting entitled *Man's Boudoir*, a *trompe l'oeil* painting of a table top with the accoutrements of a man's toilette that won the first Hallgarten Prize at the National Academy of Design's 1942 annual exhibition, has, as a pendant, a Cubist version of the same subject.[5]

Throughout Harari's work there is whimsy and wit, and an abiding desire to express a *joie de vivre*. *Sparklers on the Fourth* was made from sketches done during the summer of 1940 when Harari, his wife, and several friends were celebrating Independence Day. "It was a mild night.

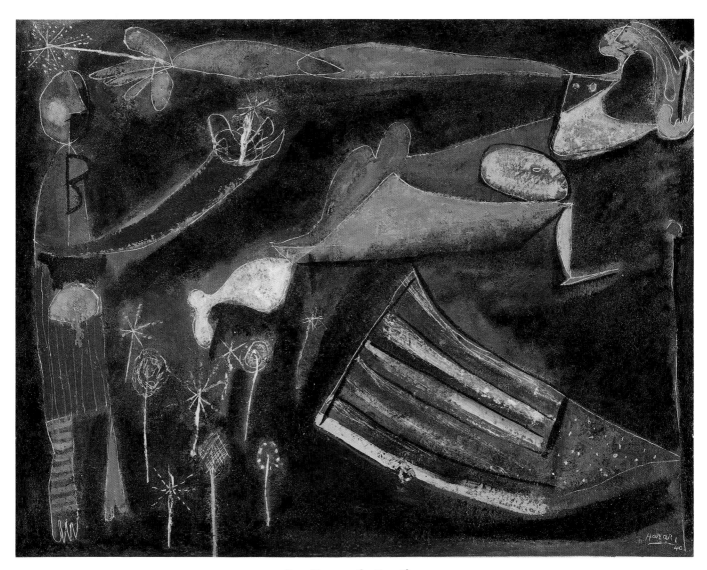

Sparklers on the Fourth

1940

oil on canvas

26 x 34

1986.92.55

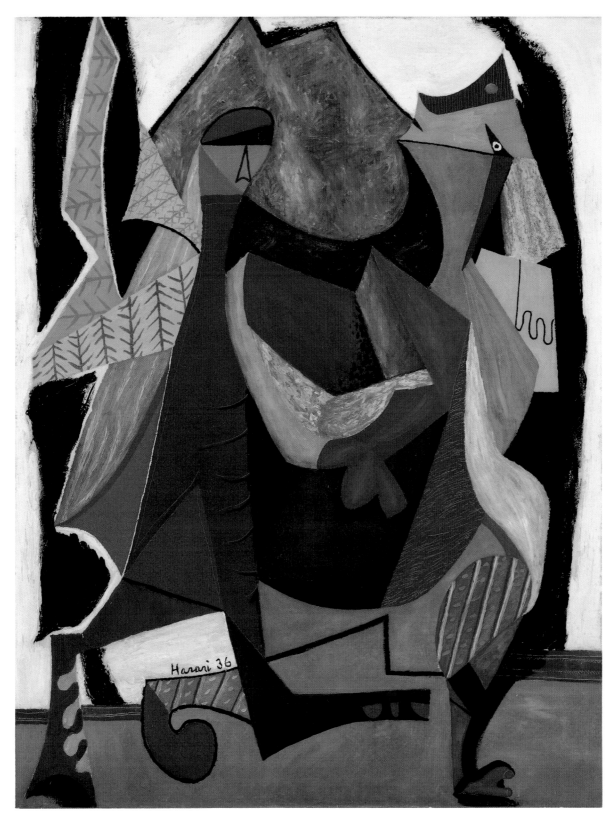

Jacob Wrestling with the Angel
1936
oil on canvas
47¼ x 36¼
1986.92.52

Interior with Statue
1935
pen and ink on paper
13 x 9 9/16
1986.92.51

Weather Vanes
1937
paper, ink, and gouache on paper
mounted to paperboard
10 7/8 x 7 3/4
1986.92.54

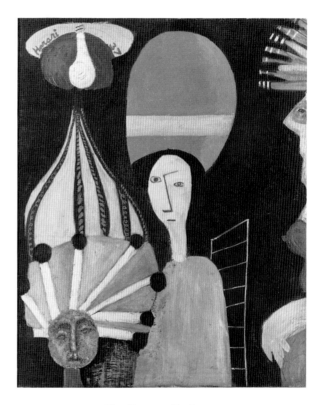

The Beauty Parlor
1937
oil on canvas
32 x 26
1986.92.53

The national flag was raised in the center of the lawn. The brilliant lights of the pyrotechnics pierced the darkness and illuminated the flag and my companions, who, abandoned themselves to the occasion and engaged themselves in running spontaneously about while holding the blazing sparklers in their hands, thus etching streaks of light against the night. . . . This scene had in it magic and beauty"[6] In the painting, Harari captures the light that pierced the dusky night. Laying dark pigment over a white ground, he etched into the painting's surface, using the whiteness of the ground to illuminate the nocturnal scene.

In 1943, Harari was inducted into the army, and at that time he ended his association with the American Abstract Artists. An active, early member of the group, Harari's artistic interests after the war no longer coincided with the group's program.

1. Hananiah Harari, "WPA—AAA," handwritten reminiscence of his experience on the WPA provided by Harari, in the curatorial files, National Museum of American Art, Smithsonian Institution, Washington, D.C.

2. Ibid.

3. "To the Editors," *Art Front* 3, no. 7 (October 1937): 20–21.

4. See "Who Killed the Home Planning Project?" *Art Front* 3, no. 8 (December 1937): 13–15.

5. For illustrations of both versions of *Man's Boudoir*, see Greta Berman and Jeffrey Wechsler, *Realism and Realities: The Other Side of American Painting* (New Brunswick, New Jersey: Rutgers University Art Gallery, 1981), p. 173.

6. Hananiah Harari, letter to Walter Baum, February 1946, courtesy of the artist, copy in the curatorial files, National Museum of American Art.

JEAN HÉLION

(born France 1904)

OF THE EUROPEANS WHO EXERTED FIRSTHAND INFLUENCE ON AMERICAN abstract artists of the 1930s, Hélion is among the most significant. A Frenchman who studied chemistry and architecture before taking up painting, Hélion's involvement in artists groups dates from the late 1920s. He was a founding member of *Art Concret* and played a prominent role in *Abstraction-Création*. Moreover, he helped (with his fluent command of English) to bring Americans working in Paris during the early 1930s together with the continental artists who were influential in shaping European modernism.

Hélion and Jean Xceron became friends as early as 1929. The association began after Xceron wrote an article about Hélion for the Paris edition of the *Chicago Tribune*. Xceron summarized Hélion's view that art should correspond with the mechanical and industrial age.

In 1932, on the occasion of his marriage to an American, Hélion first visited the United States. Although the couple settled near his wife's family in Virginia, Hélion paid frequent visits to New York. As a leading, if still youthful, member of the Parisian vanguard, Hélion exhibited in New York with increasing regularity over the next ten years. Between visits to Europe, Hélion encouraged Carl Holty, Harry Holtzman, and George L. K. Morris to form an artists' group, and his third extended trip to New York during the winter of 1936–37 coincided with the formal organization of the American Abstract Artists.

Hélion became especially well known for his close knowledge of European art and his articulate views on abstraction. He wrote regularly for advanced art magazines, served as editor of the first five issues of the *Abstraction-Création* journal, played a significant role in the British publication *Axis*, and wrote, or edited, major portions of the 1933 catalogue for Gallatin's Gallery of Living Art. More than most artists, Hélion's attachments were broad. He was friendly with School of Paris artists, yet maintained close contacts with Dutch, Russian, and British movements as well. But it was New York that held the greatest fascination for him. For Hélion, it was the only city that had a true modern spirit, and when he came in 1936, he intended to remain. Yet in January 1940, four months before the Nazis conquered France, he left to join the French army. Six months later Hélion was taken prisoner and interned in a camp near the Polish border. After a dramatic escape, the artist made his way to Paris, and eventually met up with Marcel Duchamp, Tristan Tzara, and others in Marseilles. In October 1942, he finally arrived in the United States where, to aid the Free French, he lectured widely on his war experiences and wrote a bestseller entitled *They Shall Not Have Me*.

Hélion had originally encountered Cubism through Joaquin Torres-Garcia around 1927. Afterwards, his art went through several transformations of style. For instance, his work from about 1929 to 1932 (the *Orthogonale* series) shows his appreciation for the planar severity of Theo van Doesburg and Russian Constructivism. By 1935, flattened space in his work gave way to hard-edged, fully modeled machinelike forms, suspended in colored fields. Increasingly, intuition became important to Hélion, and a number of works, such as the *Untitled* watercolor of 1939, present organic forms with surrealist overtones. Before embarking for France in 1940, however, Hélion not only did outline drawings for several large abstractions, he also planned numerous projects for figurative paintings as well. After the grueling experience of war, he concentrated on the figurative work. Hélion returned to New York in 1944, but the following year he settled permanently in Paris, and his period of close contact with the New York art world came to an end.

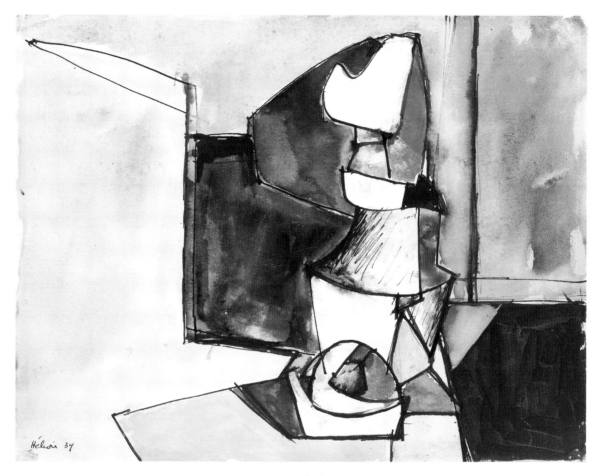

Untitled
1939
watercolor, gouache,
and pen and ink on paper
9⅝ x 12⅝
1986.92.60

From advice when Gallatin came to Paris on buying trips, to his relative success in exhibiting, Hélion's influence on the New York scene took many forms. David Hare said that Hélion represented "something . . . lacking in this country. The artist as intellectual—as accepted intellectual with a role in society. . . . He was very secure in what the artist's role was. . . . Hélion represented what the avant-garde artist could be, perhaps should be, in relation to his society. . . . He took his individuality extremely seriously. . . . It gave the Americans . . . a lot of confidence, to see somebody who has lived this way all his life and taking it as a matter of course. . . ."[1]

1. Quoted in Merle Solway Schipper, "Jean Hélion: The Abstract Decade," *Art in America* 64 (September–October 1976): 92.

FANNIE HILLSMITH
(born 1911)

A NATIVE OF BOSTON, FANNIE HILLSMITH BEGAN SKETCHING AS A TEENAGER. IN 1930, she enrolled in the Boston Museum School, which her grandfather, Frank Hill Smith, had helped found.[1] At the time, first-year students had to draw daily from casts of antique sculpture before being eligible to enroll in painting and drawing classes. However, the following year, Rodney J. Burn and Robin Guthrie from the Slade School in London took charge of the curriculum. Under their progressive leadership, students could begin to draw from life after spending a month or two drawing from antique sculpture. Despite this freer academic regime, Hillsmith encountered European modernism only after she completed the four-year course in Boston and spent a year in New York at the Art Students League. Her teachers at the league, Alexander Brook, Yasuo Kuniyoshi, John Sloan, and William Zorach, augmented her earlier academic training. But it was from contact with Vaclav Vytlacil, other progressive New York artists, and especially her study of Albert Gallatin's collection at the Gallery of Living Art, that Hillsmith was drawn to vanguard ideas. Paul Klee's paintings made a special impression on her, and by the late 1930s, Hillsmith began incorporating lyrical line and simplified, childlike forms into her own work.

The mid 1940s marked Hillsmith's emergence as an exhibiting artist. In 1943, she had her first solo exhibition at Jimmy Ernst's Norlyst Gallery. Peggy Guggenheim featured her work in three exhibitions at Art of This Century shortly thereafter. In 1944, Clement Greenberg singled out her painting *Imprisoned* as "perhaps the best thing" in Guggenheim's "Spring Salon for Young Artists," a show that also presented work by William Baziotes, Irene Rice Pereira, Robert Motherwell, Jackson Pollock, and Richard Pousette-Dart. In the summer of 1945, Josef Albers invited Hillsmith to teach at Black Mountain College. Finally, her inclusion in Sidney Janis's 1944 book, *Abstract and Surrealist Art in America*, heralded Hillsmith's arrival as a mature painter. In a statement for Janis's book, Hillsmith explained her artistic intentions: "I endeavor to find a personal way to express in painting the basic qualities of nature. I try to combine the structural with the intimate and to secure simplicity by using few colors and shapes, to acquire variation by using these in diverse ways throughout the canvas."[2]

In 1946, Hillsmith began a four-year association with Stanley William Hayter's Atelier 17. She worked beside Joan Miró, Yves Tanguy, Jacques Lipchitz, and other émigrés from war-torn Europe at the studio. Along with developing expertise in the techniques of printing, Hillsmith turned increasingly to the fractured space of Cubism, drawing particularly from the work of Juan Gris. Increasingly, Hillsmith used Cubist elements to create emotional effects, and after 1950, nostalgia, dreams, and interior realities became her primary concerns. "I am interested in abstract art, but I am also interested in the message—the problem is to convey feeling with the impact of the abstract."[3]

During the 1960s, Hillsmith began making constructions, an interest that grew out of the toys and jewelry she made during World War II to supplement her income. In the constructions and box assemblages she first undertook in the 1970s, the dream world of her paintings takes three-dimensional form. Reminiscent of doll houses, the boxes contain tiny ceramic furniture; walls are sometimes transparent, and Hillsmith uses mirrors to disorient the viewer.

The surreal overtones of these recent works, coupled with the disjunctive approach to space, are culminations of Hillsmith's longstanding ability to use Cubist formal elements to psychologically provocative ends.

1. The information here is drawn primarily from Doris A. Birmingham, "The Art of Fannie Hillsmith," in *Fannie Hillsmith* (Manchester, N.H.: Currier Gallery of Art, 1987).

2. Fannie Hillsmith, statement in Sidney Janis, *Abstract and Surrealist Art in America* (New York: Reynal and Hitchcock, 1944), p. 100.

3. Quoted in Birmingham, np.

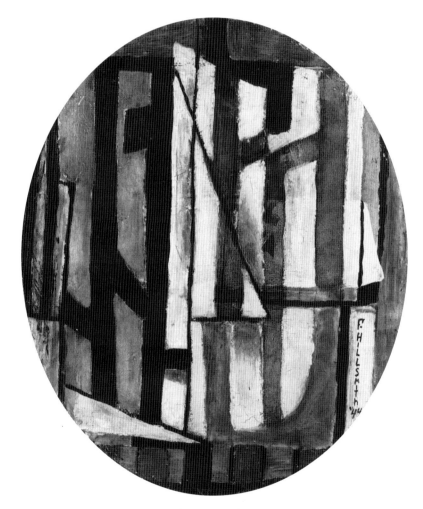

Imprisoned
1944
oil and tempera on fiberboard
12½ x 10½
1986.92.57

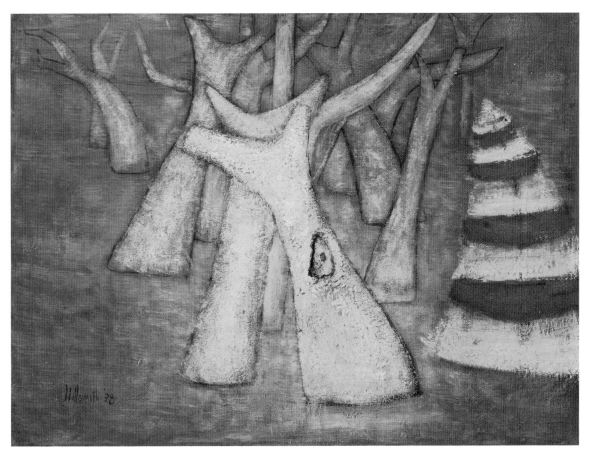

Winter Trees
1938
oil and tempera on canvas
12 x 16
1986.92.56

HANS HOFMANN

(1880 Germany–1966 USA)

IN 1966, A MONTH BEFORE HIS DEATH, HANS HOFMANN DESCRIBED HIS PROCESS of painting in these words:

> When I paint, I paint under the dictate of feeling or sensing, and the outcome all the time is supposed to say something. And that is most often my sense of nature . . . it might suggest landscape and might only suggest certain moods, and so on but this must be expressed in pictorial means, according to the inner laws of these means. Only this is acceptable as art.[1]

Hofmann was both an intuitive painter and a man with a profound understanding of modernism. He insisted on the importance of an analytical understanding of the means of painting. His ideas on art developed initially during his years in Paris. From 1904 to 1914, he knew Matisse, Picasso, Braque, and Delaunay. He frequented the Café du Dôme, where artists congregated to discuss not only ideas about art, but new theories of the universe, from Einstein's theory of relativity to Bergson's notion that movement and constant change are basic characteristics of reality.[2]

Hofmann grew up in Munich. As a gymnasium student, he excelled in music, science, and mathematics. At sixteen, as an assistant to the director of public works in Bavaria, his engineering skills became apparent. He invented a radar device for ships, a sensitized light bulb, and a portable freezer unit for use by military forces.[3] With a thousand marks as a gift from his proud father, Hofmann enrolled in art school. Soon he had encountered Impressionism, and discovered the Secession Gallery in Munich. The support of a patron allowed him to go to Paris. He attended evening classes at the Colarossi Academy and at the Académie de la Grande Chaumière. Hofmann became close friends with Jules Pascin and Robert Delaunay, whose theories on color seeded Hofmann's own ideas about color and form. At this time, Hofmann was painting Cubist still lifes, landscapes, and figurative pieces, and his work was included in group exhibitions at the New Secession Gallery in 1908 and 1909.

Hofmann went home for a visit in 1914. When World War I prevented his return to Paris, he opened his school for modern art in a Munich suburb. During the war years, Hofmann became closely acquainted with Kandinsky's work.[4] Following the war, young Americans began to flock to Hofmann's school. Carl Holty, Worth Ryder, Glenn Wessels, Vaclav Vytlacil, and others studied in Munich or attended his summer classes in Bavaria, France, and Italy.[5] In the summer of 1930, at the invitation of Worth Ryder, Hofmann taught at the University of California, Berkeley. He spent the next winter in Germany, and the following spring returned to teach in Los Angeles (at the Chouinard School of Art) and at Berkeley, where he wrote the first version of *Creation in Form and Color: A Textbook for Instruction in Art*. In 1932, he moved to New York. He taught for a year at the Art Students League, where his students included Burgoyne Diller, Harry Holtzman, and George McNeil. The following year he opened his New York school, and in the summer of 1935 began annual summer sessions in Provincetown, Massachusetts. In 1958, at age seventy-eight, Hofmann finally gave up teaching to concentrate full time on painting.

It would be virtually impossible to overestimate Hofmann's importance as a teacher. Over half the original members of the American Abstract Artists were Hofmann students. Many second generation Abstract Expressionists worked with him as well. He provided scholarships to those unable to pay full tuition, and frequently allowed students to work for him in exchange for instruction. Whether or not they attended his classes, many artists knew of Hofmann's ideas. An essay entitled "Plastic Creation" was published in the Art Students

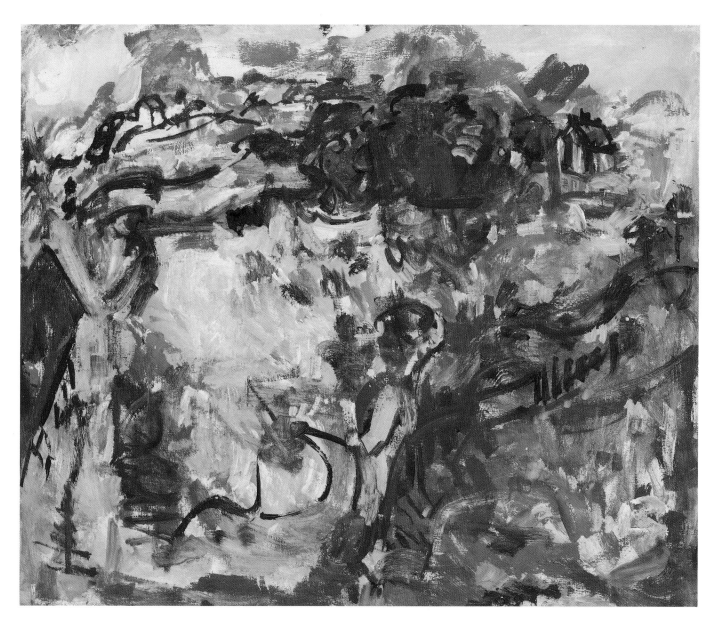

Afterglow
1938
oil on fiberboard
30 x 36
1986.92.58

League magazine during the winter of 1932–33, and a series of six lectures given during the winter of 1938–39 was attended by Jackson Pollock, Arshile Gorky, Willem de Kooning, Clement Greenberg, and Harold Rosenberg.[6]

In his teaching, as in his art, Hofmann advocated nature as a starting point. He had students draw from life and from carefully arranged still-life set-ups to learn the importance of formal and spatial relationships. Although he promoted no style (many of his students were for years vague about Hofmann's own art), many understood not only modernism, but Renaissance and Baroque art for the first time through Hofmann's explanations.[7] He considered drawing a critical precursor to painting, yet his emphasis on color, rather than perspective, as a determiner of space within a picture plane, lay at the heart of his ideas about art. For Hofmann, the artist worked to express the tension between three-dimensional form and the two-dimensional surface of the canvas. Yet in his own painting, he himself denied theory and method, and relied only on empathy.[8] Hofmann defined empathy as "the imaginative projection of one's own consciousness into another being or thing. In visual experience, it is the intuitive faculty to sense qualities of formal and spatial relations or tensions, and to discover the plastic and psychological quality of form and color."[9]

Hofmann's career as a teacher for many years disrupted his own work as an artist. From 1927 until 1935, he concentrated primarily on drawings—landscapes and figure sketches that reflected his early familiarity with Cubism. He began painting seriously again in 1935, and during the following decade landscapes, portraits, still lifes, and interior scenes were translated into highly expressionistic, energetic canvases. During the summers, especially, when Hofmann held sessions in Provincetown, he returned to landscapes such as *Afterglow* (1938). Subsequently, Hofmann began to pour and splatter paint, and increasingly exploited the accidental in his search for spontaneous expression.

Despite his renown as a teacher, it wasn't until 1944, at Peggy Guggenheim's Art of This Century Gallery, that Hofmann had his first solo exhibition in the United States. There he became part of the emerging New York School, and was friendly with Pollock, Robert Motherwell, William Baziotes, Clyfford Still, and Mark Rothko. From that time on, Hofmann exhibited widely. The Addison Gallery of American Art organized a large retrospective of his work in 1948. In 1957 another was mounted at the Whitney Museum of American Art.

Although Hans Hofmann never joined the American Abstract Artists, he encouraged its membership and sent a letter of support when the organization was formally established. Yet, through his students, who represented not only a significant number of the membership, but an important counterbalance to the geometric formalists, Hofmann's influence within the group was remarkable.

1. Irma B. Jaffe, "A Conversation with Hans Hofmann," *Artforum* 9, no. 5 (January 1971): 35.

2. For an in-depth discussion of Hofmann's Paris years, see Ellen G. Landau, "The French Sources for Hans Hofmann's Ideas on the Dynamics of Color-Created Space," *Arts Magazine* 51, no. 2 (October 1976): 76–81.

3. An excellent chronology of Hofmann's life can be found in Cynthia Goodman, *Hans Hofmann* (New York: Abbeville Press, 1986), pp. 117–19.

4. According to Carl Holty, when Kandinsky went to Russia in 1914 and due to the war was unable to return to Munich, Hofmann had charge of the paintings Kandinsky had left behind; interview with Nina Wayne, Archives of American Art, Smithsonian Institution, Washington, D.C., roll 670.

5. Cynthia Goodman, in "Hans Hofmann As a Teacher," *Arts Magazine* 53, no. 8 (April 1979): 120, writes "Among earliest memories of the Munich school are those of Vaclav Vytlacil. When he and Ernest Thurn enrolled, either late autumn 1921 or early spring 1922, the classes were held in a small dingy and poverty-ridden single studio . . . [in a] rather dismal building. . . . Glenn Wessels . . . tutored Hofmann in English every day before class in exchange for tuition. . . ."

6. Typescripts of these lectures can be found in the Karl Knaths Papers, Archives of American Art, roll 433: 1317–1465.

7. Hofmann often illustrated his lectures with diagrams of the compositional structure and movement in paintings by Piero della Francesca, Giotto, and Rembrandt, as well as Cézanne, Picasso, Braque, and other moderns.

8. Goodman, *Hans Hofmann*, p. 113.

9. Quoted in Dorothy Seckler, "Can Painting Be Taught?," *Art News* 50, no. 1 (March 1951): 63. The writings of Wilhelm Worringer, a German philosopher and psychologist, became meaningful for artists during the early years of the twentieth century.

CARL HOLTY

(1900 Germany–1973 USA)

CARL HOLTY WAS BORN IN FREIBURG, WHERE HIS FATHER WAS ATTENDING medical school, but before he was a year old, the family moved to Milwaukee. As a teenager Holty took art classes, and by age sixteen was submitting cartoons to a local antiwar paper. In 1919, hoping to become a poster artist, Holty studied briefly at the school of the Art Institute of Chicago. Shortly thereafter, he left for New York, where he enrolled at Parsons School of Design and subsequently at the National Academy of Design. In 1923, he returned to Milwaukee to pursue a career as a portraitist. Three years later he left with his new bride for Munich, planning to study at the Royal Academy. Instead, he ran into his friend Vaclav Vytlacil, who convinced Holty to join Hans Hofmann's school. Holty's ideas were immediately transformed: "No one had ever talked to me about conceptual drawing, about knowing what I'm looking at from the point of view of my tactile knowledge as well as my visual knowledge. Hofmann did. And the world opened up just like that."[1]

In 1927, with his wife suffering from tuberculosis, the Holtys moved to Switzerland. Although his study with Hofmann had been short-lived, the two kept in touch, and Holty began to assimilate Hofmann's teaching into his art. After the death of his wife in 1930, Holty moved to Paris, where Robert Delaunay sponsored his membership in *Abstraction-Création* two years later. Holty's curvilinear abstractions were published in the group's magazine in 1933. Nevertheless, his artistic aims were more closely allied with Cubism than with Neoplasticism, and he disengaged himself after a year. His canvases of the early 1930s, which reflect a close knowledge of Juan Gris's paintings and Picasso's Synthetic Cubism, were shown in several exhibitions in Paris to positive critical reviews. When Holty returned to New York in 1935, he soon found a New York dealer.

In New York, Holty became immersed in vanguard art circles and renewed his friendships with Hans Hofmann, Vaclav Vytlacil, and Stuart Davis, whom he had known in Paris. Vytlacil invited Holty to participate in the discussions that led to the formation of the American Abstract Artists. An articulate spokesman with extensive firsthand knowledge of European modernism, Holty was immediately drawn into the group, and subsequently became its chairman. He remained a member until 1944, when he felt the organization had fulfilled its purposes.

In his own art, Holty had begun to stray from the spatial and conceptual format of Cubism. Instead, biomorphic shapes that seem to move freely over the entire surface of the canvas indicate a fascination for the images, if not the ideas of Miró. Increasingly, however, his earlier concern for structure reemerged to harness the still active rhythms of his compositions. In his abstractions, Holty did not seek to eliminate references to the natural world. He used titles— *Of War, Circus Forms, Gridiron*—as reference points or to set a mood. The form of a kneeling figure holding a ball can be discerned, for example, in *Gridiron*. During the 1930s, Holty began using tape to give crisp edges to form, and in *Gridiron*, which he reworked and overpainted before arriving at his final statement, the sharpness and clarity of this approach is especially apparent.

By the mid 1940s, Holty had been creating abstract paintings for many years, yet he continually searched for new ways to render form within the two-dimensional picture plane. He described one discovery in words that echo Hofmann: "In breaking up the shapes or forms, it is

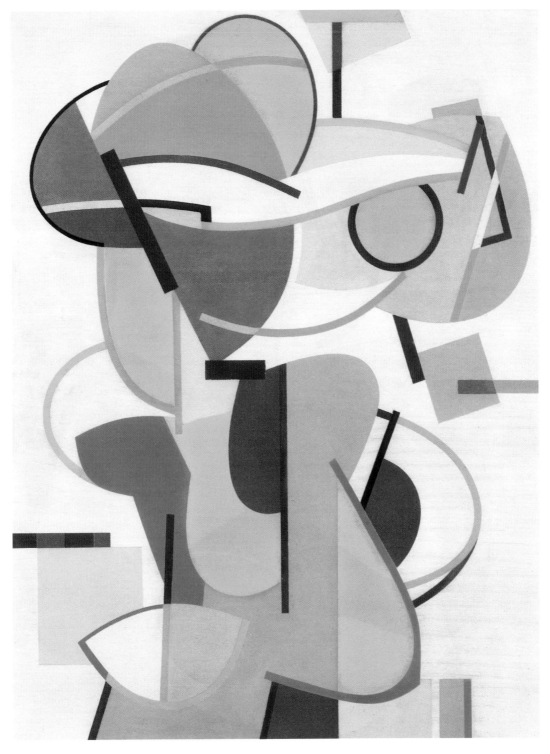

Gridiron
1943–44
oil on fiberboard
48 x 36
1986.92.59

imperative not to attempt to rejoin them because that leads to transformation only. By breaking them and keeping them broken, the forms, large and small, are simply densities in the rhythmic movement of color and shapes."[2]

By the 1960s, Holty had put aside his concern for tactile form within dimensional space. Contours disappeared, replaced by thinly washed, fluid areas of color swimming within subtly toned space.

1. Quoted in Patricia Kaplan, *Carl Holty: Fifty Years, A Retrospective Exhibition* (New York: The City University of New York, 1972).

2. Carl Holty, letter to Hilaire Hiler, 25 May 1944, in Carl Holty Papers, Archives of American Art, Smithsonian Institution, Washington, D.C., roll 670: 347.

RAYMOND JONSON

(1891–1982)

RAYMOND JONSON WAS A LEADER OF THE TRANSCENDENTAL PAINTING GROUP, an organization of artists formed in New Mexico in 1938. Devoted to nonrepresentational painting, the group aspired "to stimulate in others, through deep and spontaneous emotional experiences of form and color, a more intense participation in the life of the spirit."[1] The search for an artistic approach that went beyond descriptive realism concerned Jonson for most of his life. His early training, first at the school of the Portland, Oregon, art museum in 1909, and during the following three years at the Academy of Fine Arts in Chicago, provided a solid technical foundation from which he began more experimental work. When the 1913 Armory Show opened in Chicago, Jonson was especially impressed with Wassily Kandinsky's paintings. Kandinsky's book, *On the Spiritual in Art*, later provided a framework for Jonson's own ideas about the spiritual purpose of painting.[2]

Between 1913 and 1920, Jonson worked as the graphic art director of the experimental Chicago Little Theater and taught at the Chicago Academy of Fine Arts.[3] In 1919, he received a fellowship to the MacDowell Colony in New Hampshire, which for the first time in his life allowed him to concentrate his full energies on painting for four months. The real turning point in his career, however, came three years later, during a summer visit to Santa Fe. Fascinated with the land and with American Indian design, he resolved to return, and in 1924, moved permanently to New Mexico.

Even before he left Chicago, Jonson had begun a series of paintings entitled *Earth Rhythms*, based on drawings done during his trip. In these paintings he explored the geologic structures of the Southwest in distinctly modernist terms. After his move, he did hundreds of sketches of the hills, mesas, and the eroded landscape, to acquaint himself spiritually with the forms, shapes, and rhythms of New Mexico.[4] His subsequent paintings reflect a dual commitment to the spiritual fulfillment he found in the land and to formal pictorial concerns: "I have always felt that there should be a governing sense of arrangement, that is, that a composition usually should have order and most often a simple basic motif of spaces, an interesting variety of shapes and spaces, a balance of line direction."[5] In the *Earth Rhythms* series, as well as in paintings of cliff dwellings, the Grand Canyon, and other Southwest landscape motifs, Jonson transformed nature's elements into highly geometric, rhythmic harmonies.

In 1931, Jonson began a series of abstractions based on letters of the alphabet which he called *Variations on a Rhythm*. "In only a few of them," he wrote, "is there any connection with the so-called natural. They are entirely different from the *Earth Rhythms*. Most of them are entirely abstract except in that they do carry on an established rhythm indicated by the particular letter. . . . A – H – I are entirely independent of landscape."[6] In *Variations on a Rhythm—H*, which he selected to illustrate the brochure for his 1932 exhibition at the Studio Gallery in Chicago, hard-edged, architectonic forms exist in illusionistic space. Despite Jonson's contention that the painting was independent of the landscape, vegetal forms in the lower right corner are residual reminders of Jonson's deeply felt connection to the land.

Late in 1931, Jonson made an extended trip to New York where he exhibited at the Delphic Studios. Afterward, he remarked not on the Gallatin Collection, or on the move by younger artists toward abstraction, but on paintings by Arthur Dove, Georgia O'Keeffe, and John Marin, whose landscape-based abstractions seemed consonant with his own feelings.[7]

In 1934, Jonson began teaching at the University of New Mexico. With Willard Nash, he did a series of murals under the auspices of the Public Works of Art Project, and later became one of the artists not on relief employed by the WPA.

With the formation of the Transcendental Painting Group in 1938, Jonson was in the company of artists who shared similar views about the universal significance of art. They recognized the validity of various stylistic approaches as long as the work was nonrepresentational. In a statement of purpose, they commented that some members achieved the transcendental through "more occult and metaphysical" means, while others painted from "an intuitive emotional awareness," or even a more "scientific or intellectual balancing of elements." Whatever their personal inclinations, each sought an art that was "vitally rooted in the spiritual need of these times. . . ," one that expressed "most truly creative, fundamental and permanent impulses emerging in the American continent."[8]

Throughout his life, Jonson sought order and unity in his work. Whether abstracted from nature or entirely nonobjective, his paintings, he said, were "contrasts to the environment in which they exist." He continued,

> Around us we have realism, strife, pain and greed. I wish to present the other side of life, namely the feeling of order, joy and freedom. By setting up my own plastic means I can at least thrill to the attempt of establishing some fundamental principles that are universal and enduring.[9]

1. "Statement of Purpose," Transcendental Painting Group, 1938, in Raymond Jonson Papers, Archives of American Art, Smithsonian Institution, Washington, D.C. I am grateful to Margaret Morse, National Museum of American Art 1988 intern, for her thorough research on Raymond Jonson.

2. In 1932, Jonson wrote to his brother Arthur that Kandinsky "is one of if not the foremost worker in the abstract. . . . If I could buy a modern work and had my choice of all I would, I believe, choose a Kandinsky"; letter dated 5 December 1932, Jonson Papers, Archives of American Art. Jonson also explored the idea put forth by Kandinsky and others that colors could have symbolic meaning. In the *Digits* series, begun in 1929, each color represented a specific emotion: violet suggested the spiritual, red the physical, etc. See Van Deren Coke, "An Interview with Raymond Jonson," in *Raymond Jonson: A Retrospective Exhibition* (Albuquerque: University of New Mexico Press, 1964), p. 9.

3. Van Deren Coke, "Interview," p. 8. B. J. O. Nordfelt was also an important influence for Jonson. They first met about 1911 in Chicago, and resumed their friendship after Jonson moved to Santa Fe. Although they developed very different approaches to art, Nordfelt's experimental outlook and understanding of modernist art expanded Jonson's own ideas.

4. Kay Aiken Reeve, *Santa Fe and Taos, 1898–1942: An American Cultural Center* (El Paso: Texas Western Press, 1982), p. 10.

5. Diary entry, 9 January 1923, quoted in *Raymond Jonson: Abstract Landscape, 1922–1947* (Albuquerque, N.M.: Jonson Gallery of the University Art Museum, 1988).

6. Raymond Jonson, letter to Arthur Jonson, 29 August 1935, Jonson Papers, Archives of American Art, roll RJ1: 453.

7. In January 1933, Jonson recommended Arthur Dove, Georgia O'Keeffe, John Marin, and Willard Nash for an exhibition at the California Palace of the Legion of Honor. He wrote to Agnes Pelton (26 September 1933) that the exhibition of Arthur Dove's work he had seen at Alfred Stieglitz's gallery during his New York trip "remains one of the high spots for me. I sort of see them as a fine addition to ourselves. . . .," Jonson Papers, Archives of American Art, roll RJ4: 2568-2569.

8. Statement of Purpose, Transcendental Painting Group, 1938.

9. Van Deren Coke, "Interview," p. 10.

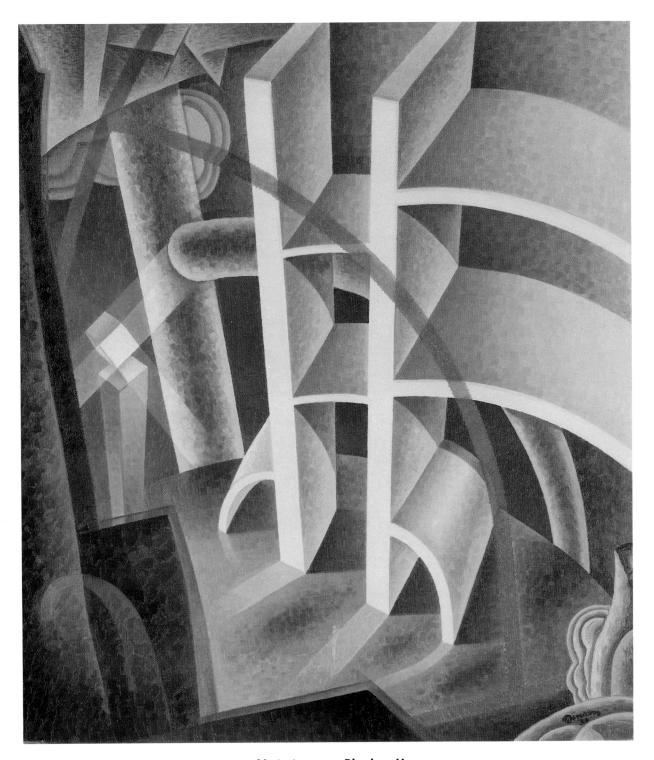

Variations on a Rhythm—H

1931

oil on canvas

33⅛ x 29

1986.92.61

GEROME KAMROWSKI

(born 1914)

GEROME KAMROWSKI ENTERED THE ST. PAUL, MINNESOTA, SCHOOL OF ART in 1932. There he studied with Cameron Booth and Leroy Turner, both former Hans Hofmann students who were also associated with the *Abstraction-Création* group in Paris. It was Cameron Booth or Turner who introduced Kamrowski to a "kind of expressionist cubism."[1] By 1935, while employed by the WPA, Kamrowski was working in a Synthetic Cubist style, as evidenced by his mural for Northrup Auditorium at the University of Minnesota.

In 1937, Kamrowski left for Chicago to study under Laszlo Moholy-Nagy and Alexander Archipenko at the New Bauhaus. There he was exposed to the role of nature in art and the "geometric basis of natural form."[2] Intrigued by Moholy's wit, Kamrowski commended him for being more than simply a "formalist-constructivist."[3] The following year, Kamrowski received a Guggenheim fellowship to attend Hans Hofmann's summer school in Provincetown, Massachusetts. From there, he went to New York, where he met William Baziotes, who was experimenting with Surrealism. Their growing friendship reinforced a fascination with Surrealism that had begun while Kamrowski was still a student in Minnesota. Before coming to New York, Kamrowski had read the Surrealist publication, *Minotaure*, and he had seen the Museum of Modern Art's exhibition, *Fantastic Art, Dada and Surrealism*, when it toured to Minneapolis. With Baziotes he shared an interest in Surrealist automatic writing, and both explored its potential in their paintings.[4] Kamrowski was especially attracted by Surrealism's appeal to intuition rather than the intellect; Surrealists, he said, offered "a certain aspect of humanism . . . that brought out a more comprehensive scheme than just the narrow, professional attitude towards form which Hofmann would try to present."[5]

Kamrowski himself was interested in the energy generated by the act of painting. He believed his work to be "essentially process, instead of representing a high, spiritual state which nonobjective art aspires to." As apparent in *Spectral Images* of 1944, he sought a process that "binds all things together . . . a kind of cosmic rhythm," which Cubism seemed to restrict.[6] He used Surrealist motifs and forms as liberating elements in his painting, but at the same time he emphasized their abstract qualities.

In 1942, Surrealist artist Matta (Echaurren) attempted to form a group of artists to investigate new applications for Surrealist methods. He invited Kamrowski, along with William Baziotes, Jackson Pollock, Peter Busa, and Robert Motherwell to join. Like Kamrowski, the others were more interested in process than in subject matter—the foundation of Matta's art—and the group soon dissolved.

Given the anti-Surrealist stance of the American Abstract Artists, Kamrowski seemed an unlikely member. Nevertheless, he joined the group in 1937 while working at the Chicago Bauhaus, and continued his membership for two years after moving to New York. In the group's exhibitions, he showed canvases inspired by Cubist principles, a style he continued to employ even after turning to Surrealism. Hilla Rebay, at the Museum of Non-objective Painting, provided support for Kamrowski based on these works. Realizing that Rebay would withdraw Kamrowski's much-needed financial assistance if she knew of his Surrealist inclinations, he continued to make Cubist paintings, and exhibited the Surrealist works anonymously. These were the paintings that subsequently brought him acclaim.[7] By 1950, his success with Surrealism prompted André Breton to remark: "Of all the young painters whose evolution I have been able to follow in New York during the last years of the war, Gerome Kamrowski is the one who has impressed me far the most by reason of the *quality* and

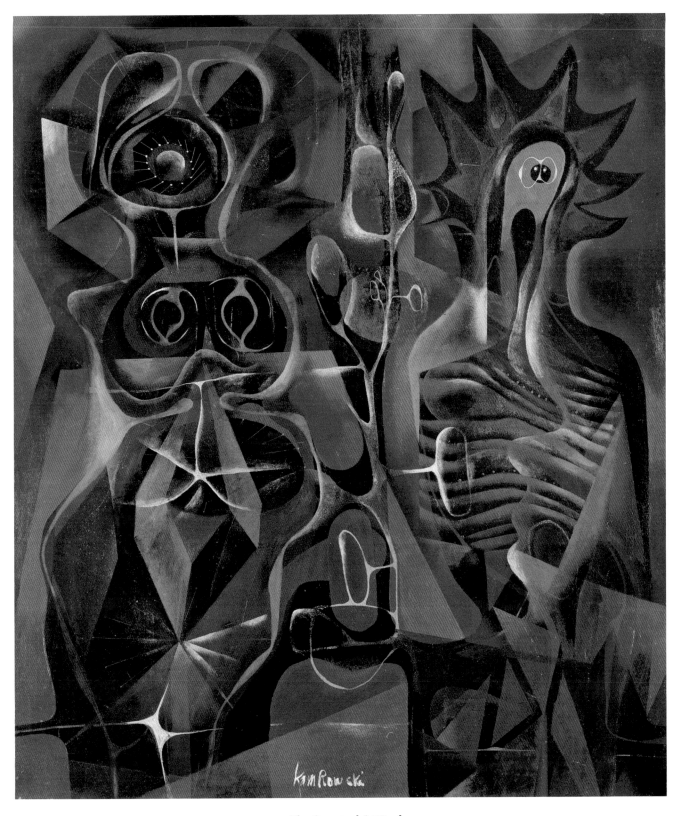

The Spectral Attitudes
1941
oil on canvas
35 x 30
1986.92.62

sustained character of his research. Among all the newcomers there, he was the only one . . . tunnelling in a new direction. . . ."[8]

During the 1950s and 1960s, Kamrowski's interest in Surrealism waned. Leaning towards abstraction, he began exploiting the expressive power of paint and the brilliant color and rich textures that are now the hallmarks of his style. A member of the faculty of the University of Michigan since 1946, Kamrowski continues to teach and to paint in Ann Arbor.

1. Quoted in Martica Sawin, "The Third Man," *Art Journal* 43, no. 3 (Fall 1988): 183.

2. Sawin (p. 183) attributed Kamrowski's interest in natural form to his reading of D'Arcy Thompson's *On Growth and Form* (1917) while he was studying at the Chicago Bauhaus.

3. Ibid.

4. Kamrowski subsequently described Baziotes' introducing Jackson Pollock to automatic writing in Kamrowski's studio. The three artists collaborated on a painting using automatic techniques. Both the painting and Kamrowski's letter describing the encounter are reproduced in Jeffrey Wechsler, *Surrealism and American Art, 1931–1947* (New Brunswick, N.J.: Rutgers University Art Gallery, 1977), pp. 55, 68.

5. See Kamrowski, interview with Evan M. Maurer and Jennifer L. Bayles, in *Gerome Kamrowski: A Retrospective Exhibition* (Ann Arbor: University of Michigan Museum of Art, 1983), p. 1.

6. Ibid., p. 2.

7. Sawin, p. 183.

8. André Breton, *Surrealism and Painting*, trans. Simon Watson Tayler (New York: Harper and Row, 1972), p. 226.

KARL KNATHS

(1891–1971)

KARL KNATHS, WHO LIVED IN PROVINCETOWN, MASSACHUSETTS, FROM 1919 until his death in 1971, was one of the first Americans whose work found its way into Albert Gallatin's Gallery of Living Art. By virtue of his residence away from New York, Knaths was never an active member of the American Abstract Artists. Nevertheless, his affiliation brought distinction to the group. Knaths was older than many of the group's members, and exhibited in New York to generally positive reviews from about 1930 on (although he once remarked that except for Duncan Phillips's annual purchase, he did not sell a single painting for twenty-three years).[1] Recognized as an important modernist, he had the valuable support of Duncan Phillips. Over the years Phillips bought many of Knath's paintings and frequently invited him to lecture at the Phillips Collection in Washington. In October 1945, Knaths exhibited in a group show at the Paul Rosenberg Gallery. The following January, he had the first of twenty-two solo exhibitions—almost one each year—until his death twenty-five years later.

Originally from Eau Claire, Wisconsin, in 1912 Knaths entered the school of the Art Institute of Chicago where he remained for five years. From there he went to New York, and later settled in Provincetown. In 1922, three years after his move to Cape Cod, he married Helen Weinrich, a pianist, whose sister Agnes was a Paris-trained abstract painter, and built the house that would be his home for the remainder of his life. During the winters, the Knaths and Weinrich usually spent a month in New York; but Europe, which attracted so many of Knaths' colleagues, failed to lure him from his beloved Provincetown.

Yet, in his lecture notes, and in a manuscript for an unpublished book entitled *Ornament and Glory*, Knaths' thorough understanding of modernist tenets as well as the principles of Renaissance and subsequent European art is apparent.[2] His papers contain typescripts of Hans Hofmann's lectures and writings by Mondrian, Malevich, Kandinsky, and other important theorists of modernism. Yet of all the artists whose work he knew well, the strongest parallels to Knaths' work come with Cézanne's late paintings. Both artists blended an intuitional understanding of structure with motifs drawn from observed nature. For his subject matter, Knaths drew repeatedly from his Provincetown surroundings: deer in landscape settings, clamdiggers returning from work, fishing shacks, boats in the harbor, still lifes of duck decoys and fishing paraphernalia. But Knaths also found inspiration in American folklore and literature, and did paintings of Johnny Appleseed, Paul Bunyan, and Herman Melville's Ahab.

Knaths was one of the most theoretically inclined painters of his generation. He agreed with Kandinsky that "there are definite, measurable correspondences between sound in music and color and space in painting: specifically, between musical intervals and color intervals and spatial proportions."[3] Knaths worked out intricate charts for color and musical ratios, which he used to determine directional lines and proportions in his paintings. Like Hofmann, he believed that "whatever is to be realized by the painting should arise through the use of pictorial elements in a thematic way. The surface being the prime element, it is possible to manipulate full spaciousness within its flat terms. . . ."[4]

At some point, Knaths discovered Wilhelm Ostwald's color system. Based on color and not on light, the Ostwald system was devised as a way of ordering color, and was quite popular among American artists of the time. Knaths not only used this system, he harnessed it to a complex set of mathematical and geometrical relations—akin to musical proportions—so that the theoretical foundations of his art were both complex and highly worked out.

In his paintings, whether sketchy, experimental works like the *Untitled* gouache, circa 1939–40, or in more highly ordered canvases, Knaths remained true to the artistic principles he began to develop early in his life.

1. Paul Richard, "Conflict of Colors: Karl Knaths at the Phillips Collection," *The Washington Post*, 11 September 1982, C-1.

2. An edited transcription of Knaths' *Ornament and Glory* that includes facsimile reproductions of about half the manuscript pages was published in Jean and Jim Young, *Ornament and Glory: Theme and Theory in the Work of Karl Knaths* (Annandale-on-Hudson, N.Y.: Edith C. Blum Art Institute, Milton and Sally Avery Center for the Arts, The Bard College Center, 1982).

3. Lloyd Goodrich, *Karl Knaths* (New York: Whitney Museum of American Art, 1959).

4. Karl Knaths, "The Problem of a Painter," *Ornament and Glory*, p. 35.

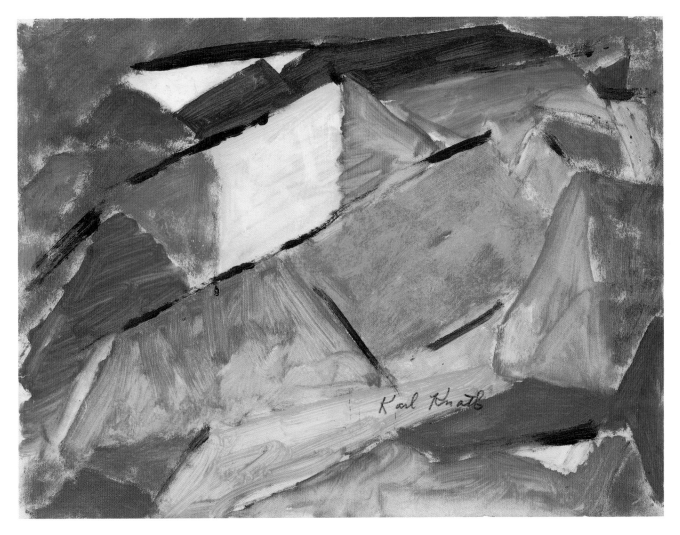

Untitled
ca. 1939–40
gouache on paper
12 x 16
1986.92.63a

IBRAM LASSAW

(born Egypt 1913)

IBRAM LASSAW CAME FROM EGYPT TO NEW YORK AS A CHILD. HE STUDIED AT the Clay Club from 1926 to 1930, and at the Beaux Arts Institute of Design in New York in 1930 and 1931. Yet he was haunted by the work of Jacques Villon, Sophie Taeuber-Arp, and Wassily Kandinsky that he saw in an exhibition of Katherine Dreier's famed Société Anonyme collection at the Brooklyn Museum in the winter of 1926–27. His turn to abstraction in the early 1930s began with Constructivist drawings. However, it was the English language version of Moholy-Nagy's *The New Vision*, and several articles on "Universal Architecture" by Buckminster Fuller, that gave Lassaw a framework for understanding the new art.[1] To Lassaw, Moholy-Nagy's book was important less for its philosophical stance than for its illustrations of the tactile experiments conducted at the Bauhaus that suggested new materials and new sculptural processes.[2] Fuller "opened up . . . new perspectives" for Lassaw because he discussed the similarities between architectural design and such natural systems as trees and the human body.[3]

Lassaw's early abstract sculptures, which were modeled in clay and then cast in plaster, explored biomorphic shape and open form. Since that time, whether in constructions of metal and Plexiglas or in his brazed and welded pieces, the interpenetration of form in space has remained one of his abiding concerns. During the mid 1930s, Lassaw worked briefly for the Public Works of Art Project cleaning sculptural monuments around New York City. He subsequently joined the WPA as a teacher and sculptor until he was drafted into the army in 1942.

Much of Lassaw's experimentation during the 1930s focused on process—finding appropriate methods to express dual respect for space and "truth to materials." He gave up plaster work as too fragile for open-form sculpture. He briefly tried liquid latex, which for a variety of reasons, including its smell, was unsatisfactory. With Gertrude Greene, he bought a forge and tried hammering steel, but found the results excessively two-dimensional.

About 1937 he began constructing sculpture. From an old refrigerator motor he improvised brazing tools and began to build frameworks with iron rods. To these structures, which he painted, he connected carved white wooden shapes. In the 1938 annual exhibition of the American Abstract Artists, he showed a series of shadow boxes, shallow wooden containers holding plaster-coated wire, mesh, and free-form organic shapes that were lighted with electric bulbs. In these works, Lassaw sought a formal balance between geometric and organic form. But when he showed a steel and plastic sculpture entitled *Intersecting Rectangles* in the 1941 American Abstract Artists exhibition, Piet Mondrian encouraged him to proceed along Neo-plastic lines. During the next several years, Lassaw experimented with geometric, Constructivist spatial configurations, often combining steel with plastic and Lucite. Yet, while each approach offered intriguing possibilities, none enabled Lassaw to work freely and intuitively. A breakthrough came for him in 1950. In a sculpture entitled *Milky Way*, he dripped melted plastic over a wire armature. Although neither aesthetically pleasing nor durable, *Milky Way* nonetheless set the stage for Lassaw's future direction.

During World War II, Lassaw had learned to weld, and in 1951, when he sold his first piece of sculpture, he bought oxyacetylene welding equipment. Following the direction of *Milky Way*, he welded rods into open-form architectonic structures, then encrusted the surfaces with droplets of metal. By using different alloys within the same piece, Lassaw achieved remarkable variations in color, which he also enhanced through chemical treatment. With sculpture such as *The Hyades* (1951), Lassaw found methods and materials that integrated biomorphic and geometric form while satisfying his need to work freely and intuitively.

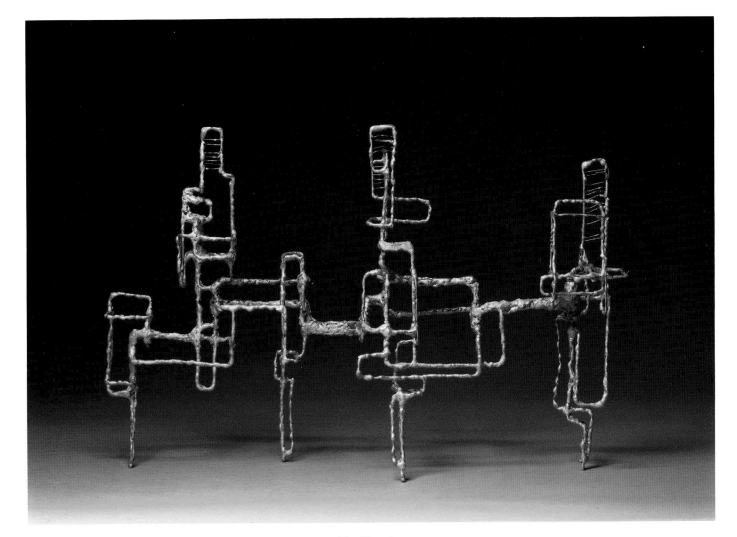

The Hyades
1951
bronze
13³/4 x 21¹/2 x 6¹/2
1986.92.64

Lassaw once remarked that all artists have ancestors. In his own work, he claimed affinities with the sculpture of Julio Gonzalez, Naum Gabo, Antoine Pevsner, Vladimir Tatlin, Jacques Lipchitz, Joan Miró, and others. Unlike many of his fellow members of the American Abstract Artists who deplored Surrealism as formally backward, Lassaw borrowed freely from Miró, especially during the mid 1930s. During this time, he also assigned neutral titles to his work—*Composition with Light*, for example, or *Three Biomorphic Forms*. In 1944, he first used the names of astronomical phenomena, Zen precepts, and Jungian terms, suggesting evocative, often cosmic, allusions.

Lassaw was a founding member of the American Abstract Artists and continues to show with the group. He was also a founding member of the Club. Despite his involvement with these and other groups, and his frequent inclusion in group shows, it was not until Samuel Kootz had seen his work at the Whitney that Lassaw had his first solo exhibition (1951). In the following years, Lassaw emerged as one of the most provocative and significant artists of the century. He has exhibited frequently, and his sculpture has received wide-ranging, positive critical attention.

1. Lassaw had begun reading extensively, trying to understand what he had seen. Clive Bell's and Roger Fry's books, other volumes of art history and aesthetics, and works in science, astronomy, cosmology, and human anatomy all contributed to his growing understanding of the new art forms. See Ibram Lassaw, "Perspectives and Reflections of a Sculptor: A Memoir," *Leonardo* 1, no. 4 (October 1968): 351–61. This article, in which Lassaw describes his artistic evolution, fascination with materials, and the myriad philosophical and artistic sources that fueled his ideas, is one of the few times Lassaw discussed his work in print.

2. Lassaw discussed the importance of the tactile element and its source in Moholy-Nagy's book in an interview with Irving Sandler, 26 August 1968, Archives of American Art, Smithsonian Institution, Washington, D.C.

3. See Nancy Gale Heller, "The Sculpture of Ibram Lassaw" (Ph.D. diss., Rutgers, The State University of New Jersey, 1982), pp. 61–63. Heller's dissertation is a thorough and articulate analysis of Lassaw's sculpture and ideas.

ALICE TRUMBULL MASON

(1904–1971)

ALICE TRUMBULL MASON BECAME A STAUNCH ADVOCATE OF NONOBJECTIVE art early in her career, and throughout her life she believed in its truthfulness over representational art. Born to an affluent family in Litchfield, Connecticut, Mason was a descendant of the American painter John Trumbull. Her mother had studied art in Paris in the 1880s, and her sister had studied with Fernand Léger and Hans Hofmann. In 1921 and 1922, Mason studied at the British Academy in Rome. Upon her return to New York in 1924, she entered Charles Hawthorne's classes at the National Academy of Design. Mason's artistic conversion came, however, as a student of Arshile Gorky at the Grand Central Art School from 1927 to 1931. Though his own work was not yet abstract, Gorky introduced Mason to the analytical aspects of Cubism and the spiritual approach of Kandinsky. During a trip to Italy and Greece in 1928, Mason was profoundly affected by Byzantine mosaics and archaic Greek sculpture. She admired the mosaics for their use of plastic elements and materials as expressive devices. She especially noted the use of line to generate motion and gilded tesserae to enhance the stylization of the line, qualities she adopted in her own untitled mosaic of 1941.[1]

In 1929, when Mason was on the brink of making abstract paintings, her mother died. Her mother's death sparked a transition to abstraction in her work, as a "form of transferred or secularized spirituality."[2] Abstraction for spiritual content did not become a predominant concern for Mason; instead she emphasized the potential of the medium to create meaning in her work:

> We look for nothing mystical or dream-like but the magic in the work itself. Abstract art demands an awareness of the intrinsic use of materials and a fuller employment of these means which build a new imaginative world by using them for their own potential worth.[3]

Mason's work from the 1930s and early 1940s shows an artist still coming to terms with a personal style. She occasionally borrowed Miró's meandering line and Kandinsky's amorphous color areas. She used line and color with a freedom reminiscent also of Arthur Dove's paintings. Her works of this period, while few in number, are emotionally expressive and evocative of nature and natural phenomena. After her marriage and the birth of her two children, Mason found very little time for painting. Instead she turned to poetry for self-expression and to literature, particularly French symbolism, for intellectual stimulation. She did, however, become a founding member of the American Abstract Artists and exhibited in its first annual exhibition. An active member into the 1960s, she served as treasurer in 1939, secretary from 1940 to 1945, and in the early 1960s, was president of the group. Among her close friends in the organization were Ilya Bolotowsky, whom she had known from student days at the National Academy, Ibram Lassaw, George McNeil, Esphyr Slobodkina, and Balcomb and Gertrude Greene. She also maintained close ties with Albert Gallatin, George L. K. Morris, and Charles Shaw. It was Gallatin who organized her first solo exhibition in 1942 at the Museum of Living Art.

In her article for the American Abstract Artists 1938 yearbook, entitled "Concerning Plastic Significance," Mason contended that the expressive potential of medium was the most important element within an abstract work of art. She also argued against Surrealism for its reliance on dream imagery and use of materials as "props for narrative."[4] In her own work she explored the relationship of biomorphic forms and expressive line.

During the mid 1940s, Mason's paintings reflected a new admiration for Mondrian's work. She credited Mondrian, who had arrived in the United States in the fall of 1940, with inspiring

her to abandon biomorphism and adopt "straight-edged" shapes.[5] Under his influence, she developed theories about "displacement" and "four-way balance," apparent in her increasing decentralization of image and use of an all-over compositional approach.[6]

In 1958, after the sudden death of her son, Mason became increasingly introspective. Her works retained a cool intellectuality but became more reductive. She turned toward an expressionist style, remaining steadfast in her rejection of representational imagery and in her belief in the primacy of plasticity.

1. Alice T. Mason, "Concerning Plastic Significance," *American Abstract Artists: Three Yearbooks (1938, 1939, 1946)* (reprint, New York: Arno Press, 1969), pp. 19–20.

2. Marilyn Brown, *Two Generations of Abstract Painting: Alice Trumbull Mason and Emily Mason* (New York: Eaton House Publishers, 1982), p. 18.

3. Alice T. Mason, interview with Ruth Gurin, 1964, Archives of American Art, Smithsonian Institution, Washington, D.C.

4. Mason, "Concerning Plastic Significance," p. 20.

5. Alice T. Mason, interview with Virginia Pitts Rembert, 1 December 1969, in "Mondrian, America, and American Painting" (Ph.D. diss., Columbia University, 1970), pp. 213–14.

6. See Alice Trumbull Mason Papers, Archives of American Art, roll 630: 169. I am grateful to Emily Mason for permission to use Alice Mason's papers.

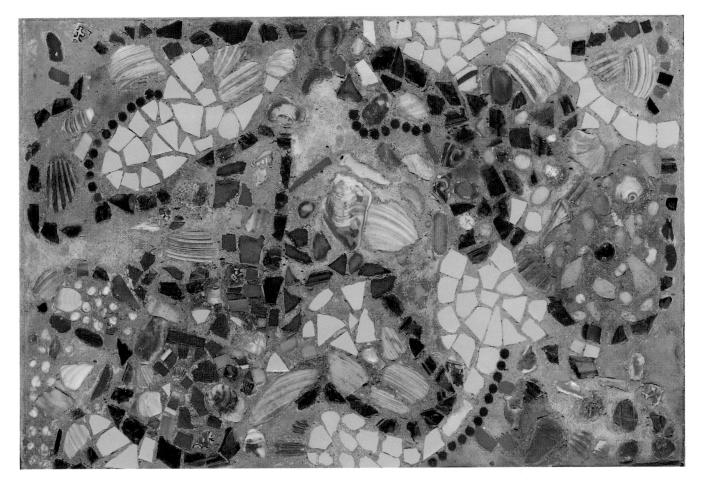

Untitled Abstraction
1941
mosaic of shells, stones, ceramic tiles,
and glass embedded in concrete
13³/₈ x 19¹/₂
1986.92.65

GEORGE McNEIL

(born 1908)

GEORGE McNEIL HAS DESCRIBED HIS ARTISTIC APPROACH DURING THE 1930s AS "a dialogue, not a conflict, between art freedom and control, between an intuitive, painterly evocation of images, and the thoughtful ordering of pictorial elements into abstract form." Attracted to Expressionism while a student at Pratt Institute in the late 1920s, McNeil developed an interest in Cézannesque structuralism and Cubist rationalization of space under Jan Matulka's tutelage at the Art Students League in 1930.[1] When Hans Hofmann joined the league faculty in 1932, McNeil entered his class; and when Hofmann left to establish his own school, McNeil followed.

It was about this time, McNeil later said, that "without any conceptual awareness of what I was doing, I learned the life premise of modern art, that energies seen in nature could be transformed into their pictorial equivalent, that paintings could assume a life of their own."[2] *Figural Composition #2*, painted while McNeil was a Hofmann student at the league, is evidence of McNeil's immediate recognition of the implications of Hofmann's artistic ideas. Following closely on the heels of a group of distinctly Cubist paintings, *Figural Composition #2*, in which a figure is barely discernible within loosely brushed rectangles of color, predates Hofmann's own efforts in this direction by several years.

Despite his precocious beginning, during the 1930s McNeil alternated between two very different artistic approaches, one structural and Cubist, the other free, figurative Expressionism. Only later did he realize that the decade for him was marked by simultaneous attempts "to embrace formal *and* expressionist art values." Like many of his contemporaries, he worked for the WPA, but left the project in 1940 to do war-related work in a factory. In the war years he entered the Teachers College of Columbia University and in 1943 received a master's degree.[3] After two years in the navy, McNeil secured, with John Opper's help, a teaching position at the University of Wyoming in Laramie. Although he had not painted for almost six years, McNeil stepped easily back into the two directions he had previously explored. At the same time McNeil recognized that he would probably begin to synthesize the two concerns in the future. In 1948, McNeil returned to New York and began teaching at Pratt Institute, where he is now professor emeritus. Although he continued as a member of the American Abstract Artists until 1956, he grew increasingly distant from the organization.

The mid 1950s was a fertile time for McNeil's art. His ideas crystallized and he found a way to synthesize the competing impulses that had formed the major part of his work. He began to work spontaneously, without "undue concern for balance, unity and other structural elements."[4] Building from a figural basis, he aimed to make his forms "plastically and psychologically alive by having lines, shapes and colors bounce with energy."[5] His new paintings, which were exhibited frequently at Charles Egan's gallery and later with the Poindexter Gallery, were well-received critically, but did not sell. Yet, McNeil continued to push the bounds of his art, knitting image and space into energetic unities of paint.

This new found figurative Expressionism was not the last transformation to overtake McNeil's work. In the early 1970s, his images became disturbing expressions of anxiety, psychological shock, and other troubling states of mind. His most recent paintings—still

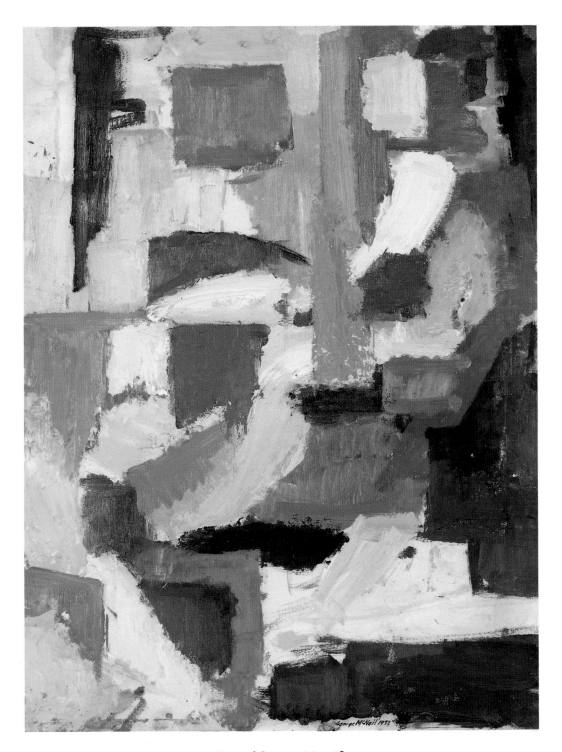

Figural Composition #2
1932
oil on paper mounted on wood
25 x 19
1986.92.68

dramatic, figurative-based, and filled with energetic color and line—ameliorate angst with wit, and attest to McNeil's restless search for ever more powerful expressive means.

1. McNeil first became seriously interested in European modernism when he attended Vaclav Vytlacil's lecture series given at the Art Students League in the winter of 1928–29. When he left Pratt Institute, before enrolling at the Art Students League, he took time off to study by himself at the Metropolitan Museum of Art. He drew from Greek marbles and from casts of the Parthenon sculpture. There he met Arshile Gorky, who was also copying Greek masterworks. The encounter with Gorky further cemented his conviction to pursue modernism. (I am grateful to George McNeil for discussing his work and the early years of the American Abstract Artists; see videotape interview, 29 November 1988, National Museum of American Art, Smithsonian Institution, Washington, D.C.)

2. George McNeil, "One Painter's Expressionism," in *George McNeil: Expressionism, 1954–1984* (New York: Artists' Choice Museum, 1984), p. 8.

3. He received an Ed.D. degree from Columbia in 1952.

4. McNeil, "One Painter's Expressionism," p. 8.

5. Ibid., p. 9.

LASZLO MOHOLY–NAGY

(1895 Hungary–1946 USA)

LASZLO MOHOLY-NAGY CAME TO THE UNITED STATES IN 1937 TO DIRECT THE New Bauhaus, an experimental school in art and design that was being established in Chicago. A prolific writer, as well as one of the most fertile experimental artists of his time, Moholy-Nagy was a painter, photographer, filmmaker, builder of light-space machines, teacher, and philosopher of new aesthetics. He believed that art offered a way to reorder society after the traumatic years of World War I, and he looked especially to technology to pave the way.

By 1937, when Moholy-Nagy accepted the directorship of the New Bauhaus, he was well known in the United States—through the exhibition of his work at various New York museums, through his book *The New Vision* (the English language edition of which appeared in 1930), and through the various articles he had published in *Cahiers d'Art*. On arriving in Chicago, Moholy-Nagy wrote his wife Sybil of the "strange town . . . it is no culture yet, just a million beginnings." Just two weeks later, Chicago captivated him: "There's something incomplete about this city and its people that fascinates me; it seems to urge one on to completion. Everything seems still possible. The paralyzing finality of the European disaster is far away."[1] Although the New Bauhaus failed for lack of financial support, in January 1939 he opened the School of Design (later called the Institute of Design), which was specifically "founded on the principles and educational aims of the Bauhaus."[2]

At first the School of Design's financial struggle seemed constant. But, it soon affiliated with the Illinois Institute of Technology, and Moholy-Nagy remained at the helm until his death from leukemia in 1946. Ironically, that was the year that returning servicemen on the GI Bill finally brought economic stability to the institution.[3]

A Hungarian, Moholy-Nagy served as an artillery officer during World War I. In 1918, he received a law degree from the University of Budapest and four years later met Bauhaus founder Walter Gropius. Gropius was impressed with the young Hungarian's art and his progressive ideas about its potential for improving society. Gropius invited Moholy-Nagy to replace Johannes Itten, who had resigned as director of the *Vorkurs* in 1923. Josef Albers was already there, teaching the experimental preliminary course, when Moholy-Nagy arrived.

Moholy-Nagy joined the Bauhaus at a moment of heated debate over the school's program. Gropius envisioned the Bauhaus as a school of industrial design, in which the arts and industry would merge. In his plan, students would contribute to improving the modern world by designing beautiful, functional objects that could be easily and inexpensively produced. New materials, made possible by technological advances, would be used for architectural design as well as for functional objects, and contribute to raising the standard of life for mankind.

However, not everyone within the Bauhaus was comfortable with these ideas. Itten disagreed with Gropius and left; Lyonel Feininger also opposed Gropius's promotion of the industrial arts. Nonetheless, the Bauhaus offered rich and exciting possibilities, and its faculty in 1926 included some of the most innovative thinkers of the day—Herbert Bayer, Walter Gropius, Marcel Breuer, Wassily Kandinsky, and Paul Klee, as well as Josef Albers, Lyonel Feininger, and Moholy-Nagy. Moholy-Nagy joined the proponents of the unification of art and industry, and with Walter Gropius, edited a series of fourteen books that defined the philosophical framework for the Bauhaus program.[4]

In 1928, in the face of increasing political pressure from outside, both Moholy-Nagy and Gropius resigned. Moholy-Nagy moved to Berlin, where he did stage design for the State

Opera, the Piscator Theatre, and experimented with photography, film, and innovative graphic design. He spent 1934 doing advanced work with color film and photography in Amsterdam. The following year, he moved to London, where, in addition to making films, he published three volumes of documentary photographs. In 1935, he began making light-space modulators—three dimensional "paintings" on transparent plastics, in which moving light sources cast changing shadows on etched and colored surfaces.

Moholy-Nagy's early paintings reflected his youthful interest in German Expressionist painting. In the early 1920s, he met Kurt Schwitters and Paul Klee, and explored Dadaism. It was his contact with Russian Constructivism, though, that fueled both the style his art would take and his ideas about art's role as a vehicle for social change. Moholy-Nagy, like Gropius, saw the machine as potentially dehumanizing and argued that the artist was uniquely capable of ameliorating its harmful potential. Yet Moholy-Nagy took an essentially positive view of technology. He believed it offered opportunities for changing the world through mass production, distribution, and communication. He further believed that since art is rooted in society, the artist had a deep and abiding responsibility to address social issues. He saw the artist as a visionary—one who would provide the forms and ideas necessary for the understanding of future societies:

> We need Utopians of genius to foreshadow the existence of the man of the future, who, in the instinctive and simple, as well as in the complicated relationships of his life, will work in harmony with the basic laws of his being."[5]

In 1939, Ilya Bolotowsky invited Moholy-Nagy to join the American Abstract Artists, and he accepted with pleasure. Although he was unable to attend meetings or actively participate in the group's activities, Moholy-Nagy exhibited annually and contributed a lengthy essay entitled "Space-Time Problems in Art" to the 1946 Yearbook. When he accepted membership, though, he asked to be considered a painter and sculptor, rather than an architect of ideas, and generally showed paintings in the group's exhibitions.

1. Sibyl Moholy-Nagy, *Moholy-Nagy: Experiment in Totality* (Cambridge, Mass.: MIT Press, 1950), pp. 143, 145.

2. This note appeared on the school's letterhead. During World War II, when the shortage of industrial materials for household products became acute, Moholy-Nagy's students experimented with a variety of alternatives for metal, including wooden bed springs, an infrared oven made of a garbage can for roasting meat, and string hung in doorways in place of screens. For a discussion of their often amusing contraptions, see Robert M. Yoder, "Are You Contemporary?" *The Saturday Evening Post*, 3 July 1943.

3. Moholy-Nagy created special programs to accommodate students who had been wounded during the war. Exercises, such as texture charts to help the blind sharpen other senses, reflected the activities he had first developed for the foundation course at the Bauhaus.

4. For a discussion of the various viewpoints of Bauhaus staff, see Krisztina Passuth, *Laszlo Moholy-Nagy* (London: Arts Council of Great Britain, 1980), pp. 19–20. Lyonel Feininger, for one, remained unconvinced about the validity of uniting art and technology.

5. Joseph Harris Caton, *The Utopian Vision of Moholy-Nagy* (Ann Arbor, Mich.: UMI Research Press, 1984), pp. xvii–xviii.

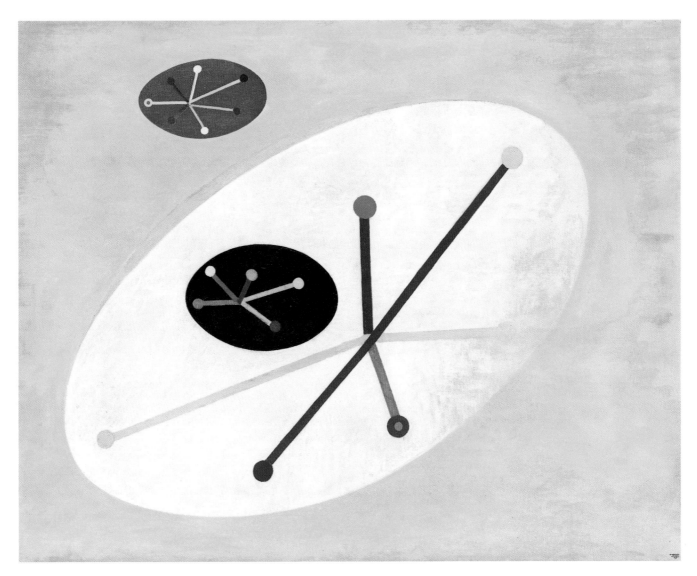

Leuk 5
1946
oil and pencil on canvas
30¼ x 38
1986.92.66

GEORGE L.K. MORRIS

(1905–1975)

A WRITER AND EDITOR AS WELL AS A PAINTER AND SCULPTOR, GEORGE L. K. Morris used various publications as platforms for advocating abstract art during the 1930s and 1940s. He believed that abstraction offered limitless possibilities for the twentieth century and set about to interpret new forms and ideas in historical terms so they would have special meaning for an American audience. "There is nothing new," he maintained in a 1937 article, "about the quality that we have come to call abstract. . . . In great works of the past there has always been a dual achievement—the plastic, or structural, on the one hand, and the literary (or subject) on the other." When "the veil of subject-matter had been pierced and discarded," he continued, "the works of all periods began to speak through a universal abstract tongue."[1]

Morris came to his understanding of modern movements firsthand. His frequent trips to Europe and close association with leading Parisian painters and sculptors gave him special authority when arguing the historical basis of their art.

Often described as a "Park Avenue Cubist," Morris came from a privileged background. He attended Groton and graduated from Yale in 1928, where he studied art and literature and edited the *Yale Literary Magazine*. He spent the fall semesters of 1928 and 1929 at the Art Students League; in the spring of 1929 he went to Paris with Albert Gallatin and stayed after Gallatin's departure to take Léger's and Ozenfant's classes at the Académie Moderne. In Paris he became a confirmed abstractionist; in his work illusionistic space in figurative paintings yielded to uptilted planes and increasingly to a Cubist fracturing of the picture plane.

On his return to New York, Morris founded a short-lived cultural and literary magazine called *The Miscellany*, for which he wrote intelligent and informed art criticism. He continued to travel frequently, often accompanying Gallatin to Paris to buy work for the Gallery of Living Art. He became friendly with Jean Hélion, who provided introductions to Braque, Picasso, and Brancusi, and he wrote catalogue notes to accompany Hélion's essay for the catalogue of the Gallery of Living Art. In 1937 he joined forces with Gallatin, Sophie Taeuber-Arp, and César Domela, to publish an art magazine called *Plastique*. There, and in the pages of *Partisan Review*—where he served as an editor between 1937 and 1943—Morris spoke of the cyclical nature of art history and placed contemporary art squarely within a framework of historical evolution. He wrote that during the nineteenth century, when art appealed to a growing middle class insufficiently sophisticated to understand its plastic qualities, it became stuck "in the mire of realism." With Cézanne and Seurat, who analyzed objects as shapes in space, the modern era began. The time is ripe, Morris continued, "for a complete beginning. The bare expressiveness of shape and position of shape must be pondered anew; the weight of color [and] the direction of line and angle can be restudied until the roots of primary tactile reaction shall be perceived again." Contemporary artists, he maintained, "must strip art inward to those very bones from which all cultures take their life."[2]

During World War II, Morris worked as a draftsman for a naval architect's firm. After 1947, he devoted his time almost exclusively to painting and sculpture, although he continued to write occasionally. A founding member of the American Abstract Artists, in the late 1940s he also served as the group's president, arranging exhibitions in Europe and Japan as well as in the United States. He continued to be active with the group during the 1950s and 1960s.

In Morris's own art, Léger served as an early model. Although his work never physically resembled that of his teacher, like Léger, Morris sought a synthesis of Cubist structure and primitive form. In Morris's work this was reflected in the incorporation of American Indian

Posthumous Portrait
1944
acrylic on plaster
embedded with tile and plastic
17 7/8 x 16
1986.92.67

imagery. During the mid 1930s, he argued for the concrete, and in his paintings juxtaposed hard-edged circular and angular forms in completely nonobjective compositions related to Hélion's work of the same time. In the early 1940s, he began to reincorporate figurative imagery in his art. In his *Posthumous Portrait* of 1944, Morris experimented with such non-art materials as tile and linoleum embedded in painted plaster compositions.

Although Morris exhibited with some frequency during the 1930s and 1940s, his paintings and sculpture received greatest recognition after the war. He remained steadfast in his devotion to his variant form of Cubism, even though many of his friends and colleagues turned to more expressionist styles in the postwar years.

1. George L. K. Morris, "On the Abstract Tradition," *Plastique* no. 1 (Spring 1937, reprint, New York: Arno Press, 1969).

2. "On the Abstract Tradition," and "The Quest for an Abstract Tradition," *American Abstract Artists: Three Yearbooks (1938, 1939, 1946)* (reprint, New York: Arno Press, 1969), p. 14.

JOHN OPPER

(born 1908)

JOHN OPPER DESCRIBED THE 1930s AS A "GREAT GESTATION PERIOD" FOR HIS ART. "I thought the Thirties was a very vital time for American art. . . . With the WPA, you got together whether it was the [Artists'] Union or the [American Artists'] Congress or whether it was a bar . . . and you talked about art, and you heard about important artists, and you began to live art."[1] But Opper also remembered the thirties as a period of breakdown in the vitality of American art; "we became aware that a great deal was missing."[2]

Academically trained like many of his contemporaries, Opper came to New York in 1934, two years after his graduation from Case Western Reserve University in Cleveland, Ohio. As a youth, he had taken Saturday art classes at the Cleveland Museum of Art and later studied at the Cleveland School of Art and the School of the Art Institute of Chicago. When he arrived in New York he was a well-trained painter, adept at rendering still lifes and particularly landscapes depicting the American scene. A reviewer of his 1937 exhibition at the Artists' Gallery in New York, for example, wrote about Opper's "colloquial flavor . . . spontaneity and an imaginative use of color which conveys just the feeling" that the subjects—East River tugboats, old garages, and scenes around Manhattan—suggested.[3]

By 1937 Opper had become familiar with modernism, though he was not yet converted to the cause. Indeed, his 1937 show was made up of the still popular regionalist paintings. Earlier, in 1935 and 1936, he studied with Hans Hofmann and began to think in terms of forces and tensions within the picture plane. He met Wilfrid Zogbaum, Giorgio Cavallon, Byron Browne, Rosalind Bengelsdorf, and George McNeil, with whom he shared a studio. He paid frequent visits to Gallatin's Gallery of Living Art. He joined the WPA easel project in 1936 and began to paint in "a kind of transformed cubist style."[4]

For Opper, though, abstraction conflicted philosophically with a strong commitment to social reform. He belonged to the American Artists' Congress and, when it was first formed, served as business manager of *Art Front*, the Artists' Union publication. He also exhibited with the American Abstract Artists, but eventually dropped out of the group. Opper said he preferred to combine creative work with social comment and was as yet unwilling to do completely abstract art. During the early 1940s, he noted, he was torn "between the needs of the society and the needs of war on one hand, and on . . . what I felt were the aesthetic needs of painting."[5] Only when he resolved to separate these two did he begin systematically to pursue abstract work. Eventually, he came to believe that the only thing important to art "is that which changes . . . the language and the substance of it."

When war came, Opper worked for three years with a marine architectural firm making drawings for the pipe systems of PT boats. After the war, he taught at the University of Wyoming and the University of Alabama, and between 1952 and 1957, he was on the faculty at the University of North Carolina. In 1957, he began teaching at New York University, where he remained until his retirement in 1974.

Opper had two solo exhibitions during the late 1930s, but it was not until the 1940s that he began to show frequently in large museum exhibitions and receive widespread attention. For Opper, this was a time of maturity. In paintings such as *Farmyard* (1937), his abstraction was based on nature; *Wyoming*, however, represents a major conceptual step. By 1947, when it was painted, Opper was committed to the idea that "painting is concerned with painting," an end in itself rather than a means to communicate other concerns. Early on he was allied with the "intuitive" (rather than the rationally inclined) faction within the American Abstract

Untitled
1935
oil on canvas
24 x 18
1986.92.69

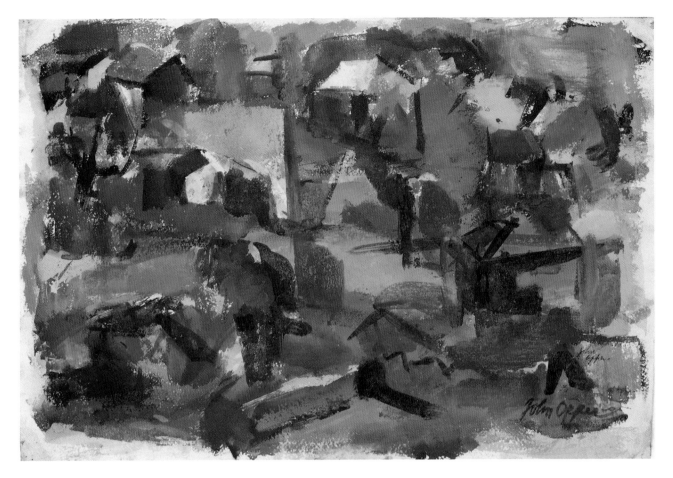

Farmyard
1937
watercolor on paper
15³/₈ x 22¹/₂
1986.92.70

Artists. But Opper moved far afield stylistically from the densely painted, expressionistic works of the 1930s and 1940s. In time, he became known as an Abstract Expressionist, a painter of large canvases in which vertical bands of varying widths pulsed with color. His gesture was controlled, yet dynamic; his overlays of color luminous and tactile. In these works, and in field paintings in which clouds of color seem to float against soft grounds, he strengthened his commitment to "painting as painting" that he first developed as a Hofmann student.

1. John Opper, interview with Irving Sandler, 9 September 1968, Archives of American Art, Smithsonian Institution, Washington, D.C.

2. Ibid.

3. J.L., "John Opper Interprets the Familiar Aspects of American Life," *Art News* 36, no. 2 (9 October 1937): 17.

4. John Opper, Sandler interview.

5. Ibid.

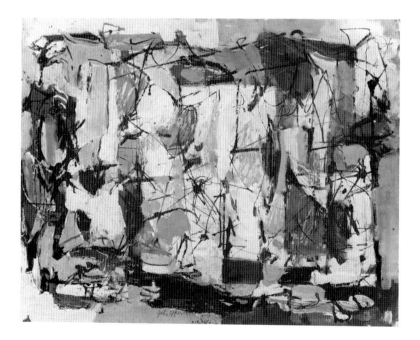

Wyoming
1947
gouache on paper
21¾ x 27⅛
1986.92.71

IRENE RICE PEREIRA

(1902 USA–1971 Spain)

MORE THAN ANY OTHER MEMBER OF THE AMERICAN ABSTRACT ARTISTS, IRENE Rice Pereira took to heart the principles of the Bauhaus. Assessing its importance, she wrote in 1939 that the Bauhaus "exerted the greatest influence on our entire social order. . . ."[1] In her paintings, her commitment to machine-age materials, and in a philosophy that called for a merging of technology and the transcendental, she was among the most avid Bauhaus proponents in the United States.

Pereira had experienced a difficult childhood. Born in Boston in 1902, she began supporting her family at an early age after her father's death.[2] In 1927, while working as a designer during the day, she enrolled in night classes at the Art Students League. Over the next four years, she and fellow students Burgoyne Diller, David Smith, and Dorothy Dehner, came to know modernism through the instruction of Jan Matulka and Richard Lahey. By 1931, Pereira had saved enough money for a trip to Europe and North Africa.[3] She attended criticism sessions given by Amédée Ozenfant at the Académie Moderne in Paris. But much of her year abroad was spent traveling—in Italy, where she studied the brilliant color of Italian Primitive painting, and in North Africa, where the light and dramatic space of the Sahara had a lasting effect on her life and on her aspirations for her art.

In 1935, Pereira helped found, and began teaching at, the Design Laboratory, a cooperative school of industrial design established under WPA auspices. She believed deeply in art's social function and considered abstract art the key to the future:

> The importance of abstract art lies in the fact that it is an experimental art—These artists are not concerned with literary documentation—but experimentation which conveys its influences to our architecture—our typography—photography—industrial design—It is an art which performs a definite social function.[4]

The curriculum at the Design Laboratory paralleled that of the Bauhaus. Students were required to take a basic course (patterned after the *Vorkurs* taught by Albers and Moholy-Nagy) that introduced them to the chemistry, physics, and mechanics of traditional as well as new art materials. Much of the instruction took place in laboratories. The students experimented with materials in order to gain a practical grasp of physical properties. They then applied this knowledge to the design of objects that could be easily mass produced. "Truth to the materials" was a basic precept and the use of surface ornament was actively discouraged. Although the traditional media of clay, wood, and stone were listed as materials to be explored in the class schedule, by 1937, Pereira's students were also working in glass, plastic, and metals.

Inherent in the philosophies of both the Bauhaus and the Design Laboratory was the notion that the individual genius was subordinate to broad social considerations. The needs of society dictated the program. Courses were taught in the social implications of technological developments, as well as the psychology, chemistry, and physics of color. Music, painting, literature, and architecture rounded out the academic schedule.

Experimentation also lay at the core of Pereira's own artworks. The paintings in her 1933 exhibition at American Contemporary Artists Gallery were semi-abstract compositions based on nautical motifs—smokestacks, ventilators, anchors, and the like—while in her 1934 and 1935 exhibitions at ACA she presented canvases in which abstracted human forms were juxtaposed against the shapes of giant machines. *Machine Forms #2* (also called *Power House*), and the study that preceded it, are among the last works in this vein. Painted early in

1937, *Machine Forms #2* was inspired by the view from her studio window: "I used to look in at a power house on 16th Street where I was living, to get the feeling of power house; and then made my own."[5]

Later in 1937, when Pereira began painting nonobjective canvases, the principles of the Bauhaus and Russian Constructivism became apparent in her work. She was especially concerned with finding a way to bring light into her work, and over the next ten years incorporated a wide range of unusual paints, as well as glass, plastic, gold leaf, and other reflective materials into her art. By 1946 she had experimented with radium paint—these works would emit ghostly patterns when lights were extinguished—and she made glass constructions in which she painted on smooth, pebbled, and corrugated glass surfaces, then layered them together to emphasize a shallow, planar depth.[6]

Pereira continued to work in an abstract vein for the remainder of her life. She said abstraction offered "a wider range for experimentation and for clarifying the problems concerning pictorial presentation."[7] Increasingly, though, she attempted to articulate her ideas in poetry and essays, the metaphysical tone of which often obscured rather than clarified her thoughts.

1. Irene Rice Pereira, "New Materials and the Artist," lecture given in 1939 at Columbia University; see notes in Irene Rice Pereira Papers, Archives of American Art, Smithsonian Institution, Washington, D.C., roll 2395: 153.

2. I am grateful to Karen A. Bearor for alerting me to Pereira's correct birthdate of 1902. Throughout published sources on the artist, the date has been given as 1905, a date Pereira herself had provided. For a detailed study of Pereira's work and beliefs about art, see Karen A. Bearor, "Irene Rice Pereira: An Examination of Her Paintings and Philosophy" (Ph.D. diss., University of Texas at Austin, 1988).

3. The dates given for this trip vary in published sources on Pereira's work, but her trip apparently took place sometime after her first marriage in 1929.

4. Pereira, "New Materials and the Artist."

5. Pereira, manuscript for *Eastward Journey*, 1953, Pereira Papers, Archives of American Art, roll D223: 0032.

6. For an illustrated discussion of this technique, see Dorothy Gees Seckler, "Pereira Paints a Picture," *Art News* 51, no. 5 (September 1952): 34–37, 54–55.

7. Pereira, letter to Emily Genauer, 25 April 1947, Emily Genauer Papers, Archives of American Art, roll NG–1: 373.

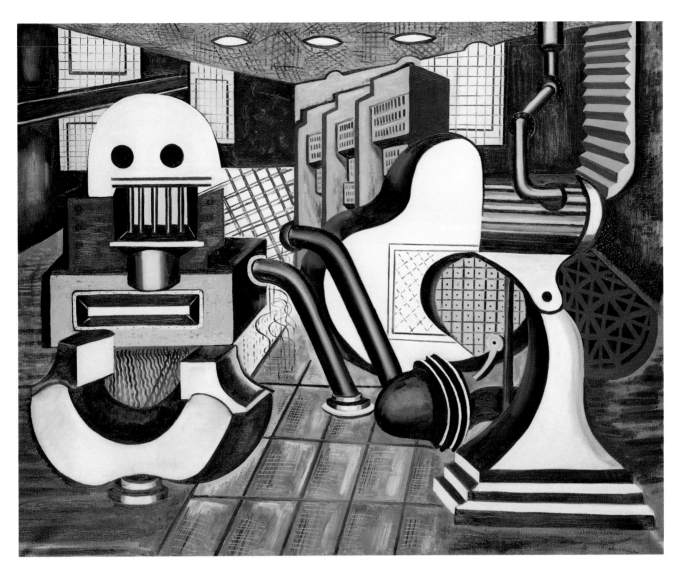

Machine Composition #2
1937
oil on canvas
48¼ x 60
1986.92.72

Sketch for Machine Composition #2
1936-37
pencil and crayon on paper
17½ x 22⅝
1986.92.73

AD REINHARDT

(1913–1967)

AD REINHARDT WAS ONE OF THE FEW MEMBERS OF THE AMERICAN ABSTRACT
Artists who began his artistic career as an abstract painter. The son of socialist parents,
Reinhardt also had leftist sympathies and belonged to the Artists' Union and the left-wing
American Artists' Congress. Yet throughout his life Reinhardt insisted that art was created
and should be understood on its own terms, without reference to social, political, or literary
ideas. "In the Thirties," he later declared,

> it was wrong for artists to think that a good social idea would correct bad art or that a good
> social conscience would fix up a bad artistic conscience. It was wrong for artists to claim that
> their work could educate the public politically or that their work would beautify public
> buildings.[1]

At Columbia University he studied art history and aesthetics with Meyer Schapiro. By the
time he graduated in 1935, Reinhardt was well versed in modern art movements, and had
contributed Cubist-inspired cover designs for a campus magazine.[2] He then studied painting
at the National Academy of Design, and with Anton Refregier, Francis Criss, and Carl Holty at
the American Artists School. Between 1936 and 1941, he was employed by the easel division
of the WPA Federal Art Project and at the same time did free-lance commercial art. One of his
most important associations was with Russel Wright, the architect and industrial designer, for
whom Reinhardt did cartoons and exhibits for the 1939 New York World's Fair. During the
1940s, he made posters for the War Bond drive, did artwork for the Office of War Information,
designed promotional materials for the Columbia Broadcasting System, created baseball mag-
azines for the Brooklyn Dodgers, and painted murals for the Café Society and the Newspaper
Guild Club.[3] He was in the navy in 1945 and 1946 and served briefly aboard ship in Salerno Bay
before the war ended. In 1947 he accepted a teaching post at Brooklyn College.

Reinhardt had a thorough understanding of the historical progression and philosophical bases
of modern art movements. His gentle, but acerbic wit garnered public attention in 1946 with
his humorous and now well-known cartoons for the Sunday section of *PM*, a leftist tabloid
founded by Marshall Field to provide a contrasting voice to the generally conservative New
York press.[4] The most famous of these cartoons, "How to Look at Modern Art in America,"
showed a large tree, its trunk labeled "Braque, Matisse, Picasso." At the juncture of various
branches was a scale of abstract art to Social Surrealist art, with Mondrian (the most abstract)
on one side, and George Grosz at the opposite end. The tree's branches bore leaves with names
of artists whose work was in some manner related. The abstract branches reached skyward;
those indicating social realists, Surrealists, and Expressionists were about to break from the
effect of weights labeled "subject matter," "Mexican art influence," and "War Art."[5]
Although the cartoon was a humorous evaluation, Reinhardt received letters from
Sinclair Lewis, among others, thanking him for clarifying the interrelationships among
modern artists.

Reinhardt joined the American Abstract Artists in 1937 at the invitation of Carl Holty: "That
was one of the greatest things that happened to me. All the great abstract artists—Mondrian,
Léger and Albers—had come over, and then all the Americans that I admired—Holty, Diller,
Balcomb Greene, Cavallon, McNeil and other post-Cubist geometric abstractionists."[6]
Reinhardt quickly became an active force within the organization, and in 1940, when the
group picketed the Museum of Modern Art, ironically for showing the work of *PM* artists
rather than the American avant-garde, Reinhardt designed the broadside that presented the
group's point of view.

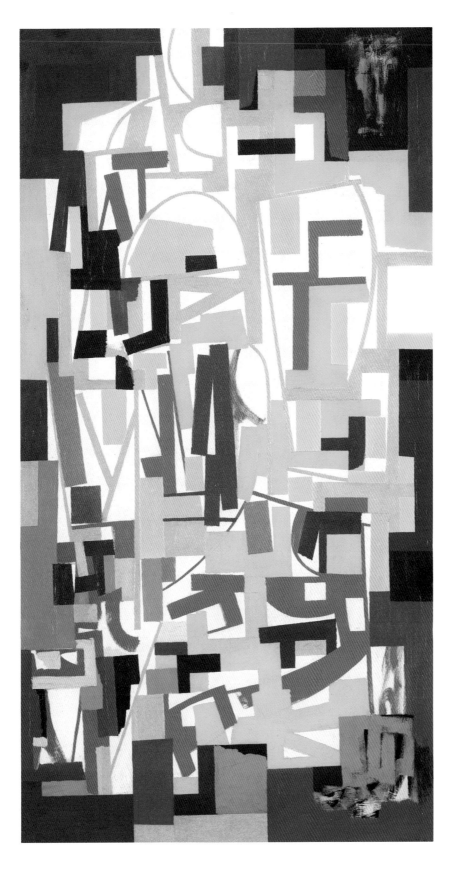

Untitled
1940
oil on fiberboard
46 x 24
1986.92.75

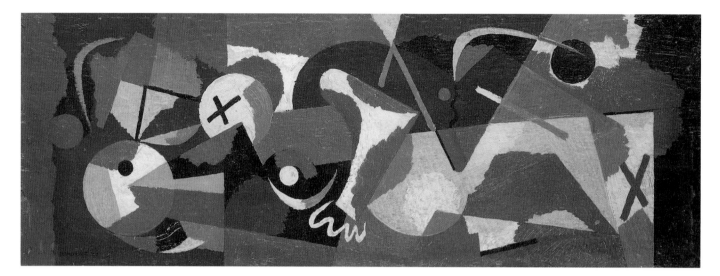

Untitled
1937
oil on wood
5¼ x 14
1986.92.74

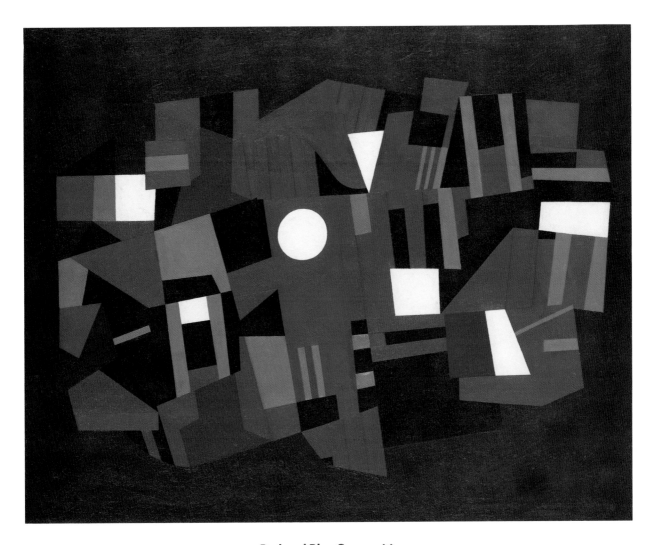

Red and Blue Composition
1941
oil on fiberboard
23½ x 29½
1986.92.76

His bold abstractions of the late 1930s, which Reinhardt called his "late-classical-mannerist-post-cubist, geometric abstractions," showed evidence of a sophisticated understanding of abstract composition.[7] He worked in collage as well as paint, bringing to this medium an all-over compositional approach that signified his imminent move toward pure geometric structure. The *Untitled* painting of 1940, with its overlapping strokes of color, provides a painted parallel to the collages of the late 1930s. Yet his work retained clues to those artists he most admired. The optical energy of *Red and Blue Composition* (1941) owes a debt to the jazzy syncopations of Stuart Davis, who became a sort of mentor to the younger painter, though Reinhardt had not yet abdicated rhythmic curvilinear forms that bespoke his appreciation for Carl Holty.

In 1941 Reinhardt began to break up the geometric structure of his paintings. By 1948, he was exhibiting compositions that replaced visual form with calligraphic, all-over patterns that put him in an uncomfortable alliance with Abstract Expressionism. By the 1950s, however, he moved again toward strict geometric purity, creating symmetrical, rectangular shapes in single colors that reflected his early appreciation of geometric abstraction. From that time until his death in 1967, Reinhardt continued to simplify and purify his paintings—purging the bold colors and eventually arriving at his black paintings, the solemn, reductivist canvases for which he is perhaps best known.

1. See "The Philadelphia Panel," *It Is*, no. 5 (Spring 1960): 36.

2. See, for example, the cover of *Columbia Review*, April 1935, in Ad Reinhardt Papers, Archives of American Art, Smithsonian Institution, Washington, D.C., roll N/69–100, which suggests familiarity with Francis Picabia's Cubist work of 1910 to 1920.

3. Reinhardt's list of commercial art credits is a lengthy one, which includes redesigning Macy's newsletter, book designs for major publishing houses, and designs for several trade associations. In 1944, he illustrated a children's book and did cartoons for *Glamour* magazine.

4. See Thomas B. Hess, "The Art Comics of Ad Reinhardt," *Artforum* 12, no. 8 (April 1974): 46–51, for a discussion and illustrations of Reinhardt's *PM* cartoons.

5. The original appeared in *PM*, 2 June 1946.

6. Quoted in Lucy R. Lippard, *Ad Reinhardt: Paintings* (New York: The Jewish Museum, 1966), p. 15.

7. Reinhardt determined his own five stages. The first was "Late-classical-mannerist, post-cubist geometric abstraction of the late 1930s." This was followed by "rococo-semi-surrealist fragmentation and 'all-over' baroque-geometric-expressionist patterns of the early 40s." Next came "archaic color-brick-brushwork impressionism and black-and-white constructivist calligraphies of the late 40's"; then "early-classical hieratical red, blue, black monochromes square-cross-beam symmetries of the 50's; and last, "classic black square uniform five foot timeless trisected evanescenses of the 60's." See "Five Styles of Reinhardt," handwritten list in Reinhardt Papers, Archives of American Art, roll N/69–100: 104.

RALPH ROSENBORG

(born 1913)

ALTHOUGH RALPH ROSENBORG HAS PAINTED ABSTRACT WORK THROUGHOUT his life, nature has served as his perennial motif.[1] He won a scholarship while still in high school to Saturday art classes at the American Museum of Natural History in New York City. After classes ended, he later continued to study privately with his teacher there, Henriette Reiss, who provided not only exacting technical training, but broad-based instruction in music, literature, and art history. More significantly, Reiss had worked with Kandinsky earlier in her career and introduced her young protégé to the vast arena of vanguard European ideas. After four years, Rosenborg was ready to exhibit. He showed frequently during the 1930s—initially in group exhibitions at ACA Galleries and later in Mayor La Guardia's 1934 "Mile of Art" at Radio City. His first solo exhibition, at the Eighth Street Theater in 1935, was followed by shows at various galleries almost annually throughout the 1940s.

A highly personal artist, inclined toward interpreting nature rather than the geometric form pursued by many of his fellow members of the American Abstract Artists, Rosenborg wrote in 1955,

> Painting will always remain a super-real world to me, devoid of all modern forms of blasphemy. It is a world in which the immensity of creation moves me to a personal form of prayer and contemplation. It is also a world in which its laws demand a personal integrity of purpose, a simple humbleness, and a sufficient set of experiences as the basic requirement for admission to it.[2]

During the 1930s and 1940s, Rosenborg moved freely between expressionist watercolors evocative of the rhythms and colors of nature (such as the *Untitled* watercolor of about 1938) and more consciously structured oils, such as *The Far-away City*, in which deep-toned, dream-world landscapes take on the color and architecture of expressive stained glass. He paid little heed to modernist theories of surface and structure that fascinated many of his contemporaries. Later during the 1950s, Rosenborg's paintings increasingly reflected the energies, as well as the appearances, of the natural world. Tumultuous seascapes, serene landscapes, and brightly colored floral still lifes, were all executed with an attention to richly textured, heavily painted surfaces.

Although New York City has remained home for Rosenborg throughout his career, he has traveled widely. In 1966, an award from the National Council on the Arts and Humanities enabled him to tour Europe. He continually strives upward in his work, and frequently draws an arrow in a rectangular box on the back of his paintings. Originally a Mayan motif, the arrow, for Rosenborg, "signifies that I will strive to always go up, aesthetically, spiritually, and from all practical points of view. It's very important because I try to stay on earth, but actually, the painting is another world."[3]

1. An excellent discussion of Rosenborg's work, especially during the 1950s, can be found in Martica Sawin, "The Achievement of Ralph Rosenborg," *Arts Magazine* 35, no. 2 (November 1960): 44–47.

2. Ralph Rosenborg, "Statement," *Contemporary Paintings and Sculpture* (University of Illinois exhibition catalogue, 1955); reprinted in "Ralph Rosenborg: Recent Oil and Watercolor Paintings" (Princeton, N.J.: Princeton Gallery of Fine Art, exhibition brochure, 1983).

3. Ibid.

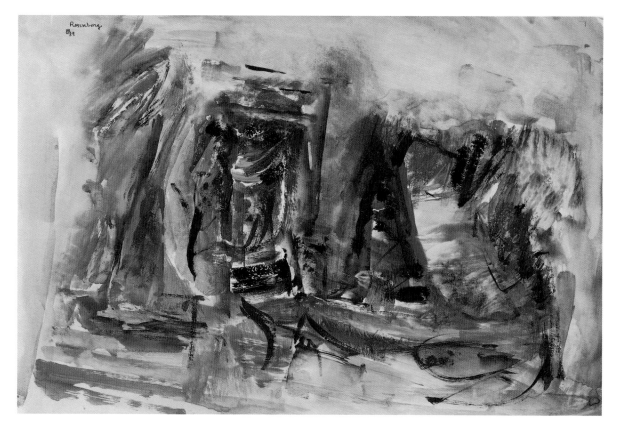

Untitled
1939
watercolor and oil on paperboard
11 x 16¼
1986.92.77

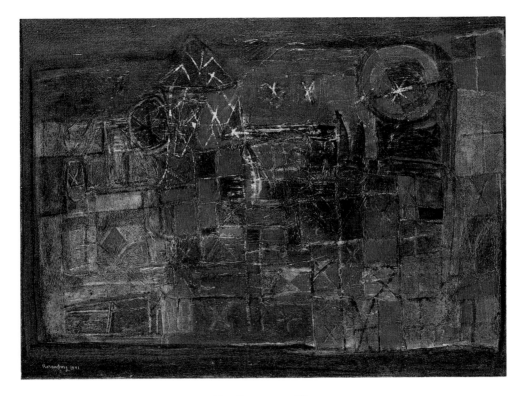

The Far-away City
1941
oil on linen
18 x 24
1986.92.78

Untitled
1944
oil on canvas
24 x 10
1986.92.79

LOUIS SCHANKER

(1903–1981)

Though much of my work is generally classified as abstract, all of my work develops from natural forms. I have great respect for the forms of nature and an inherent need to express myself in relation to those forms. No matter how far my experimental design may take me . . . there remains always a core of objective reality which I have no desire to destroy or even to impair but only to investigate, analyze, develop.[1]

LOUIS SCHANKER WAS ONE OF MANY MEMBERS OF THE AMERICAN ABSTRACT artists who chose to base his art in the objects, patterns, and rhythms of nature. Although never a student of Hans Hofmann, Schanker's ideas about art had many parallels with Hofmann's. Concern for the spatial dynamics of a painting's surface, and an insistence on some aspect of nature as a starting point for art, are two areas that mirror a shared philosophy between the two artists. Although much of Schanker's later work is completely abstract, during the 1930s and 1940s he frequently used direct, identifiable themes—motifs drawn from sports, his early years working for a circus, and even socially conscious subjects not normally employed by abstract artists.[2]

As a youth, Louis Schanker quit school and ran away to join the circus. He put in two years of "interesting but grueling hard labor."[3] After leaving the circus, he worked as a laborer in the wheatfields of Canada and the Dakotas, as a "gandy dancer" on the Erie Railroad, and as a stevedore on Great Lakes steamers. For almost a year Schanker cast his lot with hobos, riding freight trains throughout the country. In 1919, he put this itinerant life behind him and began attending night classes at Cooper Union. Subsequently, he studied at the Art Students League of New York and the Educational Alliance. Schanker spent 1931 and 1932 in Paris. He took classes at the Académie de la Grande Chaumière and worked on his own, doing *plein air* landscapes and street scenes. The work of Renoir, Degas, and Signac made a deep impression on the young artist. After he moved to Mallorca in 1933, Schanker began abstracting form to a greater degree and incorporating Cubist devices of uptilted planes and prismatic color in his work.

During the mid 1930s, Schanker began making prints and subsequently became a graphic arts supervisor for the WPA. He also completed murals for radio station WNYC, the Neponsit Beach Hospital in Long Island, and the Science and Health building at the 1939 New York World's Fair. During World War II, Schanker worked as a shipfitter and began teaching the technique of color woodblock printing at the New School for Social Research. In 1949, he became an assistant professor at Bard College, where he remained until his retirement.

Throughout the 1930s and 1940s, Schanker exhibited frequently in group shows both in museums and in commercial galleries. He became especially well known for his innovations as a printmaker. Schanker belonged to The Ten, a group that exhibited together in protest against the hegemony of American scene painting in Whitney exhibitions and in support of artistic experimentation and an international (rather than nativist) outlook in art.[4]

Schanker imbued his prints, paintings, and sculpture with an animated expressionism that aims at a fundamental emotional structure. Sculptures such as *Owl*, carved in 1937, adroitly convey not only the bird's physical appearance, but the quality of mystery that has made it a symbol of wisdom and secrecy. *Three Men*, exhibited in the American Abstract Artists' first

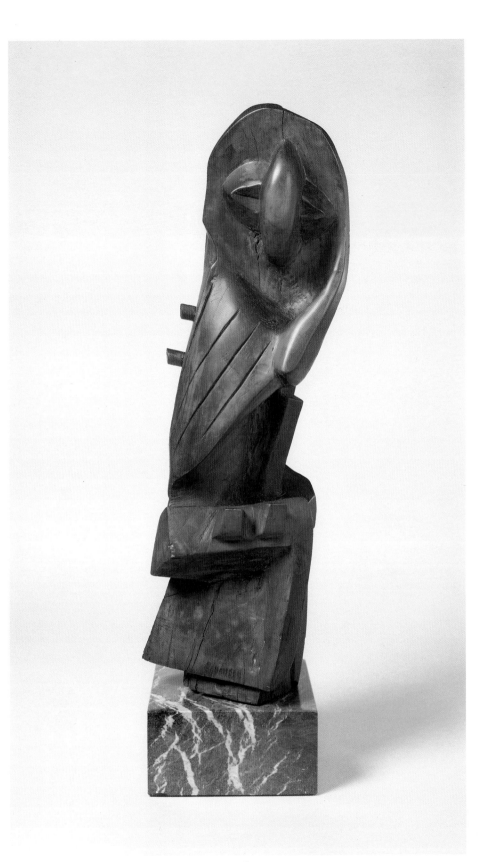

Owl
1937
applewood
$31^{1}/_{2}$ x $8^{1}/_{8}$ x $8^{1}/_{8}$
1986.92.81

Three Men
1937
oil on canvas
54 x 68
1986.92.83

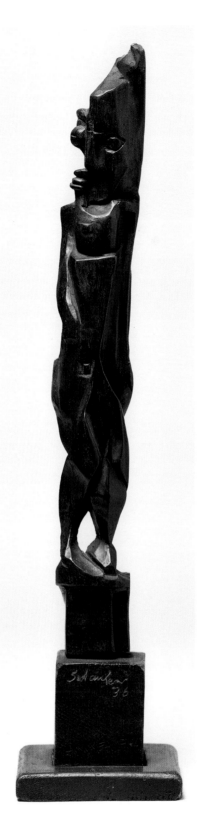

Abstract Man
1936
oil on applewood
22 x 4 ¹³/₁₆ x 5
1986.92.80

annual exhibition in 1937, exemplifies the expressive, angular animation for which Schanker's work was frequently praised in press reviews of the 1930s.

1. Louis Schanker, "The Ides of Art: Eleven Graphic Artists Write," *Tiger's Eye* 8 (June 1949): 45.

2. In a letter to the editor of *Art News* in 1938, an art historian noted the similarities between Schanker's *Circus*, a WPA mural done for the children's dining room in the Neponsit Beach Hospital and Giovanni Battista Tiepolo's *I Saltimbanchi*. In his reply, Schanker said that he had chosen his subject matter based on his own experience: "I ran away from school to join the 'big top' and put in two years of interesting but grueling hard labor as a 'canvas-man,' 'animal ostler' and 'property-man' for clowns, acrobats and other performers with one of the best known American circuses. The visual memories that I retain of this period are, needless to say, vivid if not particularly humorous"; "The Artist Replies," *Art News* 37 (29 October 1938): 16.

3. Louis Schanker, letter to the editor, *Art News* 37 (29 October 1938): 16, 21. I am grateful to Joel Schanker, Louis's brother, for relating details about Schanker's life and work in a videotaped interview, 9 June 1988.

4. Other members were Ben-Zion, Ilya Bolotowsky, Louis Harris, Earl Kerkam, Ralph Rosenborg, Joseph Solman, Adolph Gottlieb, and Mark Rothko (then still using the name Marcus Rothkowitz). The group associated for five years and held exhibitions at Montross, Passedoit, and Mercury galleries, and at the Galérie Bonaparte in Paris. For further information about The Ten, see Lucy McCormick Embick, "The Expressionist Current in New York's Avant-Garde: The Paintings of The Ten" (Master's thesis, University of Oregon, 1982).

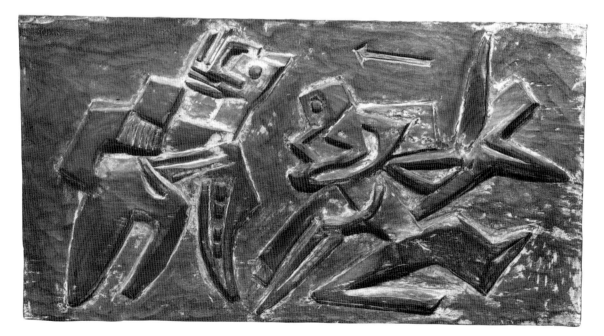

Football

ca. 1937

oil on wood

13⅝ x 26¼ x ⅝

1986.92.82

JOHN SENNHAUSER

(1907 Switzerland–1978 USA)

IN COMPARISON WITH OTHER MEMBERS OF THE AMERICAN ABSTRACT ARTISTS, John Sennhauser came late to abstraction. During the 1930s, he painted scenes of urban street life, prompting one reviewer to describe him as "a realist with a nice facility in drawing and painting."[1] Not until the early 1940s did Sennhauser first exhibit the nonobjective paintings for which he became known.

Sennhauser was born in Switzerland and grew up in Italy. He studied for two years at the Royal Academy in Venice, and in 1928 immigrated to the United States, where he worked as an architectural draftsman. From 1930 to 1933, he studied at the Cooper Union. Between 1936 and 1942 he taught, first at the Leonardo da Vinci Art School, and later at the Contemporary School of Art in New York. During this time he also did privately commissioned murals.[2]

In 1943, Sennhauser began working for Hilla Rebay at the Solomon R. Guggenheim Foundation. At that time, he explained the impulse behind his new style as "rather universal, or subjective . . . ," terms that were consonant with Rebay's ideas on mysticism. He continued,

> . . . Lines, planes, forms, colors, rhythmically moving. . . intuitively conceived. . .intuitively born of life eternal. Plastic integration of form and space of body and spirit. . .
>> Intensity. . . Stillness. . .
>> Harmony. . . Contrast. . .
> The everlasting negative in all its positive manifestations, pure as immortality, free as the infinite. . . The essence of all that is and is not. . .
> The Mythical. . . Timeless. . . Mystical. . .[3]

In *Black Lines No. 13* (1944), *Organization No. 16* (1942), and other paintings from the late 1930s and 1940s, Sennhauser sought to express universal order. Although he described his working method as intuitive, "the flowing of . . . feeling through my body into my arm . . . to my hand . . . into my brush. . .," he also consciously composed in terms of dualities of line, color, form, and space.[4] Sennhauser was not doctrinaire in promoting these ideas, however. He believed that all art, the socially conscious as well as the "esthetically directed," should seek truth and order and meet exacting standards of whatever grammar and syntax the artist chooses to use.[5]

Sennhauser, like Dwinell Grant and others who were closely associated with Rebay at the Guggenheim, became disaffected with Rebay's philosophical and personal inflexibility. He resigned in 1945. In the 1950s and 1960s, he worked as a restorer. During these years he became increasingly active in several artists' organizations, including the American Abstract Artists and the Federation of Modern Painters and Sculptors. In 1961 he again exhibited figurative work, freely painted canvases with sensual surfaces that were dramatically opposed to the more formal geometries of his earlier work. Sennhauser's switch to figuration did not come overnight, however; in his watercolor and casein works from the early 1950s on, he often adopted a free Abstract Expressionism distinct from the structural approach of his canvases.

1. *New York Herald Tribune*, 26 April 1936 (review of an exhibition of Sennhauser's work at the Leonardo da Vinci Art School).

2. In sketches for unidentified mural commissions that show scenes of workers building skyscrapers, Sennhauser has

worked out careful compositional structures. See John Sennhauser Papers, Archives of American Art, Smithsonian Institution, Washington, D.C., roll N70–33.

3. John Sennhauser, letter to Sidney Janis, 25 July 1943, Sennhauser Papers, Archives of American Art, roll N70–33: 12.

4. See "Notes Requested by the Whitney Museum of American Art After Their Purchase of *Emotive 15* in 1951," Sennhauser Papers, Archives of American Art, roll N70–33: 58. He also writes, ". . . no particular color, idea or subject is in my mind at the time of execution. My brush moves intuitively . . . slowly attuning itself to the rhythm of the feeling that permeates my whole being. Of course, this feeling does come from somewhere. It may be some music that I have heard or I am listening to . . . a charming remark from my little girl . . . a description of the constellations as related by my young son after a visit to the Planetarium It might even be the emaciated faces of Korean refugees . . . the dreadful thought of the atomic bomb. It may be anything What is important is . . . its crystallization in color-form vibrations."

5. See "Excerpt from Letter to Verna from John Sennhauser," 24 August 1968, in Sennhauser Papers, Archives of American Art, roll N70–33: 39.

Abstract Composition
1938
oil on canvas
23 x 29
1986.92.84

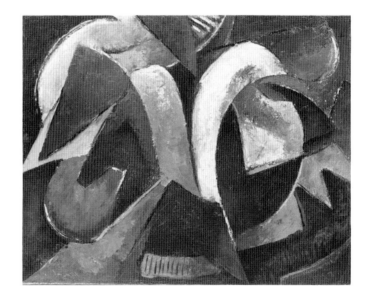

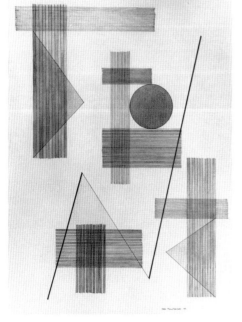

Organization No. 16
1942
watercolor on paper
19 3/8 x 14 5/16
1986.92.85

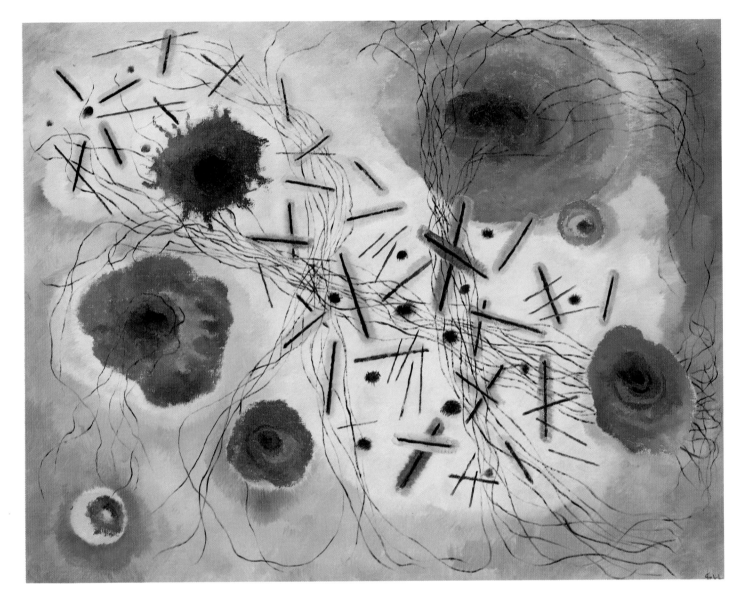

Black Lines No. 13
1944
oil on canvas
33 x 42
1986.92.86

CHARLES GREEN SHAW

(1892–1974)

CHARLES SHAW BEGAN PAINTING WHEN HE WAS IN HIS LATE THIRTIES. A 1914 graduate of Yale, Shaw completed a year of architectural studies at Columbia University. In 1927, he began to take a serious interest in art and enrolled in Thomas Hart Benton's class at the Art Students League in New York. He also studied privately with George Luks who became his friend. Prior to this, Shaw enjoyed a successful career as a free-lance writer for *The New Yorker*, *Smart Set*, and *Vanity Fair*, chronicling the life of the affluent theater and café society of the 1920s. Shaw, born into a wealthy New York family, had entrée and moved easily in the social circles of New York, Paris, and London in the late 1920s and 1930s.[1]

In addition to his witty and insightful articles, Shaw was a poet, novelist, and journalist. He published several books—a novel entitled *Heart in a Hurricane* and a collection of interviews with New York literary figures called *The Low Down*.[2] Once he had dedicated himself to non-traditional painting, Shaw's deft ability with pen made him a potent defender of abstract art.

After initial study with Benton and Luks, Shaw continued his artistic education in Paris by visiting museums and galleries. During the first week of a 1932 trip, he surveyed thirteen galleries, and was particularly impressed by the work of Cézanne and Picasso.[3] From 1930 to 1932, Shaw's paintings evolved from a style imitative of Cubism to one inspired by it though simplified and more purely geometric. In 1933, having returned to the United States, he began a series of works entitled the *Plastic Polygon* that occupied his attention until the end of the decade. The best known of these are drawn from the architectural forms of the New York City skyline and are often painted on shaped canvases that echo the architectural silhouette of the skyscrapers. Within this structural framework, overlapping rectangular forms allude to different heights and widths of adjacent buildings. In them, illusory space is compressed; only the tonal variations of the colors and the subtle manipulation of rectangles evoke a sense of three dimensionality.

The *Plastic Polygon* series, which Shaw described in an article for *Plastique*, earned him a respectable reputation among the individuals and galleries interested in American abstract art in the 1930s. He had a solo exhibition at Valentine Gallery in 1934, and in 1935, Albert Gallatin organized a show of Shaw's work at the Gallery of Living Art.

Shaw traveled to Paris again during the summer of 1935 with Gallatin and George L. K. Morris. There he met John Ferren and Jean Hélion. The following year Gallatin organized an exhibition, called *American Concretionists*, at the Reinhardt Gallery that included Shaw, Ferren, and Morris, as well as Alexander Calder and Charles Biederman.

Shaw became a founding member of the American Abstract Artists and exhibited in the first annual exhibition. His article, "A Word to the Objector," was included in the group's first publication. In it, Shaw chastised "anti-abstractionists" for their prejudice against abstract art. He also, in the article, expressed his profound belief that abstract painting was "an appeal to one's . . . *aesthetic emotion* alone . . . [rather than] to those vastly more familiar emotions, which are a mixture of sentimentality, prettiness, anecdote, and melodrama."[4]

During the 1940s Shaw strayed from the strict geometrical format of the polygon paintings. *Untitled* of 1941 is a whimsical and delicate painting of tents in a nocturnal landscape reminiscent of Paul Klee's work. Here and in *Untitled Abstraction* of 1943, Shaw softened both his palette and his edges in favor of lyrical balance and subtly modulated color.

Montage
ca. 1935–50
playing cards, mother-of-pearl jetons,
and snuffbox mounted on silk
14³/4 x 12³/4 x 2¹/4
1986.92.89

Montage
ca. 1935–50
tarot cards, mother-of-pearl jetons,
and snuffbox mounted on silk
19½ x 16 x 1⅞
1986.92.88

Montage
ca. 1935–50
playing cards, clay pipes, ivory discs,
and snuffbox mounted on velvet
15 x 13 x 2¼
1986.92.87

Untitled Abstraction
1943
oil on fiberboard
11½ x 15½
1986.92.91

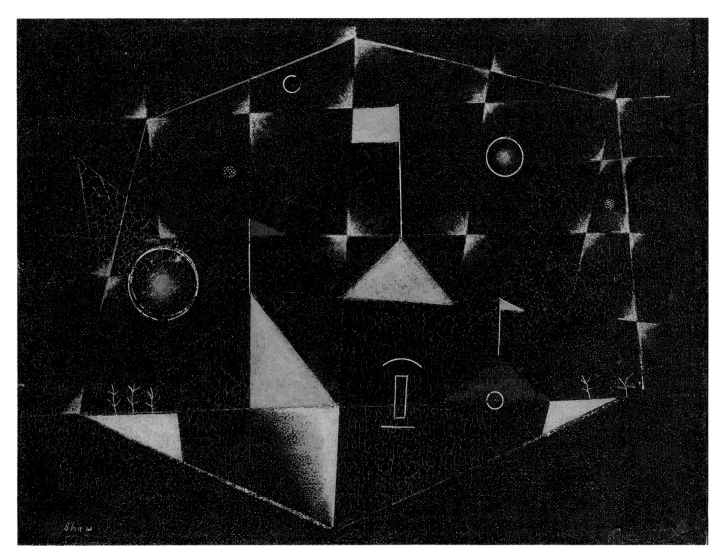

Untitled
1941
oil on fiberboard
8⁵/₈ x 11³/₄
1986.92.90

Throughout his career as an artist, Shaw made montages of antique playing and tarot cards, game boards, and other paraphernalia associated with games. Reflecting his study of the history of cards and games, Shaw mounted cards on old textiles in symmetrical and asymmetrical designs. Although most are undated, the composition of the earlier montages is randomly ordered and spontaneous, while the more highly structured later works relate to the geometric formulation of the plastic polygon paintings.[5]

These montages were personal works for Shaw. He never exhibited them, although they were installed from floor to ceiling throughout his apartment. Indeed, the enigmatic quality of the cards provides an intriguing twist in the study of Shaw's art and contributes additional clues to his multifaceted character.

1. George L. K. Morris described Shaw as "well over six feet tall and sturdily built. His appearance was elegant, with a neatly trimmed mustache and a slightly florid countenance. He might have passed as one of the elusive characters in a British spy movie. . . ." See "Charles Shaw," *Century Yearbook* (New York: Century Association, 1975).

2. For more information on Shaw's literary accomplishments and acquaintances, see Buck Pennington, "The 'Floating World' in the Twenties: The Jazz Age and Charles Green Shaw," *Archives of American Art Journal* 20, no. 4 (1980): 17–24. His accomplishments as a poet won Shaw the Michael Strange Poetry Award in 1954.

3. During his first trip to Europe, in 1929, Shaw spent only a month in Paris. In his diary entries from this trip he does not mention incidents related to art. His accounts of the 1932 trip, however, are filled with discussions of museum and gallery visits and the progress of his own painting.

4. Charles G. Shaw, "A Word to the Objector," *American Abstract Artists: Three Yearbooks (1938, 1939, 1946)* (reprint, New York: Arno Press, 1969), p. 11.

5. Shaw wrote a fascinating history of the imagery of playing cards in an article entitled "Before Kings and Queens Had Two Heads," *Connoisseur* 127, no. 524 (January 1952): 162–66, 201. Susan Larsen has discussed Shaw's montages in "Through the Looking Glass with Charles Shaw," *Arts Magazine* 51, no. 4 (December 1976): 82.

ESPHYR SLOBODKINA

(born Siberia 1908)

DURING THE PERIOD OF SOCIAL AND POLITICAL TURMOIL THAT FOLLOWED THE Russian Revolution, Esphyr Slobodkina fled with her family to Vladivostok, and then to Harbin, Manchuria. In 1928, she immigrated to New York and the following year entered the National Academy of Design. Although unenthusiastic about the curriculum, Slobodkina's visa required that she attend school, and she remained at the Academy until 1933. It was fortunate that she did, because through his sister, also a student, she met Ilya Bolotowsky, whom she married in 1933.

Slobodkina remembers her first long conversation with Bolotowsky as a lecture on composition, in which Bolotowsky talked of organization, mass, form, color, space—heady new ideas despite her several years of academic training. Through Bolotowsky, Slobodkina met Byron Browne, Gertrude and Balcomb Greene, Giorgio Cavallon, and others whose conversations roamed from discussions of the cost of canvas to the "latest capers in Picasso's procession of quickly changing styles."[1]

Slobodkina still considered herself very much a student when she married Bolotowsky, but, by signing her name to several of his early paintings, he wangled invitations for both of them to go to Yaddo, an artists' colony in Saratoga Springs, New York. Still wavering between the Impressionist theories she had learned earlier, and Bolotowsky's modernist ideas (he had not yet ventured into pure abstraction), she painted expressionist still-life and interior scenes during the several months they spent in Saratoga Springs. Her first Cubist-inspired painting— a fractured image of the sink in her bathroom—was created in 1934. Without rejecting more expressionist landscape and still-life paintings, she began in the winter of 1936–37 to concentrate seriously on abstraction. Once begun, Slobodkina moved quickly through her Cubist experiments toward a concern with planes and flattened pictorial space.

Financial pressures in the 1930s made it difficult for Slobodkina to concentrate on painting. Her parents had come to New York, but the family's economic situation was precarious. During the early 1930s she and her mother opened a dressmaking business, designing and creating fine clothing and millinery. Among other short-lived jobs, Slobodkina worked for several textile printing firms, each of which folded. Although her parents still needed her help, her own situation dramatically changed when Bolotowsky joined the Public Works of Art Project and later the WPA: "It gave us bread, it gave us time, and above all, it gave us peace of mind."[2] When Slobodkina and Bolotowsky separated in 1935, Slobodkina went on relief, and then joined the WPA herself.

She became very active in the Artists' Union, and when members were asked to make posters for a fundraising event, Slobodkina presented collages. More at ease with scissors and paper than with drawing, Slobodkina's collages honed her developing abstract style. She did several constructions early in her career, three-dimensional assemblages of wood, wire, and other found objects, and experimented with found-object sculpture. In her paintings of the late 1930s, forms are often flattened and overlaid in spatial configurations associated with collage. She also began experimenting with gesso panels, finding the evenly sanded surfaces especially suited to the linear clarity of her forms.

Slobodkina joined the American Abstract Artists early in the organization's history. She had not attended the preliminary meetings at Ibram Lassaw's studio in 1936, but once a member, served the organization in various capacities for several decades. During the early 1940s, with Alice Trumbull Mason, she helped organize an ambitious program of cultural evenings that

combined lectures and parties. In her role as hospitality chairman, she introduced socially prominent New Yorkers to the organization.

A change in the direction of her career came in 1937, when Slobodkina first met Margaret Wise Brown, a noted author of children's books. Hoping to find illustration work, she wrote and illustrated a children's story to present as an introductory "portfolio." Still not confident of her ability as a draftsman, Slobodkina cut little figures out of paper and collaged them to make her designs. Brown was charmed by their directness and simplicity and asked Slobodkina to illustrate Brown's book *The Little Fireman*, published the following year. This was the first of many children's tales that Slobodkina was to illustrate, and soon she began writing her own stories as well. *Caps for Sale*, her best-known book, has become a classic.

By the mid 1940s, Slobodkina had matured as an artist—Albert Gallatin owned two of her paintings, and she was invited to exhibit in the influential "Eight By Eight" exhibition of American abstract art at the Philadelphia Museum of Art in 1945.[3] With technical problems well in hand, she developed compositions such as *Crossroad #2* and *Spring #3*, in which she juxtaposed planar shapes to create subtly modulated movement. Often abstractions from objects, the paintings of these years are well-harmonized arrangements of color and form. Her exuberance and energy continued to surface in collages—*As Indicated*, for example—and she expressed her irrepressible wit in found object sculpture, and jewelry made of old typewriter parts. In recognition of her own accomplishment and creative potential, Slobodkina was invited back to Yaddo in 1957, and the following year she went twice to the MacDowell Colony in New Hampshire. Since then she has exhibited frequently, and her little books continue to delight children the world over.

1. Esphyr Slobodkina, *Notes for a Biographer* (privately printed, Urquhart-Slobodkina, 1976), p. 325. The three volumes of Slobodkina's *Notes* are a detailed reminiscence of her life, career, family, and friends.

2. Ibid., p. 371.

3. Other exhibitors were George L. K. Morris, Ilya Bolotowsky, Suzy Frelinghuysen, A.E. Gallatin, Alice Trumbull Mason, Ad Reinhardt, and Charles Shaw.

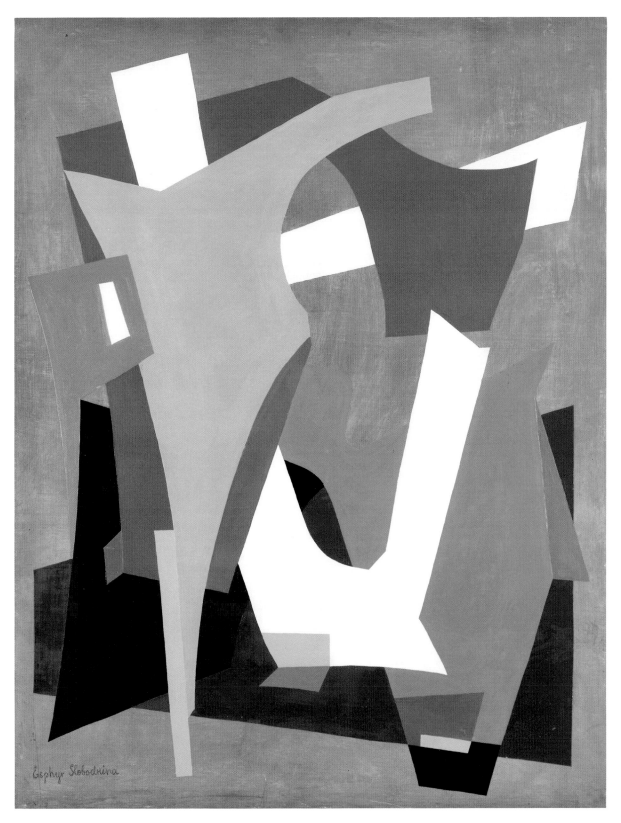

Crossroad #2
ca. 1942–45
oil on fiberboard
43½ x 33½
1986.92.92

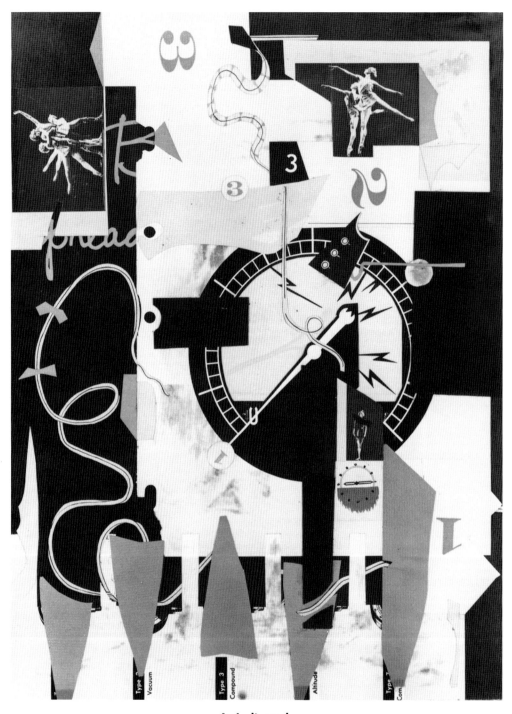

As Indicated
ca. 1945
paper and vinyl on paper
mounted on paperboard
16¹⁄₈ x 12
1986.92.93

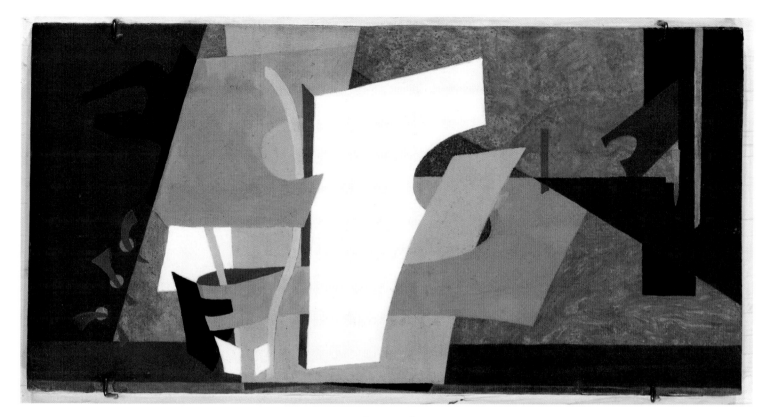

Spring #3
ca. 1948
oil on fiberboard
7 x 14¹⁄₈
1986.92.94

RUPERT DAVIDSON TURNBULL

(1899–1940s?)

ORIGINALLY FROM EAST ORANGE, NEW JERSEY, RUPERT TURNBULL STUDIED AT the Art Students League, at the Académie Scandinave and the Académie Lhote in Paris, and with Vaclav Vytlacil in Paris and Italy. He turned to abstraction about 1930, and was one of the American abstract painters whose work Albert Gallatin purchased for the Gallery of Living Art. During the 1930s, Turnbull taught at Cooper Union and, during its short existence, at the Design Laboratory in New York City. Although little is known about Turnbull's ideas on art, the *Untitled* canvas of 1938 suggests debts to both Kandinsky and Miró.[1]

Turnbull exhibited with the American Abstract Artists until 1942, and served on the group's executive committee in the early 1940s. According to Balcomb Greene, Turnbull was killed in an automobile accident during World War II.[2]

1. "Rupert Davidson Turnbull," *American Abstract Artists: Three Yearbooks (1938, 1939, 1946)* (reprint, New York: Arno Press, 1969).

2. Balcomb Greene, interview with Susan C. Larsen, 30 January 1973, in Susan C. Larsen, "The American Abstract Artists Group: A History and Evaluation of Its Impact Upon American Art" (Ph.D. diss., Northwestern University, 1974), p. 529.

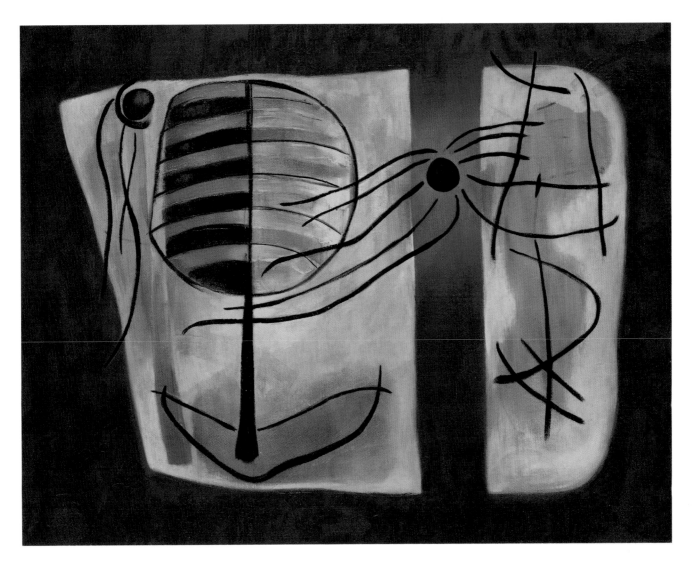

Untitled
1938
oil on canvas
28 x 36
1986.92.95

JOHN VON WICHT

(1888 Germany–1970 USA)

JOHN VON WICHT WAS HIGHLY TRAINED IN FINE AND APPLIED ARTS IN HIS NATIVE Germany before he immigrated to the United States in 1923. When he was seventeen he apprenticed in a painting and decorating shop, and spent his spare time drawing from nature. He began painting in oil about 1908, and soon thereafter sold his first canvas. Encouraged that her son would have a future as an artist, von Wicht's mother sent him to the advanced private school of the Grand Duke of Hesse, where the professors encouraged students to draw plants and flowers to learn about organic growth, shape and proportion. "I remember the Professor speaking of circular movements, of space between forms and of Equilibrium," von Wicht later recalled.[1] The students also studied ancient art, Chinese and Japanese calligraphy, as well as Mathias Grünewald, Albrecht Dürer, Martin Schongauer, Hans Memling, and other German masters whose work was in local collections. Von Wicht subsequently studied printing methods at the Royal School for Fine and Applied Arts in Berlin, but said he skipped class frequently to visit exhibitions of the newest painting—van Gogh, Cézanne, Munch, Gauguin, Kandinsky, and Franz Marc.

Wounded and partially paralyzed in the trenches during World War I, von Wicht spent several years recovering, doing book design and illustration work, and looking at art. It was during this recuperation that he discovered Mondrian and Malevich. In 1923, with inflation devastating the German economy, he immigrated to the United States. In New York, his early training served him well. He worked for two years with a lithography company, then joined a firm making stained glass and mosaics. He learned to use symbols rather than naturalistic motifs, and explored both geometry and dense color in abstract paintings such as the *Untitled* gouache of about 1938, and in murals for radio station WNYC and the New York World's Fair.

Von Wicht had his first solo show, of mural designs, at the Architect's Building in 1936. It was followed, in 1939, by an exhibition of his paintings at Theodor A. Kohn Gallery. The show at Kohn was well received by the New York press, and the following year he exhibited at the Whitney Museum of American Art. This exposure cemented von Wicht's reputation as an abstract painter. Throughout the 1940s, 1950s, and 1960s, he exhibited frequently in solo and group exhibitions in New York and around the country. He was invited to join the American Abstract Artists and the Federation of Modern Painters and Sculptors.

During World War II, von Wicht served as captain of a supply barge ferrying food to army transport ships in New York harbor; after the war he continued to command a supply scow. Harbor themes began to appear in his abstractions, and during the 1950s his sensuously colored geometric abstractions gave way to loose, expressionistic forms. In 1954 von Wicht received the first of twelve annual residencies at the MacDowell Colony in New Hampshire. The spacious studio and contact with other artists at the MacDowell Colony had an important impact on his work. In his exhibition at Passedoit Gallery that year, he exhibited paintings with nautical motifs in which the Cubist device of interlocking and overlapping planes was paramount. But von Wicht also began relating his work to music created by the composers he had met at MacDowell. Although his work was well received from the time of his first exhibition, critics attributed the expanded sense of space, brilliant color, and vigorous handling of paint surfaces in his new work to the experience of living away from the city. By the time he died, in 1970, von Wicht had received international acclaim.

1. John von Wicht, "Recollections," John von Wicht Papers, Archives of American Art, Smithsonian Institution, Washington, D.C., p. 3. Von Wicht's own recollections have provided the foundation for most subsequent writing about his early career.

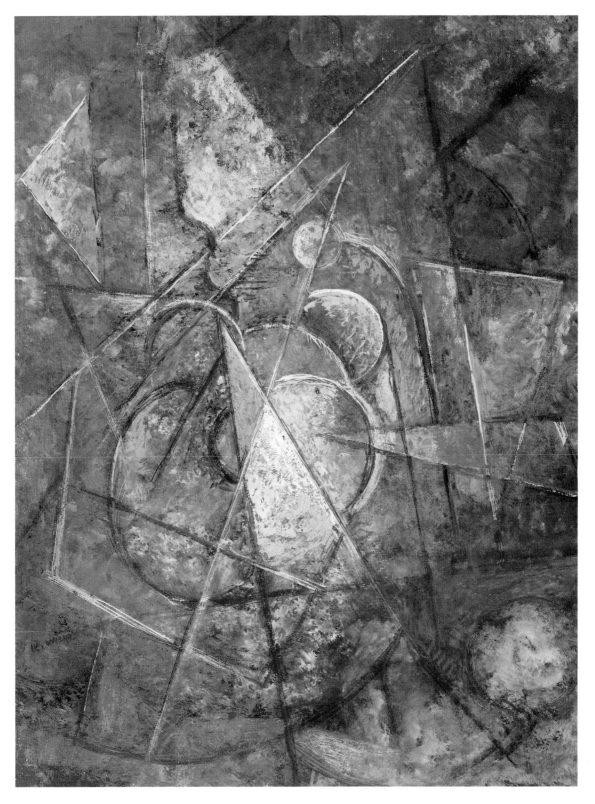

Untitled
ca. 1938
gouache on paperboard
mounted on paperboard
34³/₄ x 26¹/₄
1986.92.96

CHARMION VON WIEGAND

(1896–1983)

CHARMION VON WIEGAND BEGAN MAKING ABSTRACT ART ONLY AFTER MEETING and becoming close friends with Piet Mondrian in the spring of 1941. Von Wiegand had been painting casually since about 1926, but after undergoing psychoanalysis, she realized that art remained as compelling in her adult years as it had been in childhood. But only after she met Mondrian, stopped painting the landscapes she found increasingly troublesome, and spent a year and a half reading and thinking about his Neo-plastic ideas, did she finally come to grips with developing her mature artistic approach.

Long before her encounter with Mondrian, von Wiegand was immersed in the New York art world as a writer and art critic. She grew up in Arizona, but her strongest childhood memories were of San Francisco, where her family moved when she was twelve. Wandering around Chinatown nurtured what would become a life-long interest in Oriental culture. As a teen-ager, she lived for three years in Berlin, then after a year at Barnard College, she transferred to Columbia University in New York to study journalism, theater, and art history. Too "anar-chistic" to take the required curriculum, von Wiegand did not complete her bachelor's degree, but she continued through extension courses to study theater, aiming to be a playwright. Shortly thereafter she began to paint. In 1929 she took a trip to Moscow, and while there obtained a job as a correspondent for the Universal Service of the Hearst Press.[1] On her return to the United States in 1932, she married Joseph Freeman, a founder of *The New Masses* and later an editor of the *Partisan Review*. Von Wiegand, herself, continued to write. She served as an editor of the Artists' Union publication *Art Front*, and wrote perceptive, often impassioned articles on art and exhibitions for *The New Masses*, *Art Front*, and other periodicals. She counted among her friends at this time Carl Holty, Raphael Soyer, Frederick Kiesler, Joseph Stella, Max Weber, John Graham, and other progressive and vanguard artists.

She decided to do an interview with Mondrian about six months after his arrival in this country. Carl Holty had arranged the introduction. Von Wiegand and Mondrian quickly be-came friends, and von Wiegand assisted the elderly Dutch painter with revisions and transla-tions of his writings. Although she had known Mondrian's works from the Gallatin Collec-tion, she initially regarded them as overly mathematical. Only after meeting Mondrian did she become fascinated with the spiritual aspects of Neo-plasticism. Abandoning her land-scape painting, von Wiegand immersed herself in Mondrian's ideas and read publications by Kandinsky and the Russian Constructivists. At Holty's urging, she became an asso-ciate member of the American Abstract Artists in 1941, but only began to exhibit with the group in 1948.

Although von Wiegand's paintings from the mid and late 1940s show evidence of her close study of Mondrian's work, she did not adopt the stringent grid format nor limited palette he preferred. She was fortunate to have watched Mondrian work on both *Broadway Boogie Woogie* and *Victory Boogie Woogie*, paintings in which he put aside his characteristic ortho-gonal black structure in favor of an architecture of color. Von Wiegand's paintings are spatially denser and more lyrically conceived, with diagonals, pointed arches, and curves enlivening her patterns of color. About 1946 she began making collages, whose stylistic kinship lay with Kurt Schwitters, rather than Cubism or Neo-plasticism. In *Transfer to Cathay* and others she combined strips of colored paper with pieces of matchbooks, subway and bus tickets, snippets of menus, and handwritten notes, harnessing the energies of the outside world within a loose, almost playful architecture.

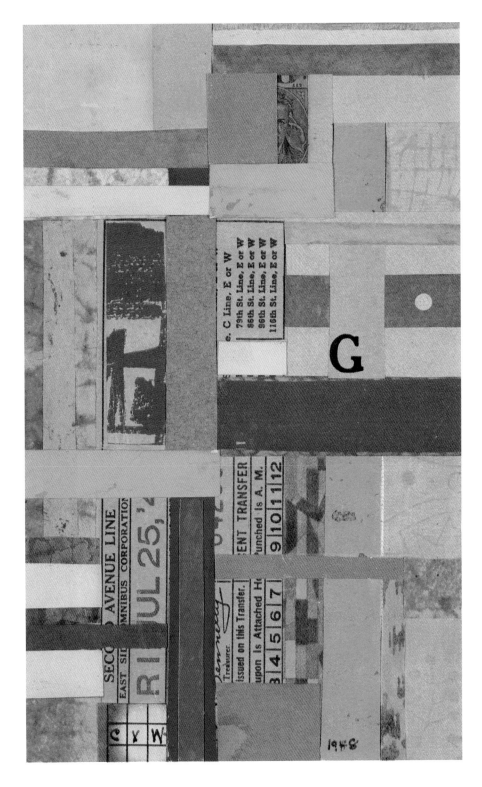

Transfer to Cathay
1948
paper on paper
7^{1}/$_{2}$ x 4^{9}/$_{16}$
1986.92.97

During the 1950s von Wiegand moved away from Neo-plasticism. In 1968, she said, "I am not a disciple of it today. . . . I still believe in the principles. But the expression that I am making now is different and is motivated in a different way and therefore must have a different basis."[2] The different basis of which she spoke came from her renewed interest in Eastern philosophy. Tibetan art and ideas, in particular, became central to her work; "its combinations of figurative and abstract symbolic elements in a hieratic, geometric formal structure" served as a foundation for her artistic and philosophical ideals.[3]

1. Biographical information here comes from two sources: interviews by Paul Cummings with von Wiegand on 9 October, 15 November, and 1 December 1968, Archives of American Art, Smithsonian Institution, Washington, D.C.; and an illuminating article by Susan C. Larsen, "Charmion Von Wiegand: Walking on a Road with Milestones," *Arts* 60, no. 3 (November 1985): 29–31.

2. Von Wiegand, interviews with Paul Cummings.

3. Larsen, "Charmion Von Wiegand," p. 31.

VACLAV VYTLACIL

(1892–1984)

VACLAV VYTLACIL WAS AMONG THE EARLIEST AND MOST INFLUENTIAL ADVO-cates of Hans Hoffman's teachings in the United States. Vytlacil, who first met Hofmann in Munich in 1923, had already completed his art studies and had been teaching art for five years. Vytlacil immediately grasped the significance of Hofmann's ideas. "I quickly realized," he later recalled, "that this is what I had been searching for."[1]

As a child, Vytlacil had taken art classes at the Art Institute of Chicago. In 1913, he received a scholarship to the Art Students League in New York, where he worked with John C. Johansen, an able portraitist whose expressive style resembled that of John Singer Sargent and Anders Zorn. On completion of his studies in 1916, he accepted a teaching position at the Minneapolis School of Art. Vytlacil saved enough money to go to Europe in 1921. He hoped to study Cézanne's paintings and the work of Old Masters. He spent a month in Paris, then went to Prague (his parents were Czechoslovakian). He toured Dresden, Berlin, and Munich. The paintings he sought out—works by Rembrandt, Titian, Veronese, Cranach, and Holbein—gave him a new perspective. "I am, for the first, beginning to understand some of the laws the old masters used in their paintings and wonderful things they are too. It was no hit or miss affair with them, neither was it just feeling: but rather real solid laws and facts that not only one used, but they all used."[2]

In Munich, Vytlacil enrolled at the Royal Academy of Art, where Worth Ryder and Ernest Thurn were fellow students. When Thurn left the Academy for Hofmann's school, Vytlacil soon followed.[3] Vytlacil worked with Hofmann throughout the mid 1920s, first as a student, and subsequently as a teaching assistant. With Thurn, he organized Hofmann's 1924 summer school on the island of Capri.

The contact with Hofmann made Vytlacil reconsider his own artistic approach. "More and more I realize that drawing is the bottom of it all and to paint without being able to draw leads only to grief."[4]

Vytlacil returned to the United States in 1928. During the summer of that year, at Ryder's invitation, he gave a series of lectures on modern European art at the University of California at Berkeley. The next fall he joined the faculty of the Art Students League. Although he encountered opposition from Reginald Marsh, Boardman Robinson, and Kenneth Hayes Miller at the league, Vytlacil gave a series of public lectures on modern art that had lasting importance. George L. K. Morris was only one of many young Americans lured into modernism after hearing Vytlacil speak.

Vytlacil returned to Europe after a season at the league. In Munich he attempted to interest Hofmann in teaching at the league. He then set up a studio in Paris, where he gained first-hand knowledge of Picasso, Matisse, and Dufy. Over the next six years, Vytlacil divided his time between Paris, Capri, and Positano. In 1931, he took a five-year lease on a villa in Positano and opened an informal school. He returned to New York in 1935, and the following year helped found the American Abstract Artists. During the late 1930s and early 1940s, he taught at a variety of places—the Art Students League, Queens College in New York, Black Mountain College in North Carolina, the College of Arts and Crafts in Oakland, California, and other art schools. In 1946, he rejoined the faculty of the Art Students League and remained there until his retirement in 1978.[5]

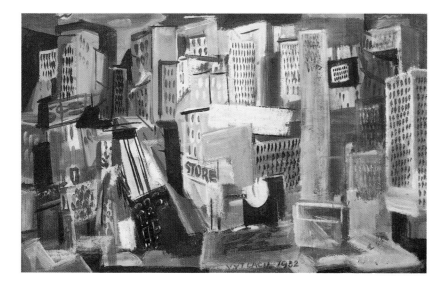

City Scene #10
1932
oil on canvas
15 x 24
1986.92.99

Theater District
1933
oil on canvas
28³/4 x 39³/8
1986.92.100

Village Scene
1918
oil on canvas
29³/4 x 26
1986.92.98

Construction
1938
painted wood
53³/₈ x 6 x 1³/₄
1986.92.102

Untitled
1938
oil on fiberboard
24 x 18
1986.92.101

Even before Vytlacil went to Europe, his paintings showed a decided inclination toward modernism. In the expressionistic *Village Scene* of 1918, and other work from the the same decade, Vytlacil compressed space and balanced his compositions through an adroit use of color. His still lifes and interiors from the 1920s reflect an understanding of Cézanne gleaned partly from his discussions with Hofmann:

> No one in my former period of training had ever spoken of the properties of the two-dimensional plane, that planes built volumes, not lines, that volumes were three-dimensional and that the negative space in which they exist also has a three-dimensional volume."[6]

During the 1930s, Vytlacil pursued two distinct and very different kinds of art simultaneously. Landscapes and cityscapes of the early 1930s, such as *City Scene #10* and *Theater District*, merge Cubist-inspired spatial concerns with an expressionistic approach to line and color. He also began doing constructions. These were usually of discarded wood from a department store opposite his studio. He occasionally added cardboard, string, metal, and cork to these works.[7] Though he experimented with constructions for several years, Vytlacil eventually gave them up as too limiting. He continued to prefer the spatial challenges of painting. Over the years Vytlacil occasionally ventured into complete nonobjectivity; still most of his work is abstracted from recognizable subjects.

During the 1940s and 1950s there was a new found freedom in Vytlacil's paintings. Energy replaced form as primary concern, and his subjects—landscapes, still lifes, the human figure—possessed a spontaneity unsuspected from his earlier work.

1. Vaclav Vytlacil, interview with Leontine Zimiles, in Joan Marter, *Beyond the Plane: American Constructions, 1930–1965* (Trenton, N.J.: New Jersey State Museum, 1983), p. 96.

2. Vaclav Vytlacil, letter to Elizabeth Foster, his future wife, 5 January 1922, Vaclav Vytlacil Papers, Archives of American Art, Smithsonian Institution, Washington, D.C., roll D295: 259. (This letter was probably written on 5 January 1923, since another, dated 5 January 1922, indicates that Vytlacil had just arrived in Prague, after a month in Paris.)

3. Lawrence Campbell, "Introduction," *Vaclav Vytlacil: Paintings and Constructions from 1930* (Montclair, N.J.: Montclair Art Museum, 1975), p. 3, describes Thurn's situation. Thurn was forced to leave the Royal Academy when the Bavarian Ministry of Culture decided to limit the age of students to thirty-five. To retain his visa, Thurn had to find alternative, approved instruction. He discovered Hofmann's school, which had police permission to accept students of any age and nationality.

4. Vytlacil, letter to Elizabeth Foster, January 1925, Vytlacil Papers, Archives of American Art, roll D–295: 288.

5. The most thorough chronology of Vytlacil's life can be found in the Montclair Art Museum publication.

6. Worden Day, interview with Vaclav Vytlacil, Montclair, New Jersey, 1975, Vytlacil Papers, Archives of American Art.

7. Vytlacil began making constructions after seeing those of his friend and former student Rupert Turnbull. He worked closely with Turnbull in Positano, where the two experimented with tempera painting. Their explorations were published in Rupert D. Turnbull and Vaclav Vytlacil, *Egg Tempera Painting, Tempera Underpainting, Oil Emulsion Painting: A Manual of Technique* (New York: Oxford University Press, 1935).

STUART WALKER

(1904–1940)

ABOUT 1935, ONLY FIVE YEARS BEFORE HIS UNTIMELY DEATH AT AGE THIRTY-FIVE, Stuart Walker converted to abstract art. Originally from Indiana, Walker had studied at the Herron School of Art in Indianapolis and for many years was a naturalistic painter. After he moved to Albuquerque, New Mexico, Walker frequently chose his subject matter from the state's landscape and the distinctive architectural forms of its Spanish-style churches. In addition, horses, native women, and the Southwest's unique plant life were favored themes. Yet when Walker turned to abstract work, his commitment was total. He began exhibiting his new paintings immediately in Denver and throughout the Southwest.

When the Transcendental Painting Group was organized, Walker was an original member. His artistic concerns paralleled those of Raymond Jonson and other members of the group, and he showed with them at the Golden Gate International exhibition in San Francisco in 1939. He was concerned in his paintings with the convergence of planar forms and architectural structure. The exploration of rhythmic form in a painting—a parallel concern to Raymond Jonson's work at this time—became a major artistic interest. Like others in the Transcendental Painting Group, Walker hoped to appeal directly to the viewer's senses. In many of his paintings, including *Composition #61*, he used anonymous titles to avoid any reference to the natural world he had artistically left behind.

Fellow members of the Transcendental Painting Group believed Walker had just begun to realize his artistic promise when he died. In his abstract work, they felt, he had found a level of inventive freedom not evident in his earlier, more realistic work.[1]

1. At his death, the inventory of Walker's paintings was relatively small. Little published material exists about his life, but examples of his work are in the collection of the Jonson Gallery, University of New Mexico. See Raymond Jonson's "Tribute to Painter Stuart Walker on Occasion of a Recent Exhibition," 1940, Raymond Jonson Papers, Archives of American Art, Smithsonian Institution, Washington, D.C., roll RJ8: 5754.

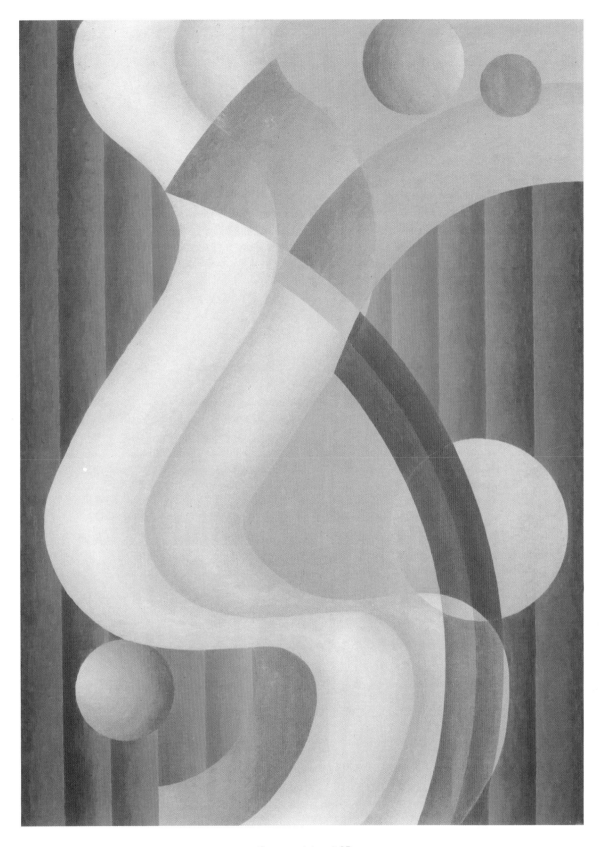

Composition #61
1939
oil on canvas
36 x 26
1986.92.103

FREDERICK J. WHITEMAN

(born 1909)

FREDERICK J. WHITEMAN CONSIDERS HIMSELF AN ANALYTICAL PAINTER, an approach that grew out of childhood interests in motors, electricity, and radio instruments. Like a scientist or engineer, he visually dissects his subjects to understand the nature and function of their constituent elements and rebuilds as he seeks new expressive possibilities.

Whiteman grew up in a small town in Pennsylvania and on a farm in Indiana. From an early age he worked with his father, a merchant, contractor, and distributor of electrical, mine, and railway supplies. Cultural activity in his rural Indiana focused on music and theater, rather than the visual arts, and Whiteman became a musician at an early age. But Whiteman was also an inveterate draftsman and did character drawings to amuse his classmates. In high school he enrolled in a correspondence art course, and although he calls his early drawings stiff, mediocre, and pale, by the time he was sixteen he had developed sufficient ability to obtain employment as an engineering draftsman after the death of his father left the family in financial straits.[1]

After completing high school in 1927, Whiteman studied for a year with Alexander J. Kostellow in Pittsburgh, and from 1930 to 1932 he worked with Jan Matulka and Eugene Fitch at the Art Students League in New York City. During these early years, Whiteman made a living working in the art department of a Brooklyn advertising agency. Yet he was already a committed modernist, and by 1935 he was one of the few young artists to be included in the Whitney Museum's controversial *Abstract Art in America* exhibition.

After several years in the advertising business, Whiteman began teaching privately. With Kostellow, he hoped to establish a school for modern art in which students would study design and work in a school factory to produce commercially viable products. Based partly on Bauhaus ideas of the unity of art and life, the school did not materialize. When the Federal Art Project was established, Whiteman joined the teaching project. From 1937 to 1939, he served as director of the WPA art centers in Greensboro, North Carolina, and Greenwich, Mississippi.[2] He returned to New York in 1939, and the following year joined the faculty at Pratt Institute, where he remained until his retirement in 1974.

Whiteman's paintings of the 1930s reflect a highly developed understanding of the principles of artistic structure, space, and color. Much of his work, including the 1935 *Still Life with Pitcher*, is Cubist in inspiration and spatial arrangement, although the compositional arrangement of Italian Renaissance art has also contributed to his ideas about space. Never a theoretical artist, Whiteman concentrated on teaching his students to see with analytical eyes and to evaluate form, space, color, and structural line in objective terms.

1. The information about Whiteman's early years is drawn from his "Personal History Statement" provided by the artist and now in the curatorial files at the National Museum of American Art, Smithsonian Institution, Washington, D.C. I am grateful to Mr. Whiteman for this information.

2. For further information about his work with the Federal Art Project, see Frederick J. Whiteman, interview with Dorothy Seckler, 21 April 1965, Archives of American Art, Smithsonian Institution, Washington, D.C.

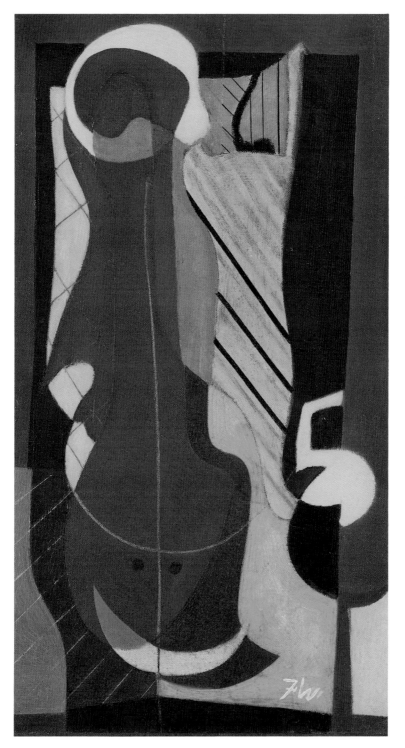

Still Life with Pitcher
1935
oil on canvas
18 x 10
1986.92.104

JEAN XCERON

(1890 Greece–1967 USA)

JEAN XCERON, GREEK BY BIRTH, CAME TO THE UNITED STATES WHEN HE was fourteen years old. For the next six years he lived and worked with relatives in Pittsburgh, Indianapolis, and New York City. In 1910, determined to be an artist, he moved to Washington, D.C., and enrolled in classes at the Corcoran School of Art. At the Corcoran, where the curriculum focused on the traditional academic practice of drawing from plaster casts, Xceron perfected his skills as a draftsman. He first encountered modernism when, in 1916, two fellow students arranged an exhibition of avant-garde paintings borrowed from Alfred Stieglitz. The show made a deep impression on Xceron, whose own appreciation for flat color and expressive distortion paralleled the work being done by others.

In 1920, Xceron moved to New York and became friends with Joaquin Torres-Garcia, Max Weber, Abraham Walkowitz, and Joseph Stella. He exhibited in the New York Independents' exhibitions in 1921 and 1922. In New York, Xceron studied Cézanne and read as much as possible about new artistic movements abroad. Xceron was finally able to travel to Paris in 1927. There he began writing reviews of the latest in art for the *Boston Evening Transcript* and the Paris edition of the *Chicago Tribune*. His articles on Jean Hélion, Hans Arp, John Graham, Theo Van Doesburg, and other artists showed his increasingly sophisticated understanding of recent art. About the same time, his own painting underwent a dramatic transition. As a writer, he was quickly accepted into the Parisian art world as one of the few critics sympathetic to modern art; but few realized that Xceron was an accomplished painter as well. Soon, however, members of the Parisian Greek community became aware of Xceron's talents, and Christian Zervos, editor of the influential magazine *Cahiers d'Art*, arranged a solo exhibition at the Galèrie de France in 1931. Visitors to this first exhibition saw an artist who was working his way through Cubism. Still-life and figural motifs remained prominent, but the artist was striving to capture rhythmic and fluid movement rather than solid form. Over the next several years, Xceron moved away from his figural foundations, introducing at first gridlike structural patterns and, by the mid 1930s, planar arrangements of severe Constructivist purity.

When Xceron returned to New York in 1935 for an exhibition at the Garland Gallery, he was among the inner circle of *Abstraction-Création* and other leading Parisian art groups. Moreover, he had achieved some reputation. He again visited New York in 1937 for a show at Nierendorf Gallery. Although planning only a visit, his move proved permanent. Xceron soon joined the American Abstract Artists, who welcomed him as a leading Parisian artist. Despite his reputation, however, he fared little better commercially than did his new colleagues. He was hired by the WPA Federal Art Project and executed an abstract mural for the chapel at Riker's Island Penitentiary. In 1939 he began working for the Solomon R. Guggenheim Foundation, where he remained for the rest of his career.

Portrait No. 61 and *Portrait No. 38*, both of 1932, represent midway points in Xceron's artistic development. Created several years after his move to Paris, they reflect Xceron's simultaneous commitment to a tactile surface and the rhythmic movement of line and form. By the early thirties, Xceron was fully indoctrinated into the aesthetics of De Stijl, but had not yet accepted the geometric formulation of spatial balance that would shape his work during the mid 1930s. The muted palette of soft gray tones in the portraits had not yet yielded to the vibrant, almost optical color that became his hallmark during the geometric phase of his work. By the late 1930s, Xceron's paintings took on striking similarities to Kandinsky's work of the mid 1920s, and works like *Watercolor #308* (1947) show parallels with the paintings of

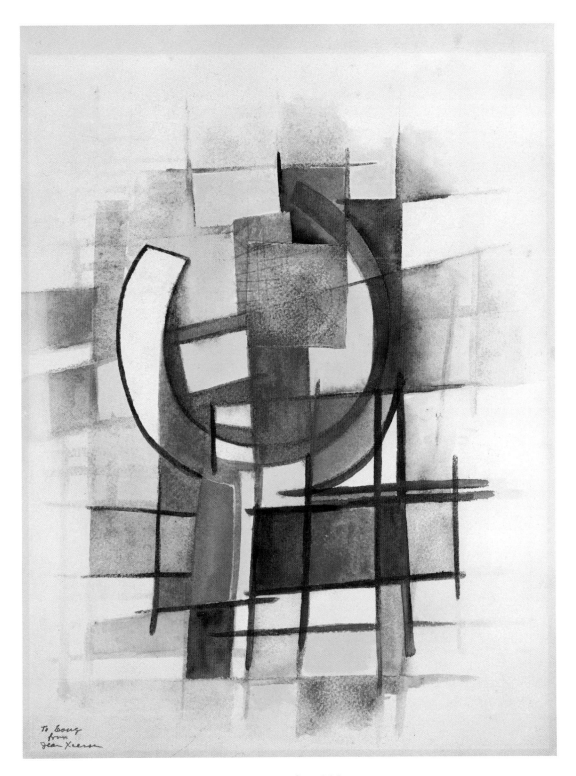

Watercolor #308
1947
watercolor on paper
15^{7}/$_{8}$ x 11^{15}/$_{16}$
1986.92.107

Rudolf Bauer that played so prominent a role in the exhibitions Hilla Rebay presented at the Guggenheim Foundation and later at the at the Museum of Non-Objective Painting. This connection with Rebay meant that Xceron never became closely involved with the inner circle of the American Abstract Artists. They, for the most part, rejected the mystical notions of art propounded by the influential baroness.[1]

1. The anti-Rebay stance taken by several members of the American Abstract Artists is described in greater detail in Hananiah Harari's catalogue entry.

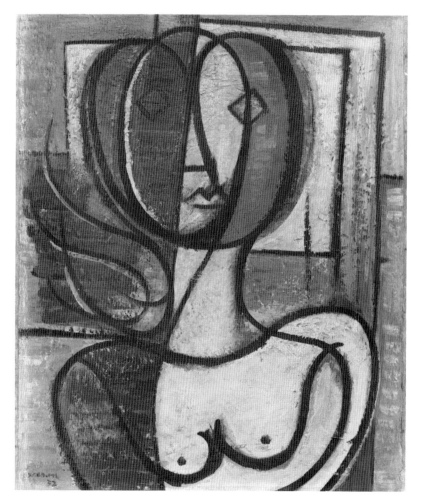

Portrait No. 61
1932
oil on paperboard
18 x 15
1986.92.105

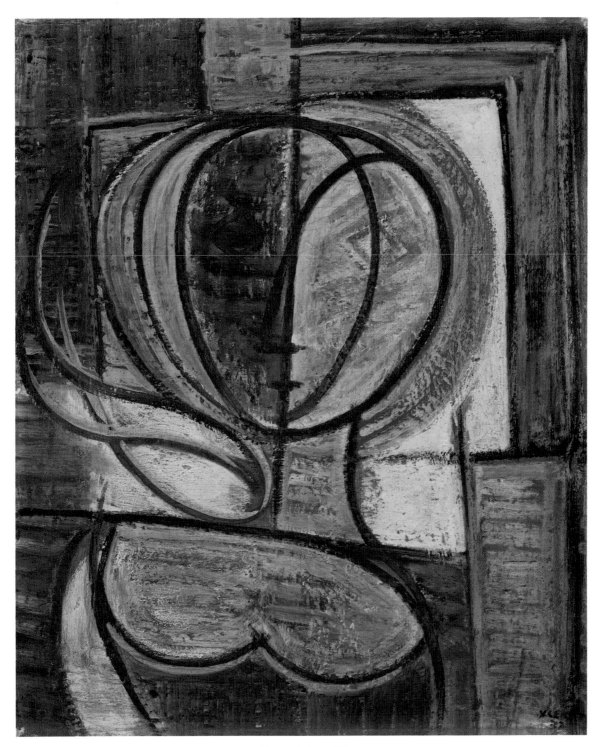

Portrait No. 38
1932
oil on paperboard
18¹/₄ x 15
1986.92.106

BECKFORD YOUNG

(1905–1979)

BECKFORD YOUNG BECAME ASSOCIATED WITH THE AMERICAN ABSTRACT
Artists after he returned from an extended stay in Europe. The son of a builder in Petaluma,
California, Young learned carpentry at an early age, and while still in his teens, built a house
on his own. A high school athlete, Young passed up a football scholarship. Instead, he decided
to attend the University of California at Berkeley, where he was influenced by John Haley and
Worth Ryder. It was Ryder, Hans Hofmann's former student in Munich, who arranged the
summer teaching position that first brought Hofmann to the United States.[1] And it was Ryder
who introduced Young to Hofmann's ideas. When Hofmann himself arrived in Berkeley, he
took Young under his wing. Hofmann advised Young to forget everything he had learned, and
draw using only ink and a matchstick. When Hofmann returned to Germany, he convinced
Young to join him, although when Hofmann decided to move permanently to the United
States, his student remained abroad. In Berlin he met and married Janet Todd. From Germany,
the couple traveled to Rome, and then to Positano, the art colony on the coast of Italy where
Vaclav Vytlacil held summer classes. Later Young described his time in Positano as his most
creative and prolific period. However, little of the work from that time remains today. In
Positano, Young worked closely with Vytlacil and also studied fresco painting, attempting to
duplicate ancient Pompeian techniques.

In 1937, with the political situation worsening in Europe, the Youngs returned to California,
where Beckford joined the WPA.[2] His newly acquired expertise in fresco led to immediate
employment on mural projects for federal buildings in the San Francisco Bay area. In 1938, he
transferred to the Sacramento project, where he organized an art school and gallery. Although
he also taught painting, his primary responsibilities in Sacramento were administrative.
Subsequently Young managed a variety of WPA projects in Oakland and San Francisco, where
he served as art director until the WPA came to an end.[3]

Young was deeply committed to the WPA's concept of public art. He believed art should be
integrated with life and should make a positive contribution to the community. Much of the
work he did on the WPA was directed toward educating children to the beauty and enjoyment
of creating works of art.

During World War II, Young did camouflage work for the armed forces and served in other art-
related fields. In the 1950s and 1960s, he completed mural commissions for various hotels and
other public spaces. He also worked for a residential construction firm, and during the early
1960s handled remodeling projects for the Hilton Hotel chain.

Living in California, Beckford Young was a long-distance member of the American Abstract
Artists and exhibited in several of its early annual exhibitions. He considered himself an
experimental, rather than an abstract artist, who incorporated Hofmann's ideas into a body of
work that was, for the most part, representational. The dramatic white *Construction*, in
which the artist attached architectural moldings, strips of wood, and other found objects to a
door, was an unusual work for Young. It owes a conceptual debt to Russian Constructivism,
yet is stylistically closer to Vytlacil's constructed work of the 1930s than to that of Pevsner,

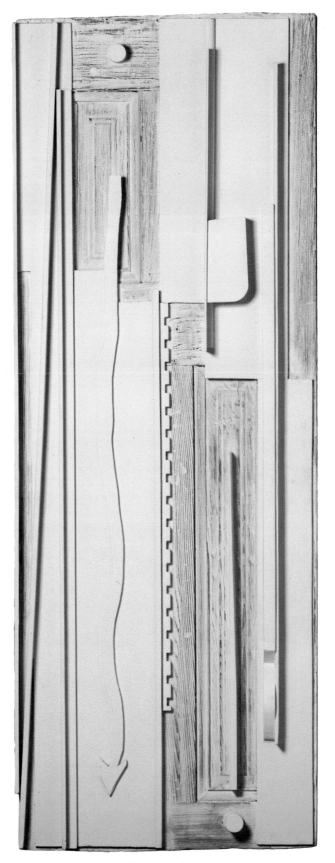

Construction
1937
painted wood
74³/₄ x 28¹/₄ x 3³/₄
1986.92.108

Gabo, or Tatlin. Young's admiration for Vytlacil is perhaps most clearly revealed in the *Untitled* gouache of about 1938. The compressed space of the figures, defiant of the implied dimensionality of the brick foreground and building, relates directly to a short-lived classical phase of Vytlacil's work during the 1930s.

1. The biographical information about Beckford Young is drawn from an interview with Young's widow, Eleanor, and his children Gayle, Mark, and Beckford, Jr., conducted by Mary Drach, March 1988, curatorial files, National Museum of American Art, Smithsonian Institution, Washington, D.C.

2. Beckford Young spoke at length about the California WPA art programs and the role he played in an interview with Mary McChesney, 19 May 1965, Archives of American Art, Smithsonian Institution, Washington, D.C.

3. Among the projects Young directed were a mosaic mural at the University of California by Helen Bruton and Florence Swift, the Beach Chalet murals by Lucien Lebaudt, and murals at Treasure Island and the San Francisco Federal Building. He also provided oversight for various sculptural and mural projects at the San Francisco Aquatic Park.

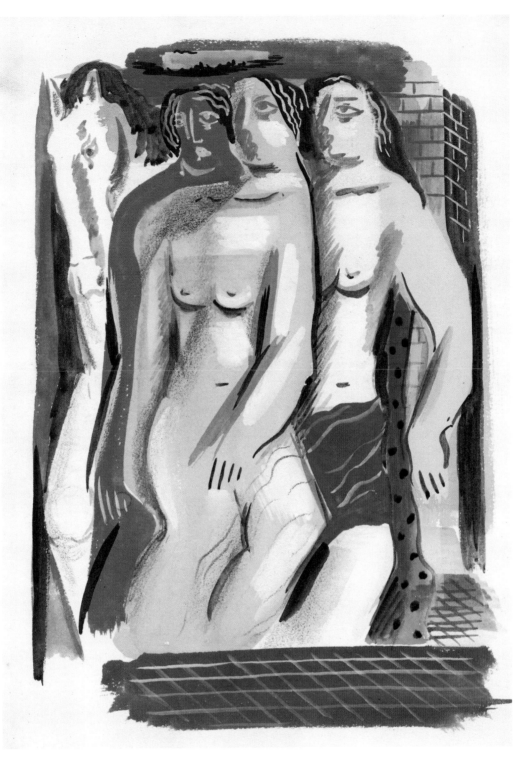

Untitled
ca. 1938
gouache and pencil on paperboard
8¹/₂ x 6
1986.92.109

JANET TODD YOUNG

(born 1908)

THE DAUGHTER OF A CONGREGATIONALIST MINISTER AND THE OLDEST OF four children, Janet Young was raised in Illinois. She received her bachelor's degree in languages from Oberlin College in Ohio; her fluency in Italian, French, and German later led to work as a translator for the United States government during World War II. After graduating from Oberlin, Young traveled to Germany, where she helped her father organize European tours for school teachers. In Germany she discovered the Bauhaus, and while she never attended its classes, the fertile environment had a lasting effect on her work. During the early 1930s, she spent much of her time in Berlin. It was there that she met and married Beckford Young, a California art student who had gone to Germany to study with Hans Hofmann.[1] Shortly after their marriage, the Youngs traveled in Italy, and spent a summer at the art colony in Positano where Vaclav Vytlacil was teaching.

This period was a productive one for Janet Young. The artist was already committed to developing a personal language of abstraction based on Constructivist ideas. Young continued to experiment with Constructivism after she and her husband returned to California in 1937. Although the early complex wooden assemblages she exhibited in the 1938 annual of the American Abstract Artists are now lost, it is apparent from photographs that Young had thoroughly assimilated the Constructivist aesthetic. In them she combined rectangular wood cutouts, half-round and serrated wood moldings with spherical and hemispherical shapes, and possibly plastics within a shallow relief format. Tightly composed into architectural structures, they are concerned with the balance of static and dynamic form.

Unlike Beckford Young, from whom she was divorced, Janet Young pursued an abstract style throughout her career.[2] Until the 1960s, when she introduced color into her work, she concentrated primarily on stark, black-and-white compositions and frequently worked with collage. *Collage #17* and *Collage #20*, in which Young assembled clippings from magazines and newspapers into articulate, architectural compositions, are typical of her work during this period.[3]

1. The couple divorced in the 1940s.

2. Janet Young was diagnosed as having Parkinson's disease in 1941 and currently lives in a convalescent home in California.

3. The information about Janet Young's life is from an interview with Beckford Young, Jr., by Mary Drach, conducted on 31 March 1988. I am grateful to Mr. Young for his assistance.

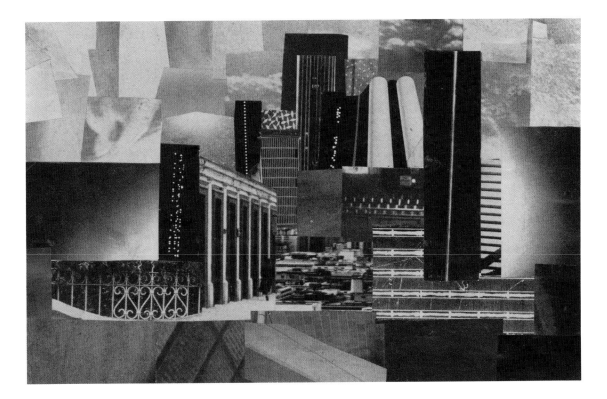

Collage #20
ca. 1938–39
magazine and newspaper clippings on paper
image: 5^{11}/$_{16}$ x 8^{7}/$_{16}$
1986.92.111

Collage #17
ca. 1938–39
magazine and newspaper clippings on paper
image: 5^{1}/$_{2}$ x 7^{3}/$_{16}$
1986.92.110

WILFRID ZOGBAUM
(1915–1965)

BEST KNOWN TODAY AS A SCULPTOR, WILFRID ZOGBAUM BEGAN HIS ART career as a modernist painter. He was the son of an admiral and the grandson of Rufus Fairchild Zogbaum, an artist-illustrator who covered the Spanish-American War. As a child, Zogbaum traveled extensively in Europe, and spoke French and German fluently. In high school, he spent two summers studying painting and drawing at the Rhode Island School of Design. In 1933 he enrolled for a year at the Yale School of Art, but left to go to New York where he studied initially with John Sloan. Beginning in 1935, Zogbaum attended Hans Hofmann's school, where, with Giorgio Cavallon and George McNeil, he served as a class monitor.

Zogbaum described Hofmann as "the only prophet of modern art in America." He believed, with Hofmann, in the importance of nature within art: ". . . when art gets too far away from nature or from ordinary things it begins to lose itself in a kind of . . . glorious mist."[1] Some of Zogbaum's paintings from this time, such as the 1936 *Untitled Abstraction*, evoke the color of the Provincetown landscape where Hofmann had a summer school. However, in the *Untitled Abstraction* (ca. 1934–39), the visual connection with nature is more elusive, based perhaps on the unseen structures of the world.

By 1937, when Zogbaum won a Guggenheim Fellowship to Europe, he was already a member of the American Abstract Artists. The trip to Europe, though, proved significant. Zogbaum met Ben Nicholson, Naum Gabo, and Laszlo Moholy-Nagy in London. In Paris he met Wassily Kandinsky and developed a close friendship with Fernand Léger, a relationship that continued after the Frenchman fled to New York to escape the war. But Zogbaum spent most of his fellowship year in Bavaria, where he associated with Fritz Winter and other former Bauhaus teachers. Returning to New York, Zogbaum painted independently for two years. In 1942, he joined the U.S. Army Signal Corps as a photographer and was with the first U.S. troops to liberate the Pacific islands.

During the late 1940s, Zogbaum became a successful commercial photographer in New York. But in 1948 he left this career to devote himself full time to his art. He exhibited frequently during the 1950s in group and solo exhibitions, and became well known as an Abstract Expressionist. During the mid 1950s, he began making sculpture, initially as a supplement to his painting, and for several years divided his time between the two media.[2] By the late 1950s, however, a decision to temporarily stop painting became a permanent choice. Given his love for nature, it is not surprising that many of his early sculptures are animals and figures. These were often made of discarded machine parts and other found objects, whose identities became submerged within a total statement:

> Most of my sculpture has been made with the methods and materials at hand. One of these is the beach-stone which seemed a means of introducing a solid volume into the open cage-like structure of steel. At first it was used as a head-like part in a somewhat human or animal image. Later in a more abstract sense and in counterpoise with other objects within the image in a variety of meanings.[3]

In 1957 Zogbaum taught for a semester at the University of California at Berkeley. This position was followed by short-term teaching posts at the University of Minnesota, Southern Illinois University, and at Pratt Institute in New York, and a return year at Berkeley in 1961–62.

Untitled Abstraction
ca. 1934–39
oil on canvas
23³/4 x 20
1986.92.112

1. Wilfrid Zogbaum, interview with Dorothy Seckler, 2 November 1964, Archives of American Art, Smithsonian Institution, Washington, D.C.

2. Zogbaum described his transition from painting to sculpture in a draft statement for an exhibition brochure entitled "Four American Sculptors," written in October 1964, Wilfrid Zogbaum Papers, Archives of American Art.

3. Ibid.

Untitled Abstraction
ca. 1936
oil on paperboard
15¹/₂ x 21¹/₄
1986.92.113